Primitive Painters

in America

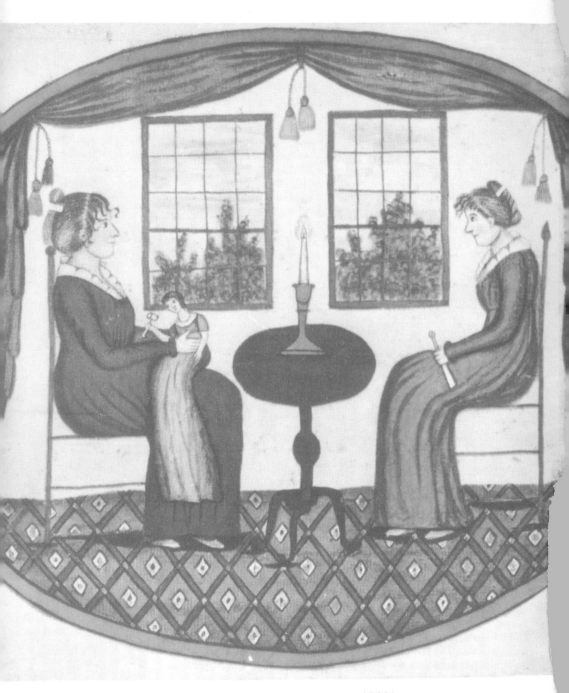

PINNEY, Two Women *(c. 1810)*
Jean and Howard Lipman

Primitive Painters in
AMERICA
1 7 5 0 - 1 9 5 0

AN ANTHOLOGY BY

JEAN LIPMAN AND ALICE WINCHESTER

Biography Index Reprint Series

BOOKS FOR LIBRARIES PRESS
FREEPORT, NEW YORK

INTERNATIONAL STANDARD BOOK NUMBER:
0-8369-8100-6

LIBRARY OF CONGRESS CATALOG CARD NUMBER:
70-179732

PRINTED IN THE UNITED STATES OF AMERICA
BY
NEW WORLD BOOK MANUFACTURING CO., INC.
HALLANDALE, FLORIDA 33009

Acknowledgment

We are grateful to the ten authors whose work is included in this book, to the owners of the paintings reproduced, and to the following publishers who gave permission for all this material to be assembled here: American Collector, Art in America, Art Quarterly, Dial Press for TWENTIETH CENTURY PRIMITIVES, Copyright, 1942, by Sidney Janis. Houghton Mifflin & Company for material from SOME AMERICAN PRIMITIVES. Copyright, 1941, by Clara Endicott Sears. Illinois State Historical Society, Magazine of Art, Old-Time New England, Oxford University Press for material from AMERICAN PRIMITIVE PAINTING. Copyright, 1942, by Oxford University Press, N. Y. Mrs. Frederic Fairchild Sherman, The Magazine Antiques for EDWARD HICKS, Copyright, 1936; JOSEPH WHITING STOCK, Copyright, 1938; DEBORAH GOLDSMITH and JOSEPH H. DAVIS, Copyright, 1943; ERASTUS SALISBURY FIELD, Copyright, 1944; WILLIAM MATTHEW PRIOR and THOMAS CHAMBERS, Copyright, 1948 by THE MAGAZINE ANTIQUES. Special thanks for the use of color plates are due to the Book-of-the-Month Club, Doubleday and Company, Oxford University Press, and the Vermont Historical Society.

TO
NINA FLETCHER LITTLE
A PIONEER
IN THE STUDY AND APPRECIATION OF
AMERICAN PRIMITIVE PAINTING

Contents

Illustrations

ILLUSTRATIONS

ILLUSTRATIONS

Why American Primitives?

A BOOK about painters must also be a book about paintings. Where and when a painter was born, lived, and died are interesting and illuminating details, but what he did *as a painter* is what makes those details worth bothering about. So, though this book is intended to be more about painters as people than about their pictures, we find the artist and his art so inevitably interrelated that consideration of one without the other loses meaning.

American primitive paintings no longer need to be identified as a category. Since they were first "discovered" in the 1920's, interest in them has spread amazingly, and now they are very generally recognized. But they are still not very thoroughly understood. That is indicated by the fact that they are called by so many different names—primitive, folk art, popular, provincial, pioneer, artisan, amateur, and probably others too. Many writers have tried to establish firmly one term or another, but discussion still goes on, because the pictures themselves are so diverse that no one name seems to cover them all.

Primitive, for instance, is perhaps not the most precise, but probably the most descriptive, and is the most generally accepted. It is misleading if it suggests the work of men in a primitive society, like the wall paintings of the cave man, or the first attempts of what later became a fully developed school of painting, like the Italian primitives, for American primitives did not grow from an aboriginal society nor did they develop a school. Yet they have many of the same characteristics. And if we take primitive to mean characterized by qualities belonging to the original state of man, such as naturalness and simplicity—which Webster says it does—then it is the word for these pictures.

Many people prefer to call them folk art, a name that also covers sculpture and often many other crafts. Some object on the grounds that folk art means the products of a peasant society with folk traditions, such as never existed in this country. But folk art is eminently suitable as a name if it connotes instead that good old American expression, "the folks" —the ordinary, everyday people. This kind of American art is the art of the folks.

Popular art has a similar connotation—the art of the people. In a sense provincial means somewhat the same thing, but not quite: it suggests origin in the sticks as contrasted with the city, and that distinction does not apply to these pictures. Provincial as the opposite of cosmopolitan does, however.

Pioneer is one of the more misleading of these terms. Even if we stretch it to mean the whole progressive American spirit instead of referring to the frontiersman alone, to call these pictures pioneer paintings is to suggest that they were uniquely an American expression. It is quite true that American primitive paintings (we must use *some* name for them!) have distinctive qualities, but "the folks" in other countries had their own art too. Recent investigation has shown a quite comparable development in England, and we should probably find it on the Continent if we were to look for it.

Artisan and amateur are terms proposed not for the whole body of this art but as labels for differentiating one type from another. As such they are valid and useful. In fact, we may in time be able to sort out this considerable group of painting into smaller and more readily comprehensible categories, and provide an accurate name for each.

At present the very diversity of names implies the diversity of the pictures. What they are called is perhaps not very important, after all, so long as the name is mutually agreed upon and generally understood. These pictures comprise the oil paintings, water colors, drawings, and pastels made in this country during three centuries, which have in common a mingling of true artistic quality with what has been called "artistic innocence." In contrast with academic painting, they have the freshness, directness, simplicity, and stylized manner of the unschooled artist. Often they appear inept in their execution, but always they reveal imagination and a strong sense of design. Some of them are early efforts by painters who later became academic, though far more of them were by people who, whether trained or not, remained primitive in their work. Many of these

2

were professionals in the sense that they earned their living by their art. Others were, in the same sense, amateurs.

And here consideration of the pictures brings us back directly to the people who made them. It seems easier, somehow, to describe the people than their pictures—but even that is not easy.

When collectors began taking these forgotten pictures seriously nearly thirty years ago, they differed on the qualities they saw in the pictures, and on their merits relative to other types of painting, as well as on nomenclature. But regarding the artists themselves there was from the first general agreement: they were untrained, itinerant, and anonymous.

In the years since then, while many arguments about the pictures have remained unsettled, the one undisputed "fact" about the painters has been proved wrong. They are not all anonymous, by any means. The names of some 600 of them are known and recorded in this book; in most cases, the dates of their painting activity are also known, the region in which they worked, and the medium in which they made their pictures. It has become apparent that besides having names and identities, they were not all untrained and not all itinerant. Much fuller details are known about a number of them, details sought out and pieced together by careful students so that the painter's history emerges with some completeness. And as that happens the painter himself takes on life and becomes a real personality in a genuine environment.

Who, then, were these American primitive painters? How did they happen to paint? Whom did they paint for? Were they the product of a single environment? Do they, in short, conform to a type?

In the hope of finding answers to these questions, we have gathered together in this volume the life stories of more than a score of American primitive painters of three centuries, as they have been recorded in scattered periodicals. They have been selected as representative or particularly significant in terms of their work.

The chief emphasis is on those of the nineteenth century because the period from, roughly, the close of the Revolution to the Civil War was the great period of primitive painting in America—the most prolific, the most diverse, and, to most critics, the best. In separate chapters Nina Fletcher Little and Sidney Janis consider, respectively, the primitive painters of the eighteenth and of the twentieth centuries, while the painters singled out for more detailed discussion are all of the nineteenth. From the artistic point of view, those of all three centuries belong in the one category

of primitive, but historically speaking they are products of three eras which are quite distinct even though they grew gradually one from the other.

Considering the nineteenth-century painters alone, then, for the present, we may risk a generalization or two. While in some cases their biographies remain sketchy, they are complete enough for us to see that we can make no single composite portrait of the American primitive painter. These painters were all individuals, and individualists. That, of course, is a big reason why they made the pictures they did, and why we find those pictures interesting. There is as much diversity among the people as among their works. We cannot readily find a common denominator in their lives, or characterize the primitive painter as a single type.

We have, for instance, Joseph Whiting Stock, of Springfield, Massachusetts. He might be called an average man, of an average family in an average New England town. If he had not suffered a serious injury in his childhood he would probably have grown up to work in the Armory, as his father did, or perhaps in a mill or other local industry. As it was, he studied art and became a professional painter, successful enough to make his living at it. He was not untrained, or itinerant, or amateur. He was a talented individual who emerged from a humble environment.

Deborah Goldsmith and Joseph H. Davis were true itinerant painters, more or less fitting into the type that has often been described. They came from inconspicuous beginnings in rural communities, the one in New York State, the other in northern New England, and traveled about the countryside painting to make a living. That they *could* make a living this way, painting portraits of farm and village folk instead of hiring out to them to work in their kitchens or fields, is one of the phenomena of nineteenth-century life in America that is underlined by this study of the primitive painters.

James Sanford Ellsworth was a Connecticut Yankee and in a sense another itinerant; his travels took him far from home. He felt the call of the frontier, of the greener fields where settlement was newer, and he went to practice his art—or to peddle his pictures—in the West. Though he returned eventually to New England, his life calls attention to another highly important aspect of nineteenth-century development in America, the westward expansion.

Other painters in and of the West, though somewhat later, were Olaf Krans in Illinois and Paul Seifert in Wisconsin. Both were immigrants as well as pioneers, coming from Europe to win their way in the new West. Both are counted as American primitive painters, but in their lives if not

obviously in their painting they brought European tradition to the American frontier.

Then we come upon such an amateur as Eunice Pinney, a woman who made her pictures just for the fun of it, apparently, with no motive of financial recompense. She lived at a time when it was the thing for ladies to make genteel paintings; they were trained to it as schoolgirls and produced a vast quantity of decorative and often sentimental pictures. A considerable body of these is now ranked among the nineteenth-century primitives, though they are not considered in this book since they are chiefly anonymous. But Eunice Pinney does not belong to that relatively stereotyped group. Her work is individual and personal, independent of the conventions of academic painting.

Rufus Porter emphasizes more than any other of these painters the transitional character of the age in which they lived and worked. His preoccupation with scientific developments, his own inventions, indicate that he was well abreast of his times and in tune with the developing machine age. Yet his painting belongs to the craft or artisan tradition. With his brush he was able to decorate the walls of rural homes with an acceptable substitute for the fashionable but costly scenic wallpapers of the day. It was not a mechanical expression, nor yet a purely esthetic one, but a craft at which he was singularly skilled.

The Bard brothers, John and James, also had a scientific bent of sorts, along with their artistic leanings. Their pictures were of ships, and though they lived in the age of photography and mechanical drawing, they chose to make meticulous records of river craft with paint and brush instead of with these devices. Their pictures seem to be intended as accurate records, indeed, rather than to have any pretensions to art as such.

Still a different type was William Matthew Prior, professional painter, who cut his cloth according to the price his client could pay. He produced fair portraits in the academic style of the time if the sitter desired it; if the price for that was too high, he produced a simplified version—less work, less cost. It is, amusingly enough, the simpler, cheaper pictures that first attracted attention to Prior, though in a sense they were only his pot-boilers.

While the work of these and the other nineteenth-century painters whose life stories are told in this book all fall in the class we call primitive, it covers a wide range of media and subjects. Oil, watercolor, tempera, and pastel are represented. Of subjects, portraits are the most numerous. They are portraits for the most part of people immortalized in no other

5

way—country and small-town folk, many of whom still remain anonymous. Landscapes occur in some quantity, landscapes real and imaginary, from Hidley's portraits of small New York villages to Chambers' romanticized river scenes. Genre subjects, like Olaf Krans' pictures of the Bishop Hill community, offer rare records of certain aspects of American life, and records of another sort are provided by the Bards' ship pictures. Then there are decorative pieces, like some of Eunice Pinney's mourning subjects and family records, and some purely imaginative compositions, like Hicks' *Peaceable Kingdoms* and Field's *Garden of Eden*, that fall in none of the usual categories.

From all this diversity, it becomes apparent that in terms of work, or life, or both, our nineteenth-century primitive artists do not conform to a single type, any more than academic artists do. They do represent, however, a certain type of background or environment, and collectively their lives reflect several major aspects of American development during the era in which they flourished.

In characterizing the most fruitful period of primitive painting in America, it is difficult to avoid falling back on such well-worn phrases as the emergence of the individual, the era of the common man, the rise of the middle class, the dawn of the machine age. For the primitive painters, and the people for whom they made their pictures, were indeed individuals, they were the common man, they were the great middle class, they were a product of the young machine age. Gone were the days when art was only for the aristocracy. The conception of personal identity and independence, fundamental in the American republic, not only encouraged obscure people to become artists, but provided a market for their work. Just as any lad could grow up to be President, so anyone could have his portrait painted, anyone could have pictures for his walls, anyone could be a painter and make his living by it.

The painters and the people who bought their pictures were the same ones who were replacing their candles with lamps, their old pine settles with Hitchcock chairs, and their pewter plates with Staffordshire china and pressed glass. They were learning to save labor by means of the machine, and to ornament their homes with its products. But the old-fashioned crafts were not immediately eclipsed, by any means; for long into the nineteenth century they persisted, particularly in rural areas. That is why we can sense the artisan tradition in the work of many nineteenth-century primitive artists. When eventually the machine invaded

the field of art in the form of inventions for making pictures, the scope of the primitive artist diminished.

At the same time that life in America was being gradually transformed by industrial development, it was being broadened by the constant westward expansion, and in the lives of our primitive artists we see reflected also the influence of the frontier. Many of them, it is true, worked in the older, established towns of the East, where life was settled, but the spirit of expansion was a part of nineteenth-century thought and affected even those who did not actively participate in it. For others who lived in more outlying parts of the East, life was not too different from that of the frontier. And then there were those who were true pioneers, traveling westward in search of fortune, or adventure, or just a change of scene.

Incidentally, it seems probable that in time we shall hear more of primitive painting in the West and also in the South. So far the great majority of artists identified have been those who worked in New England, New York and Pennsylvania, and there too most of the pictures have been found. There were, of course, the *santeros* of the Southwest who made religious pictures that are certainly primitive, but in such a different tradition from those considered here that they seem really to belong in a different category. I suspect, however, that there were many more primitive artists painting beyond the Alleghenics than have yet been recognized, and that in time they too will be discovered.

The gradual rescue of our primitive painters from anonymity is filling in a new chapter in our art history, and in our social history as well. This means much more than recording names and dates. It means increasing our perception of human values. It was exponents of modern art who were the first to acclaim our early primitives, for they saw in these simplified pictures the same qualities of abstraction that modern painters were seeking. They were soon joined by people who appreciated them for historical as well as esthetic reasons, who saw them not only as examples of art forever but as expressions of their time and place. As we have learned more about them, we have recognized also their human interest, as expressions of the individuals who created them. Specific information of the kind given in this book has done much to bring these individuals into focus. Knowing something about our American primitive artists does not, of course, enhance the qualities of their paintings, but it increases our enjoyment of them and broadens our understanding of our own background.

ALICE WINCHESTER

7

II

Primitive Painters of the Eighteenth Century

THE AMERICAN primitive painters of the eighteenth century are a transitional group. They stand midway between the pre-Revolutionary artists of the English school and the indigenous, self-taught, nineteenth-century limners, whose essentially non-realistic approach reached its peak between 1820 and 1850. The nineteenth-century primitives might be considered the first group of truly native artists since they were born during the intensely nationalistic years of the early Republic, and most of them were raised in a rural setting which had little artistic contact with the outside world. They were certainly less affected by foreign traditions than either the colonial artists who had preceded them, or the twentieth-century primitives whose art must necessarily be conditioned by the complexities of a modern environment. The greater part of the men working in the eighteenth century were born while the Colonies were still under English rule, and most of their pictures show the influence of the academic pattern. Thus Winthrop Chandler disposed his striking portrait of Captain Samuel Chandler in aristocratic pose emphasized by the conventional Chippendale chair, mahogany table, and silver-hilted sword typical of the period. Its primitive quality is chiefly apparent in the strength of the features, and in the unexpected dominance of the detailed battle scene.

Although the years previous to the Revolution were fraught with political unrest and mounting personal tensions, the gentry in city and town had never been as closely attuned socially to the mother country, which many of them still spoke of as "home." It was natural that the arts should follow the fashions set on the other side of the water. Many painters advertising in the mid-eighteenth-century newspapers of New York, Philadelphia, and cities farther south prided themselves on offering to a prospective clientele "work executed after the most accurate method followed in

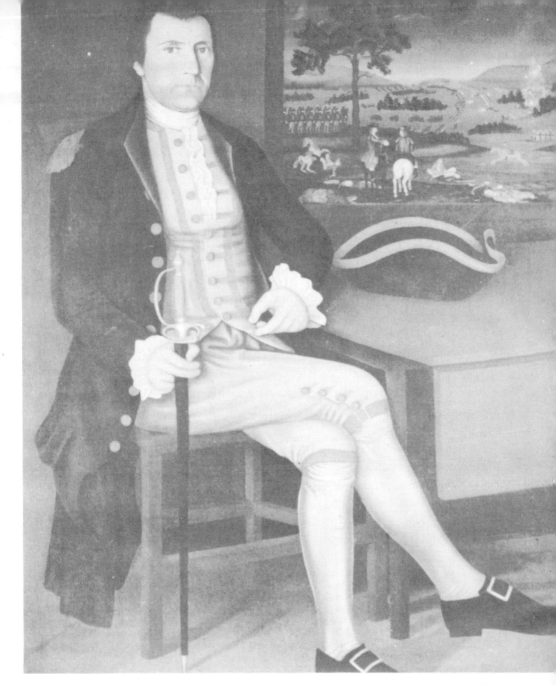

CHANDLER, Captain Samuel Chandler of Woodstock, Connecticut *(c. 1776)*
Mrs. Robert Child Paine

London." The more ambitious young artists felt their training incomplete until they had studied abroad. Benjamin West, as a simple country painter, sailed for Leghorn in 1759, and eventually became in England the acknowledged master of his day. John Singleton Copley, Gilbert Stuart, and Charles Willson Peale were among those who went to England for instruction, the first never to return to his native land.

Other provincial painters, who through force of circumstances had to forego a European trip, struggled to pose and array their sitters in the manner demanded by the times, in some cases to the detriment of their innate talent. Joseph Badger, housepainter, glazier, and decorator of fire buckets, might have been one of our outstanding primitive artists if he had not lived in a large city when custom decreed that subjects be painted in an artificially fashionable manner. This was beyond his abilities, and put him in unfortunate competition with such masters of social portraiture as Blackburn and Feke. Only his portraits of children, stiff and colorful, indicate what his contribution might have been had he lived in a rural district outside the influence of conventional painting. Then his sitters could have been arrayed in printed calico, their features their own, instead of the doll-like masks which he usually felt constrained to depict in pre-Revolutionary Boston. "The other extreme," as James Thomas Flexner has said in *First Flowers of Our Wildnerness*, "unadorned realism that strove to show the face exactly as it was, manifested itself only occasionally during the first century of American painting. Before the 1750's such portraits were socially unacceptable to the upper classes, and the artisan-painters themselves would probably have felt rude had they shown a girl as plain, or a minister as chinless."

Fortunately not all of the aspiring limners lived in cities where academic work of English type was in demand. Many young countrymen were trained as apprentices in the painting and glazing trade. If they took up the "drawing of effigies" it was usually as a side line to the more important business of house and sign painting. After the end of the War, with the social and economic changes which peace brought to the young nation, these men began to express themselves with more freedom and individuality. Their sitters wished to be depicted in a straightforward manner, and against a background which expressed their own business or profession, and it is these realistic portraits, most of them done between 1770 and 1800, which are now coming to be considered the primitives of the eighteenth century. Although they vary greatly in skill and technique, all have

common qualities of painting which convey the simplicity and strength of the American pioneering stock

Scattered examples of primitives painted during the middle or early eighteenth century may occasionally be recognized in historical societies, discerning museums, or the collections of a few individuals, but the majority being unsigned, identification of the artists is difficult and often unrewarding. A particularly interesting group comprises a number of canvases done in New York State which still await definitive study and attribution. These, however, do not fall within the scope of this book, which is intended primarily to deal with the work of those painters whose biographies are at least partially known.

Decorative scenes, painted on wood or canvas, became extremely popular during the last quarter of the century, and pictures featuring the owner's home, executed in colors or india ink, were advertised as early as 1737. Some of these landscapes showed hunting scenes, harbor views, or country vistas and were often incorporated in paneling over the fireplaces. Like the portraits they were done with individuality unfettered by the concepts of traditional art.

Ralph Earl is an example of a provincial painter whose early work is of significance in view of his later development. Born in Worcester County, Massachusetts, in 1751, he sailed for England in the spring of 1778 leaving behind him two portraits and one landscape of real merit, which are at present the only pictures attributable to his first American period. Had Earl not received his English training he would still have been one of our great eighteenth-century painters. Although his work after returning to America in 1785 had gained academic status, he retained in some of his canvases a straightforward simplicity of treatment which has given his portraits their universal appeal. His *View of the Town of Concord,* first illustrated in an article by William Sawitzky in *The Magazine Antiques* in 1935, is believed to have been painted from studies made on the spot in company with his friend Amos Doolittle, during the summer of 1775. Four engravings based on this view and three companion sketches, depicting the battle of Lexington and Concord, were issued by Doolittle in December 1775. This, however, is the only original painting known to exist. It is illuminating to compare this naïve view of the famous battle and its setting with the backgrounds painted in the English manner which Earl did on his return to America. This has all the attributes of the typical provincial landscape of its period, and is comparable to those of Chandler

11

EARL, A View of the Town of Concord, Massachusetts *(c. 1775)*
Mrs. Stedman Buttrick, Sr.

and other painter-decorators working during the second half of the eighteenth century.

John Durand is another outstanding artist whose work has been found in New York, Connecticut, and Virginia. He seems to have painted in these several localities between 1767 and 1782, but little about him has as yet appeared in print. Signed pictures in the New Haven Colony Historical Society constitute key pictures for the attribution of other paintings including those owned by the New-York Historical Society and the Museum of the City of New York. In 1834 in his *History of the Arts of Design in the United States,* William Dunlap said of Durand: "He painted an immense number of portraits in Virginia; his works are both hard and dry but appear to have been strong likenesses, with less vulgarity of style than artists of his calibre generally possess." Today we feel that his portraits are strong and individual likenesses without the insipid qualities which characterize the work of many of his contemporaries. One of his most striking canvases shows the children of Garret and Helena de Nyse Rapalje of New York City. Still in its original frame, it is fully inscribed on the reverse with the names and birth dates of the four young people, from which it is possible to deduce the date of painting as about 1768. It is a unique example of the presently known work of Durand and shows unusual handling of a group in which full- and three-quarter-length figures are successfully combined.

A close contemporary of Durand's was Winthrop Chandler, a full account of whose life and work was published by the writer in a special issue of *Art in America* for April 1946. Chandler's activities may be considered as typical of many other men of his period whose names have yet to be discovered. Born in Woodstock, Connecticut, in 1747 he became a house painter by trade, although on several legal documents he hopefully designated himself as "limner." On May 8, 1770, he executed two likenesses of the Reverend and Mrs. Ebenezer Devotion of the Third Church in Windham (now Scotland), Connecticut, which are among the most powerful primitives of their time. During the next twenty years, until his death in 1790, he painted twenty-eight known portraits and doubtless many more which are undiscovered or have disappeared.

Chandler was not an itinerant. He lived all of his life in or near Woodstock except for a few unhappy years in Worcester, Massachusetts, between 1785 and 1790, at the end of which he deeded all his property to the Selectmen of the town of Thompson, Connecticut, to defray the ex-

DURAND, Children of Helena Nyse Rapalje of New York City *(c. 1768)*
New York Historical Society

CHANDLER, Colonel Ebenzer and Samuel Crafts *(c. 1781)*
Public Library, Craftsbury, Vermont

penses of his last illness and burial. He did not go far afield for his subjects, most of his sitters being relatives or friends. When portrait painting was not in sufficient demand he, and many like him, turned to other branches of the decorating trade. In 1773 he helped to collate the old plans and produce a revised map which appears in Bowen's *History of Woodstock*, and he wrote and illustrated a manuscript dealing with the plants of Windham County. For the home of his Tory cousin, Gardiner Chandler of Worcester, he carved in pine the royal arms of George III, while a receipted bill in the American Antiquarian Society proves that he was retained in 1788 by the city of Worcester to paint and gild the weathervane of the old Court House.

Perhaps his most interesting sideline was the painting of landscapes in the prevailing fashion. One is a framed canvas, another is a wooden fireboard with a view of the Battle of Bunker Hill, and several are overmantel panels. These decorative views of country scenes have an unsophisticated charm which, to the lover of primitive painting, is unequaled by the more formal landscapes of the nineteenth century.

Richard Jennys was another provincial artist whose work deserves particular mention. Thanks to a number of scholarly articles by Frederic Fairchild Sherman which appeared in *Art in America* between 1925 and 1935, with supplementary data added by Jean Lipman in 1941, considerable information about him is available. Jennys was an engraver as well as a painter, and a mezzotint from his oil of the Reverend Jonathan Mayhew is thought to have been executed by him before 1766. He advertised in Boston as a dealer in dry goods in 1771, subsequently made a trip to the West Indies, and finally left Boston in 1783. An advertisement in the South Carolina *Weekly Gazette* places him in Charleston on the 31st of October of that year. In this notice he calls himself a portrait painter, and says that he has "followed that business at the northward and in the West Indies." On July 15, 1784, he again advertised "portrait painting, chiefly in miniature." Several of the ladies in his large pictures are wearing locket miniatures, but no examples on ivory or paper have as yet been identified. There is no present record of his whereabouts from 1785 to 1793, but from 1794 to 1799 he was active in New Milford, Brookfield, Washington, and Litchfield, Connecticut. The date and place of his death are also unfortunately unrecorded.

Unlike Chandler, Jennys is not known to have painted landscapes although it is quite possible that some unattributed examples may one day

be recognized as his work. He painted bust portraits of his sitters, sometimes enclosed in an oval, with a truthfulness which none can doubt. His delineation of Ithamar Canfield was painted in New Milford in 1794 when the latter was thirty-five years old. This likeness conveys the impression of a vigorous and intense personality which he evidently recognized and transferred without hesitation to his canvas.

In speaking of Jennys, Frederic Fairchild Sherman has this to say: "The portraiture of Jennys presents definite characteristics that distinguish it from that of other artists of his time and a scheme of coloring that is highly individual. Heads he drew with exactitude and faces he painted with an economy of detail that found ample justification in an exploitation of determining forms which gave them a really sculpturesque quality. This exploitation of form invests his likenesses with a look of vigor and vitality in contradistinction to the more ingratiating style of those artists who employ a more photographic method with its consequent inclusion of unessential detail. One cannot but admire the manner in which he utilizes the dominant characteristics of a face—the mass of forehead, curve of a cheek, structure of a nose or chin, and with them builds up an impressive presentment of individuality . . . his portraits have a definite resemblance to those of William Jennys (probably a relative) who painted several likenesses in the vicinity of Stratford, Connecticut, in 1795. They differ from them notably, however, in the coloring, the latter artist's being generally somewhat lighter in effect and somewhat higher in key."

Certain pictures painted between 1800 and 1815 should be included with those of the preceding period as they looked backward rather than forward in style and feeling. Only the costumes belie their eighteenth-century date. During the 1790's the Classic Revival which became so quickly apparent in architecture and furnishings began to influence the Revolutionary modes of dress. Attention to costume details is, therefore, an invaluable aid in the dating of these transitional portraits. Thus the raiment of Captain Samuel Chandler and the Rapalje children is in complete accord with the Revolutionary period, while that of Jennys' Mrs. Smith and the McCormick family by Joshua Johnston proclaim their proximity to an 1800 date. Piles of curls topped by feathers and pearls, or beribboned headdresses of enormous size, were abruptly replaced by close coiffures of Grecian style featuring flat curls and close fitting caps. Ladies' gowns became high-waisted and simple of skirt, the bodices without benefit of fichu or bows. Gentlemen's queues, tricorne hats, ruffled

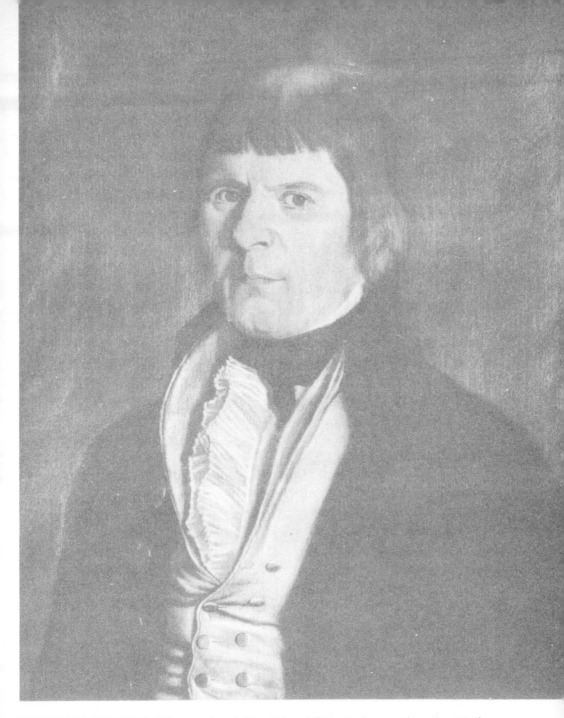

RICHARD JENNYS, Ithamar Canfield of New Milford, Connecticut *(c. 1794)*
Frederic Eli Mygatt

stocks, and satin knee breeches disappeared in favor of long tight trousers and hair brushed forward in a straggling bang.

A portrait which falls into this group is that of a lady whose style of painting closely resembles the five pictures of the Benjamin and Storrs families which are signed respectively *Willm Jennys* and *J. Wm. Jennys*. What the relationship of these men may have been to Richard Jennys, or to each other (if indeed they were not the same person) has not as yet been elucidated in print. This striking and therefore unknown likeness is thought to be a daughter-in-law of Mr. and Mrs. Cephas Smith of Suffield, Connecticut, and Rutland, Vermont, and with its companion bears such a strong resemblance to the portraits of Colonel and Mrs. Constant Storrs as to leave no doubt that they are by the same hand. Colonel Storrs' picture is inscribed on the reverse *J. Wm. Jennys, June 23, 1802. Aged 50.* A letter which appears in Mr. Smith's portrait is headed *Rutland* with the numbers *1916,* and suggests the interesting possibility that this artist worked in Vermont as well as in Connecticut.

Another artist whose activities extended over the last years of the eighteenth and the first decade of the nineteenth centuries is Joshua Johnston (or Johnson), the Negro painter of Baltimore, Maryland. There is little specific information concerning him except the entries in the Baltimore directories which list his name between 1797 and 1824, always as limner or portrait painter, and once as a "Free Householder of Colour." Although it seems likely that he began life as a slave, probably in the family of a master who taught him to paint, he was probably eventually allowed to purchase his freedom.

Dr. J. Hall Pleasants, who has written fully about Johnston in the Walpole Society *Note Book* for 1939 and in the *Maryland Historical Magazine* for June 1942, says in part: "To appraise fairly Joshua Johnston as an American painter of the late eighteenth century we should not set our standards unreasonably high. He must in a way perhaps be classed with the primitives, although whatever his primary instincts may have been, his style was certainly influenced by the Peale-Polk family group . . . Charles Peale Polk may indeed have been Johnston's master in more than one sense." In 1948, at the time of the exhibition of his work at the Peale Museum, twenty-five portraits were attributed to him. He painted a number of young people, mothers with children, and several family groups all of which bear many characteristics in common. All are primly drawn, and the women wear the simple high-waisted dresses fashionable

18

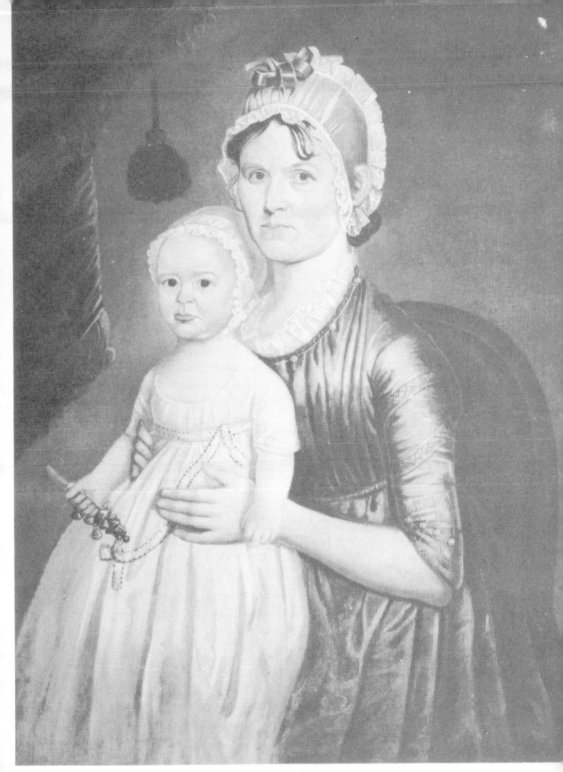

J. WILLIAM JENNYS, Member of the Smith Family of Suffield, Connecticut, and Rutland, Vermont *(c. 1800). Miss Harriet Chase*

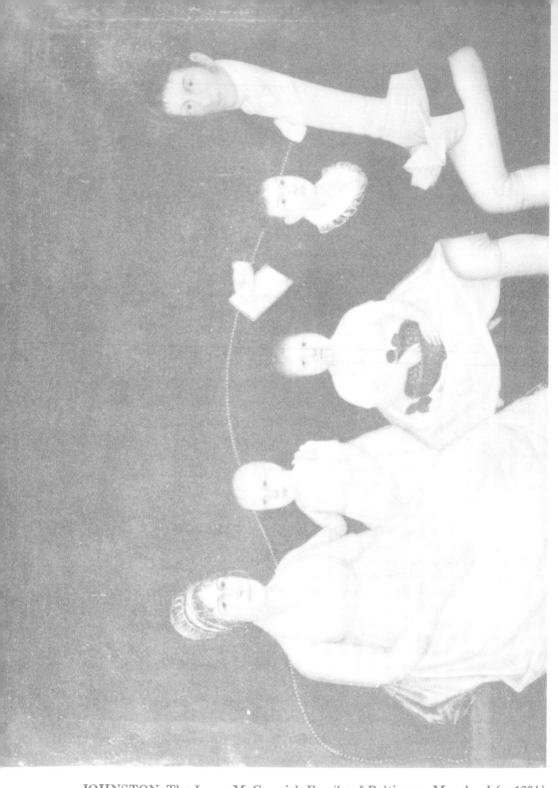

JOHNSTON, The James McCormick Family of Baltimore, Maryland *(c. 1804)*
Maryland Historical Society

at the turn of the century. Typical accessories are held in stiff fingers—a flower, a glove, a book, a basket of fruit or flowers. Many of the faces, however, have sweetness and charm, and the groups are posed with a dignity which befits their aristocratic sitters.

By 1825 primitive painting had gradually evolved into the pattern which it was to follow for the next thirty-five years, until it in turn was displaced by the daguerreotype and the ubiquitous prints of Currier and Ives. The first to break away from the European tradition, the post-Revolutionary provincials not only made an outstanding contribution to American art, but opened the way for the great surge of popular interest in painting which was to find its fullest expression during the second quarter of the nineteenth century.

NINA FLETCHER LITTLE

———◆———

Eunice Pinney

EUNICE PINNEY *(1770-1849)* is the earliest and certainly one of the most remarkable primitive watercolorists whose life and work may be recorded; and it is significant that many more examples of her painting have been preserved than of any other early American watercolor artist. Her product, scarcely typical of her times, stands out from the body of nineteenth-century watercolors as a unique and original performance. Much of the early nineteenth-century watercolor painting, done by inexperienced schoolgirls, so charms us with its quaintness and naïveté that we overlook the tentative, wabbly drawing, the stereotyped themes and designs. Eunice Pinney's work, no more sophisticated than these seminary paintings, is, however, entirely different. A mature woman when she began to paint, she was endowed with a robust originality and a great flair for design which she developed into a uniquely vigorous and varied amateur art.

In estimating Eunice Pinney's rank as an American primitive painter we need not limit our comparisons of her work to her immediate contemporaries, to the members of her sex, or even to the watercolorists. No other attempted as wide a range of subjects; only a few of the greatest were as free of convention, as bold draftsmen, as able composers in line and color.

From what we can reconstruct of her background and life, Eunice Pinney seems to have been an unusually well born, well educated, capable, and influential woman. She was a descendant of Matthew Griswold, who in 1639 came from Kenilworth, England, to Windsor, Connecticut. He in turn belonged to a family settled in Warwickshire for twelve generations prior to 1619. He is recorded as a man of true worth and piety, of superior education for the times, and as an active participant in the affairs of the Colony from the start.

PINNEY, Plenty *(c. 1810)*
Jean and Howard Lipman

Eunice Pinney was the daughter of highly respected and wealthy parents and the sister of the well-known bishop, the Rt. Rev. Alexander Viets Griswold. A *Memoir of the Life of Bishop Griswold,* published in 1844 by John S. Stone, D.D., mentions her as "a woman of uncommonly extensive reading" and "zealously instrumental in the first organization of our church, in that Diocese, and in the election of its first Bishop." Rev. Stone also remarks that Eunice Viets (Eunice Pinney's mother) was an unusually pious woman of remarkable intelligence and uncommon energy, and that her marriage with Elisha Griswold "brought together two of the most considerable families and estates in the town."

Elisha was known in his community as "a man of quiet good sense, and remarkably homekeeping habits." The eight children were, we are told, "a family of various talent." Two of the boys, Alexander Viets and Samuel, entered the ministry, Alexander Viets to become one of the greatest Episcopal bishops. Two others, Roger and Elisha, were "intuitively ingenious mechanics"; their ingenuity "was in fact too versatile—they ran the race of too many other inventive geniuses of New England, and lived poor, because, in the homely phrase, 'they had too many irons in the fire.' " The children were trained from their first years to develop "abiding habits of industry" and were taught always to do something useful "in moments which would otherwise run to waste." This early training, and the fact that the favorite amusement of the children was acting in plays performed for the neighborhood, may have some bearing on Eunice's ambitious artistic output and on the sense of drama inherent in her watercolors.

The chief facts of Eunice Pinney's life are as follows: she was born in 1770 in Simsbury, Connecticut, and died in 1849, probably in Simsbury. She married Ōliver Holcombe of Granby *(b. 1769)* who was drowned in his twenties when fording a stream on his way from Connecticut to Ohio. By him she had two children, Hector and Sophia Holcombe (Phelps). In 1797 she married Butler Pinney of Windsor *(1766-1850).* In 1844 she is mentioned as living in Simsbury, so it may be assumed that the Pinneys had moved from Windsor to Simsbury some time prior to that date. By her second marriage she had three children, Norman, who grew up to bcome a clergyman, Viets Griswold, who died as a youth, and Minerva Emeline (Bright) who before her marriage was a painting teacher.

Some of Eunice Pinney's personal belongings and letters, among them a few written to her young lady daughter Emeline when she was away teaching school in Virginia, are preserved by various of her descendants.

PINNEY, The Cotters Saturday Night *(c. 1815)*
Jean and Howard Lipman

These letters have a very religious tone and also some tendency toward verse—in one to Emeline for instance: "And now good night for I have a dismal light. Write soon I pray and come you home without delay." The aspect of these letters which most interests us is that on the backs of several of them are finished watercolor paintings intended for Emeline to use as models for her scholars.

A number of Eunice Pinney's watercolors and drawings are still held in the family; more have been dispersed and have found their way into various collections. As all her signed watercolors are inscribed *Eunice Pinney* and the only accurately datable ones range from 1809 to 1826, it may be assumed that the artist engaged actively in her hobby of watercolor painting some time after her second marriage and that most of her work was done in Windsor and Simsbury, Connecticut, in the early nineteenth century.

Thus, too, we see that her painting was not the work of a schoolgirl but of a mature woman—a fact which might indeed have been deduced from the paintings themselves. If, as we believe, her work as a watercolorist was largely done in the first three decades of the 1800's, she was between the ages of thirty and sixty. This fact is more significant than it may appear. Painting always in great measure reflects the painter and Eunice Pinney's firm, solid, robust watercolors could only have come from the hand of a vigorous artist in the prime of life. Her designs are sturdily, architecturally balanced in plan—foursquare is the word that comes to mind—the figures are stocky, the contours bold, the colors full-bodied. Her numerous pencil sketches for various portions of the finished pieces reveal her sure-handed draftsmanship and show the careful preliminaries which entered into the production of her watercolors.

Eunice Pinney's style might be compared with Rowlandson's, for it seems not only mature in its lusty vigor but actually more masculine than feminine. Her manner of painting and even the costuming of her figures belong to the 1700's. Eunice Pinney's formative period, her schooling, the development of her habits of thought and work, were entirely of the eighteenth century. By 1800 she was thirty years old; she had been married twice and had three children. It is scarcely stretching the point to consider her an eighteenth-century person who worked in the early nineteenth century.

This explains some of the differences between her painting and that of her younger contemporaries who were, actually, of a different generation.

PINNEY, Masonic Memorial *(1809)*
 Jean and Howard Lipman

The very style of the schoolgirl paintings is adolescent, with willowy figures, delicate drawing, pale coloring, and designs often timidly askew. Moreover, the great majority of the early American lady watercolorists were active in the second rather than in the first quarter of the century. Eunice Pinney painted before theorem pictures had become a fad, and she was educated before the popular art-instruction books and painting recipes were part of every schoolgirl's equipment.

This at least partly accounts for the freedom of manner and theme in Eunice Pinney's watercolors, which is evidenced by their bold style, the variety of the compositions, and the range of subject matter. Mrs. Pinney was an extraordinarily prolific and versatile amateur. Her watercolors provide examples of genre, landscape, memorials, stylized figure pieces, allegorical, historical, religious, and literary subjects, and even include birth registers, a village scene, and a painting of Old Newgate Prison. Her dramatic scenes of everyday life are unprecedented in her period.

There is every reason to believe that many of her allegorical and literary pieces were adapted from or at least suggested by eighteenth-century English engravings, but Eunice Pinney cannot be considered a copyist. The genre scenes are strikingly individual and the memorials entirely the artist's own designs. Her flair for original design may indeed be felt at a glance if we compare a few of her memorial pictures, which vary enormously in composition, content, and coloring—and this in spite of the tendency of the times to standardize such pieces.

Beneath all this variety is a basic core of style that remains constant and clearly definable. The Pinney watercolors could never have remained anonymously scattered. Even if her name had not been known, her work would have been recognized as by one painter, for each example is clearly stamped with the earmarks of her style. At the heart of this style is a robust breadth and solidity which is the exact opposite of the refined techniques of the typical lady watercolorists of the early nineteenth century. The most striking aspect of Eunice Pinney's painting as a whole is her versatile, dramatic, and infallibly sound sense of design.

The *Two Women* was first reproduced on the cover of *Antiques* for May 1932, and the late Mr. Homer Eaton Keyes then called it the work of an artist who, "quite untrained, guided by instinct rather than by rule," produced a masterpiece—a monumentally designed New England tableau full of dramatic implication. Years later when another Pinney watercolor was discovered, representing the same two New England

PINNEY, Undedicated Memorial *(c. 1815)*
Jean and Howard Lipman

women in the same clothes and in the same room, having a heated argument, Mr. Keyes' sense of this "dramatic implication" was corroborated.

The *Masonic Memorial* was painted in memory of the Rev. Mr. Ambrose Todd *(1764-1809)*, the rector of the Episcopal church in Simsbury. The verses inscribed on the face of the watercolor are no doubt an expression of the artist's versifying tendencies:

> Death cant disjoin whom Christ hath joined in love
> Life leads to Death and Death to life above
> In Heavens a happyer place frail thing despise
> Live well to gain in future life the prize
>
> Oh spotless soul look down below
> Our unfeignd sorrow see
> God gave us strength to bear our wo
> To bear the loss of thee.

The Cotter's Saturday Night, dramatically illustrating the ninth stanza of Burns' poem, was possibly inspired by an English aquatint. The background is done in gray watercolor wash, the row of sturdy figures lightly colored in a rainbow of pastel shades.

Plenty is one of Eunice Pinney's most naïve watercolors, with oversized grapes growing out of a leafy tree, and three strangely assorted arms belonging to two figures, with only a tiny hand appliquéd to the lady's hip suggesting the existence of a normal number of extremities for the gentleman. But the rhythmical action and bold primary colors in this little allegorical piece make it an outstanding and again most original bit of painting.

The large *Undedicated Memorial* has an unusual feature in the pinpricking of the women's dresses, which gives the sleeves, bodices, folds, and ruffles actual plastic bulk and texture. The small scale of the woman at the right is an interesting but puzzling detail. Is she perhaps a less important relative and so portrayed in diminutive scale? More likely, her size is dictated purely by the requirements of the compact design. In any case we have here a modest progenitor of the "creative distortion" which our moderns proudly practice.

<div align="right">JEAN LIPMAN</div>

IV

Ruth Henshaw Bascom

GOING down to Bascom Hollow to have one's profile taken by "Aunt Ruth" Bascom was apparently a favorite diversion of young and old who lived in Gill, Massachusetts, in the early 1830's. It was no long and tedious process to sit for Aunt Ruth, who merely posed her subject against the paper which was to form the background of the portrait, traced the shadow in profile, and later filled in the details from notes she made at the time of the sitting.

She was clever indeed, employing all the known tricks of the trade and inventing new ones, the result being that there is not a dull portrait among the dozens located to date. Occasionally she cut the profile from paper, colored it with crayons, and mounted it upon another background already prepared or made from wallpaper.

These backgrounds were a test of her ingenuity. They were sometimes landscapes, as in the portrait of Henry Root owned in Bernardston, Massachusetts. He is represented as a child of seven or eight wearing a black coat and broad white collar. In the foreground is a tiny streamlet upon which float seven miniature sailboats with white sails. Beyond is a flower-studded hillside with a little brown path running down it. In other portraits the upper corners are striped with blue in varying shades. Figures are often posed against groups of stylized pine trees, higher at one side of the picture than at the other. Only occasionally a plain solid color provides a less imaginative background.

But Aunt Ruth's originality did not end here. For the Reverend Timothy Rogers, whose portrait hangs in the Unitarian Church at Bernardston, she fashioned spectacles of tinfoil and placed them aboard his nose where they remain until this day. For Hannah Chapin Hoyt's necklace she sketched the outline in crayon and pasted bits of gold paper

on it at intervals to represent beads. This portrait is owned in Greenfield, Massachusetts.

Hands, however, proved a problem to her and whenever possible she avoided drawing them or skillfully tucked them out of sight. For instance, in the portraits of three little girls their hands are thrust into the bibs of their white pinafores.

Practically all of Ruth Bascom's known portraits have been discovered in Franklin County, Massachusetts. A number of interesting ones are now in the museum at Ashby, and there are several in the Antiquarian Society in Concord, Massachusetts. Her most attractive portrait of a child that I have seen is owned in Bernardston. It is of Paul Jones Allen and shows him in a vivid blue coat, with brown hair and a face of a fresh, glowing color.

A portrait of the Rev. Ezekiel Bascom, Ruth's second husband, is owned in Deerfield. He wears conventional black and into his neckcloth is tucked a tiny gold cross. The same owner has Ruth's self portrait, which shows her in a black gown and white cap. To supplement this picture we have only this brief description of her as she appeared in later life, from a letter owned by a great-niece: "I have heard it said that she was short, stooped, and with dark eyes." Besides making portraits she was clever at spinning, weaving, and sewing.

Aunt Ruth was born in Leicester, Massachusetts, December 15, 1772. She was the eldest of the ten children of Colonel William and Phoebe Swan Henshaw. Her father, whose ancestor had come from England in 1653, served in the French and Indian War and in the Revolution. It is said that he made the motion before the Provincial Congress for the formation of companies of "Minute Men." Ruth's childhood was spent in Worcester. In 1804 she married Dr. Asa Miles of Westminster, a Dartmouth professor. After his death in 1806 she married Rev. Ezekiel L. Bascom, whose calling took him to many towns including Deerfield, Massachusetts, and Fitzwilliam, New Hampshire. The Bascoms were also known to have been in Charleston, South Carolina, as well as in Savannah, Georgia. In 1836 Mrs. Bascom returned to Gill where she stayed for some time, and later to Ashby where she died in 1848.

Her diaries, formerly owned by descendants and recently presented to the American Antiquarian Society in Worcester, Massachusetts, reveal that Ruth Bascom led a full and varied existence. She began these diaries at the age of seventeen and kept them for fifty-seven years. The

BASCOM, Self-Portrait *(c. 1835)*
Mrs. George Wright

brief day-to-day jottings give a fresh and direct impression of the home life of that time and are especially interesting for the occasional accounts of Ruth's paintings. The selected excerpts which follow are quoted through the courtesy of Clara Endicott Sears, who first published them in *Some American Primitives.*

"Went to town and dined at Uncle Swan's with Cousin Moses Richardson. Drank tea at Mr. Scott's, then returned to Uncle Swan's in the evening. Spent a very agreeable evening with girl friends. Played book games, 'Nick the Weaver,' 'Grind the Salt,' danced some, sang songs, etc. We stayed all night."

"Quilting at Mr. Andrews'. Had a great number of gallants. 'Wool break' at Mr. Southgate's, spinning frolic at Mr. Green's. Had a Cappadocian Dance. Mr. Shaw played for us."

"Betsy and I carding and spinning. Later we went to pick blackberries out of old Mrs. Andrews' pasture and she was mad as hops."

"Sun and sang songs all day until night approached."

"A dancing school held at Landlord Waite's. We learned 'Freedom' and 'Assembly' steps. The master had us practice upon 'New Jersey,' 'King's Return,' and 'Belles of New York.' I put new bows on my shoes for the dancing class, and wore my new cloak called pearl color, which I bought in Boston at Fox's Store on Cornhill."

"At four o'clock attended Academy Hall with A. Perry. Upwards of one hundred and twenty ladies and gents made their appearance and danced until past twelve and then retired; probably

> *"Some pleased and some disgusted,*
> *Some with rigging maladjusted,*
> *Some merry, some sad,*
> *Some sorry, some glad,*
> *Some elated, other tired,*
> *Some neglected, other admired,*
> *Some jovial, some pouting,*
> *Some silent, some shouting;*
> *Some are calm, some are crazy,*
> *Some sprightly, some lazy,*
> *Some resolved to keep awake,*
> *Some resolved their sleep to take.*
> *I am of the lazy crew,*
> *Sense and nonsense,*
> *Both adieu!"*

BASCOM, Rev. John White *(c. 1835)*
Concord Antiquarian Society;
Frick Art Reference Library Photograph

"Set out [for Boston] with Daddy in a chaise. Stayed at Mr. Allen's and Salisbury's (Worcester) one hour. Dined at Williams' Tavern at Marlborough at two, lodged at Watertown. In Cambridge called upon Cousin Thomas Denney at Harvard College at six in the morning. Went with Hannah Bass a-shopping, likewise over Charlestown Bridge, to call upon Mrs. Howe."

On another visit to Boston, in October 1793, "went to the Mall with Dr. and Mrs. Hayward to see the parade which was occasioned by the death of Governor Hancock."

"The procession consisted of several companies of horse, and of artillery, the field pieces covered with black velvet. Drums muffled played the 'Dead March' and the band a solemn dirge, preceded by the coffin. The Lieutenant Governor, Secretary, Judges of the Supreme Court, Members of Congress, followed by twenty-one carriages belonging to Boston, made a very elegant and respectable apearance, and the bells tolled."

"Went with Mr. Bass and daughters to Beacon Hill, where we had a delightful prospect of Boston and neighboring towns. From there went on the new bridge leading from Boston to Cambridge. Visited new theatre, from there to Fort Hill, for a view of the harbor."

"Kept house with fourteen in the family, almost distracted with singing, crying, laughing, talking—and what not."

"December 31, 1810, reflection."

"In after years this was reviewed. I now seem to wonder how we survived the drudgery of receiving company or going abroad every day in the year! But we did it for many years."

On November 4, 1810, Ruth started from Worcester with friends for a trip to Norfolk, Virginia, making the journey by stagecoach as far as Baltimore. There they took a packet for the sail to Norfolk, where they arrived on November 19th, the fifteenth day after leaving Worcester. On December 24 she writes from Norfolk.

"We made apple pies for Christmas and other nick-nacks. Guns fired incessantly from four o'clock to midnight to usher in Christmas."

On the 25th, "the streets all day mostly filled with negroes, all ages, sizes and figures, dressed in their best, playing and dancing, shaking hands, etc. This and the following five days being the negroes' holidays.

"After this came a kind of market day for slavery, on which they are hired and let, bought and sold like the herds in the stalls."

After eight months in Virginia she started back on June 23, 1802, sailing for New York in the brig *Alexander* and arriving after a stormy passage on the 30th. By sloop and packet from New York to Providence, thence by stage, she made her homeward journey, arriving at Mr. Moses

BASCOM, Mr. and Mrs. Otis Jones of Athol, Massachusetts *(1831)*
Miss Mary Allis

Bass's in Boston on July 5. Her cousins had just returned from hearing an oration by Mr. Emerson. All the company went in the evening to view fireworks from the Mall, and the next morning she took the stage at five o'clock from King's Tavern for home.

It was apparently in later life that Ruth Bascom took up the making of silhouettes and pastel portraits, for one of the earliest references to it in her journal tells of making a profile of Susan Rice on September 14, 1819, when Ruth was nearly forty-seven. After that notations like the following continue for some years.

"July 11, 1826. Woodward brought the glass and Southgate sent two frames. Put Harriet in a frame." This may have been Harriet Denny, for she wrote to a relative, "I have the little red-haired niece with me, and I am doing her picture." And Harriet Denny's daughter wrote in after years, "We have one paster of mother when she was a little girl."

Boston, 1830: "Went to some shops on the way to Hanover Street . . ., bought some crayons at Burdit's and crayon paper; began to paint the two sisters, Rebecca and Lydia Lovejoy of Nelson, N. H. Painted till twelve and slept little after that for the continually rattling of coaches going and coming on pavements under my windows."

"July 6, 1837. Painted on little Mary Denny."

"July 17, 1837 . . . finished the painting and framing of twin sisters Woodcock."

"July 24, 1837 . . . began little Stephen Salisbury's sketch."

"Sept. 8th, I painted Herbert Richardson, ten years old, a neighbor who was sketched last P.M., and then took Miss Knight's shadow at evening."

Family tradition has it that Ruth Bascom never accepted money for her portraits. A hundred years after her death they not only bring money, they are ranked among the more interesting and original of our American primitives. These life-size portraits provide a life-like gallery of men, women, and children in the small towns of central Massachusetts a century ago.

AGNES M. DODS

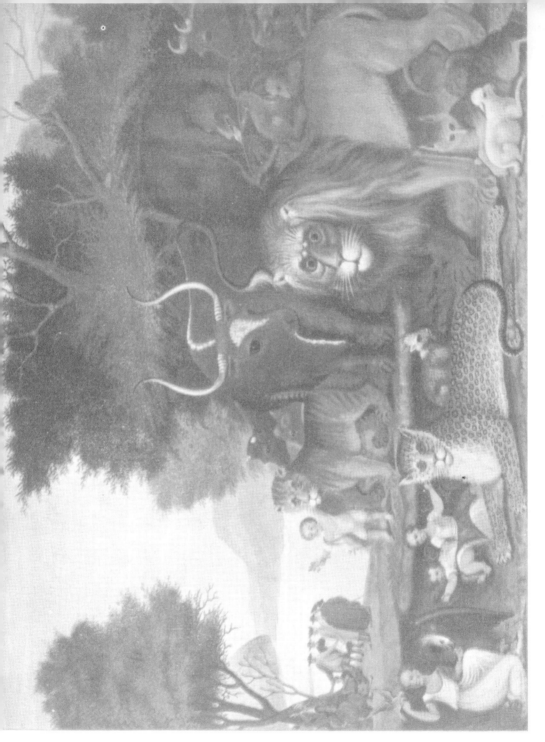

HICKS, The Peaceable Kingdom *(c. 1835)*
Mr. and Mrs. Holger Cahill

Edward Hicks

EDWARD HICKS, the Quaker painter, was in many ways alien to his environment. His seed was of England and New England; his roots, nourished in Pennsylvania Quaker soil, thrust upward to achieve a uniquely fantastic flowering. Given full scope for his talents, he might have become our Pieter Bruegel. As it was, his fellow townsfolk ridiculed him. He was a Quaker, pure, deeply religious, and accepted in the ministry; but he was, too, an artist, an unaccountable anomaly. Hicks was, in fact, one of the foremost Quaker preachers of his time. (He must not be confused with Elias Hicks, who was a distant cousin.) He traveled extensively, and wherever he preached was harkened to by large gatherings. His personality is described as magnetic; he had a clear, strong voice readily heard by an assembly of thousands. There was a charm about his speech that seemed immediately to capture and hold an audience. But his popularity was not due solely to his gifts of oratory. Contrary to the general opinion about Quaker preachers, he was genial, sympathetic, and personally beloved. Whenever there was a wedding or a funeral Edward Hicks was summoned from far or near.

As he grew older, however, he longed for repose and the leisure to devote himself to painting. One Sabbath day, in Quaker meeting, he ventured to urge the value of art in life. He was inspired. Indeed, yielding to the rancor of long criticism, he became vehement. The meeting was upset. A committee was appointed to wait upon him, and condemn his testimony. Not that the Quakers of Newtown, where he lived, despised beauty; they loved it. Their homes were beautiful; so was their dress. In their lives they aspired to beauty, though of an inward rather than an outward form. They grew flowers, studied botany, read, and even wrote poetry. They taught their children to make samplers, to be well mannered, and to live harmoniously. But to pursue beauty as an end in life! That seemed to them very like consorting with the devil.

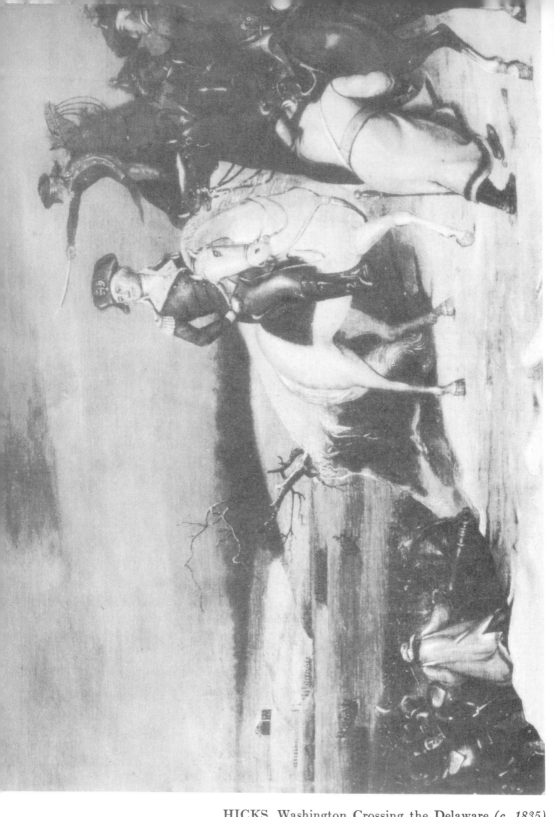

HICKS, Washington Crossing the Delaware *(c. 1835)*
Bucks County Historical Society

Hicks, in spite of his devotion to painting, did not champion his avocation because it was a fine art, but because it was a useful craft. He regarded himself as a primitive Quaker, and thus, to be consistent, a craftsman rather than an artist. He wrote in his memoirs, "There is something of importance in the example of the primitive Christians and primitive Quakers, to mind their callings or business . . . avoiding idleness and fanaticism. Had I my time to go over again I think I would take the advice given me by my old friend Abraham Chapman, a shrewd, sensible lawyer that lived with me about the time I was quitting painting (to begin farming), 'Edward, thee has now the source of independence within thyself, in thy peculiar talent for painting. Keep to it, within the bounds of innocence and usefulness, and thee can always be comfortable.' "

Edward Hicks was born in the village of Attleborough, now called Langhorne, Bucks County, Pennsylvania, April 4, 1780. He came from an old New England Puritan family, originally gentry in England. He was a Hicks on both sides, his father being Isaac, son of Gilbert Hicks, a chief justice of the court of common pleas, and his mother, Catherine, the daughter of Colonel Edward Hicks, a cousin of Gilbert. Both these grandparents, unfortunately for young Edward, were royalists. Hence, when the Revolutionary War was over, Isaac and Catherine, reared in luxury, found themselves comparatively destitute.

This circumstance had a profound effect upon Edward Hicks, in respect not only to his position in life, but to his character as well. He records in his memoirs (published in Philadelphia in 1851) the words of his grandfather, Gilbert Hicks, when the latter, a refugee with the British army in New York, for the last time spoke with his son Isaac: "You are a young man, and as you may be exposed to many temptations, my last and most serious advice to you, is, never act contrary to your conscientious feelings, never disobey the voice of eternal truth in your soul. Sacrifice property, personal liberty, and even life itself, rather than be disobedient to the heavenly voice within. I disobeyed this inward monitor and am now suffering the due reward of my deeds." These words, repeated by Isaac, remained always in Edward's memory.

Not long after her father's exile in October 1781, Catherine Hicks died, leaving Edward, a frail infant of eighteen months, in the care of an old Negro mammy, Jane. This faithful woman helped the bereaved and impecunious Isaac by going out to work for the neighbors of Attleborough. Often she took the child with her. One day when she was working on

the farm of David and Elizabeth Twining, prosperous Quakers, the little Edward so appealed to the hearts of these good people that they offered to keep him with them. Thus it was that Edward Hicks grew up in a Quaker household.

His father, however, cared for him. With inherited aristocratic ideas, he even planned a law career for the boy, who, however, was not so inclined. At the age of thirteen he was apprenticed to a coachmaker, for seven years as was the custom. During this period of service he developed such skill at painting and lettering that, at the expiration of his term, he decided to follow the vocation of sign and house painting. Many an artist learned to wield the brush in this way. As a sign painter Hicks attained a technical skill and a knowledge of the correct use of colors and media that served him well in later life, for his pictures have endured. Hicks' signs were once scattered over all Bucks County. Every inn or tavern of any pretension displayed one, sometimes picturing Washington on horseback, sometimes the Declaration of Independence. But the artist's favorite subject was William Penn's Treaty with the Indians.

Hicks even painted fingerposts. The following advertisement appeared seven times in *The Newtown Journal and Workingmen's Advocate,* beginning with the issue of May 9, 1843:

EDWARD HICKS

Wishes to inform the Supervisors and all others interested in putting up the *Directors,* on our public highways, according to law, that if they will paint the boards white, to suit themselves, and bring them to his shop, in Newtown, he will letter them and ornament them with hands, &c., on both sides, completely, for thirty-five cents per board. Or should he receive orders for forty or fifty in a place, he will deliver the boards, finished ready to put up, at any distance not exceeding fifty miles, for sixty-five cents per board.

It was not until fairly late in life that Hicks began to paint creatively, depicting views of farmsteads and imaginative scenes. He died August 23, 1849.

The portrait of Edward Hicks painted by his cousin Thomas Hicks, in 1838, reveals surprisingly well (for Thomas was then only fifteen years of age) the character of the Quaker painter. He is sitting in a high-backed Windsor chair. Holding palette and brushes in his hands, he leans intently forward with his spectacles pushed up on his forehead, as if he

had momentarily glanced up from the *Peaceable Kingdom* on the adjacent easel. The portrait reminds us of the likeness of Chardin, who painted himself at his easel, his spectacles and eyeshade on his forehead.

Edward Hicks did not become known outside his native county and state until 1932, when one of his *Peaceable Kingdoms* was included in the folk-art collection assembled by the Gallery of American Folk Art in New York, and sent on a nationwide tour. Hicks' contribution attracted much attention, and created an immediate demand for surviving examples of his work. These paintings express an almost childlike though sensitive and sincere point of view coupled with a creative urge so strong as to achieve a significance transcending technical ineptitudes.

It is just because Edward Hicks had a primitive point of view, and was unhampered by academic conventions, that he is admired today. It was indeed very childlike of him to think of Pennsylvania, "Penn's Holy Experiment," as the fulfillment of Isaiah's prophecy: "The wolf also shall dwell with the lamb, and the leopard shall lie down with the kid; and the calf, and the young lion, and the fatling together; and a little child shall lead them. And the cow and the bear shall feed; their young ones shall lie down together; and the lion shall eat straw like the ox. And the sucking child shall play on the hole of the asp, and the weaned child shall put his hand on the cockatrice's den." Never was painting more religious or more naïve than his. It is truly in the spirit of those Quakers who once called themselves "a primitive people."

Close to a hundred of these *Peaceable Kingdom* pictures survive. Hicks painted most of them for his friends as gifts. When he sold them, he received $50 each. He devised a stock of animal types, the list mentioned in Isaiah—a lion, a leopard, a bear, an ox with great curving horns, a wolf, of course, a sheep, and a goat, and sometimes he put in a rattlesnake. These he shifted about, so that no two pictures are alike. He loved the spotted leopard best, and often spread the beast in the foreground like a magnificent rug.

The accompanying landscape is generally well done. Beyond a doubt, for his river the painter used Neshaminy Creek, a considerable stream flowing close by Newtown. But he must also have portrayed the Delaware, which was but four miles distant. There is light and atmospheric distance in these scenes, and the painting of the nearer trees achieves agreeably decorative effects. To be sure, one detects the influence of sign painting in these trees, and even more in the figures, which are childishly drawn. Hicks probably never used a model, but drew his figures either

from imagination or from his recollection of prints. In a way they follow a formula. Hicks' pictures, however, are not to be judged by naturalistic standards, but by their conception. At first surprised by the quaintness of the subject, we gradually perceive its seriousness, and its symbolism. We are taken back to the beginnings of art impulses, when art interpreted a spiritual idea.

It is remarkable that, while Hicks was a Quaker minister, he was first of all an artist. He used his subject as a pretext for indulging in fantasy. The fact that his animals are put in the foreground, and grouped around according to his caprice, while the meaning is but subtly suggested by the little figures of Penn and the Indians in the distance, is a proof that he was interested primarily in his vision, and but secondarily in his theme. Occasionally he indulged in homily when he bordered a picture with a rhymed description of the peace to come. In due time he paraphrased Isaiah's entire prophecy in verse form, which he had printed on cards for recipients of his *Peaceable Kingdoms*. His great-grand-daughter, Mrs. Stanley Lee of Newtown, still preserves one of these cards, from which she permits me to quote:

PEACEABLE KINGDOM

The *wolf* shall with the *lambkin* dwell in peace,
His grim carnivorous thirst for blood shall cease,
The beauteous *leopard* with his restless eye,
Shall by the *kid* in perfect stillness lie;
The *calf*, the *fatling*, and the young *lion* wild,
Shall all be led by one sweet little *child*.
The *cow* and *bear* shall quietly partake,
Of the rich food the ear and cornstalk make;
While each their peaceful young and joy survey
As side by side on the green grass they lay;
While the old *lion* thwarting nature's law,
Shall eat beside the *ox* the barley straw.
The sucking *child* shall innocently play
On the dark hole where poisonous reptiles lay;
The crested *worm* with all its venom then,
The weaned *child* shall fasten in his den.
The illustrious *Penn* this heavenly kingdom felt,
Then with Columbia's native sons he dealt:
Without an oath a lasting *Treaty* made,
In Christian *Faith* beneath the elm tree's shade.

There the broad river, like a lake outspread
The islands, rapids, falls, in grandeur dread,
This great, o'erwhelming work of awful Time,
In all its dread magnificence, sublime.
The stunning tumult thundering on the ear,
With uproar hideous, first the *Falls* appear
Turns to behold new opening wonders lie,
Above, below, where'er the astonished eye.

HICKS, Falls of Niagara *(c. 1825)*
Edward Barnsley

Edward Hicks' farm scenes are quite different. To him they probably represented an ideal of peace and prosperity. But as far as we are concerned they seem primarily illustrative of family life one hundred years ago. As such, aside from their charm as landscapes, they are valuable documents. They were painted in the latter part of his life, purely for pleasure, and are his best achievement. Indeed, these rural pictures remind us forcibly of the landscapes of Pieter Bruegel, with which they may safely be compared. They are executed in the same lively spirit, with an evident attempt faithfully to depict people amid their work or their pastimes. In one version, cows, sheep, and pigs wander in the meadow, a man ploughs in an adjoining field. At the gateway stands the master of the domain. Beneath a tree sits his wife engrossed in her Bible. In the lane, beyond, a young man and a bonneted companion control spirited saddle horses, while behind them spreads the spaciousness of a stone farmhouse, with its wellsweep, barns, and other outbuildings. Pieter Bruegel was called "the Droll," and Hicks too was droll, mixing homely humor with seriousness. The analogy might be carried further. Bruegel preached in his own way; so did Hicks. Bruegel was amused by the life about him; so was Hicks. But Bruegel was one of the greatest painters of all time; whereas no one will claim equal greatness for Hicks, although in his farmsteads he approaches eminence.

The Cornell Farm is the artist's masterpiece. It is a large canvas, brilliant in color and full of detail. The sky is clear, transparent, and full of movement; the distant hills, the apple orchard, are skillfully subdued. Such light is not the result of chance, or of the haphazard though lucky attempt of an untrained hand. It betrays evidence of technical knowledge, accurate observation, and understanding of the qualities of painting. Hicks was what Maurice Sacks calls "a painter of texture." His buildings, faulty as they may be in linear perspective, are yet beyond criticism, so sure are their outlines, so marvelous their surfaces. Not least commendable is the charm of the little figures. They belong where they are placed —and each plays its part. They and their environment as portrayed by Hicks give us an authentic picture of American life in a guise that few people of today remember, and that will never again be seen.

To the countryside from which Edward Hicks drew inspiration have come, a hundred years later, many artists. Perhaps a Pennsylvania school of landscape painting, destined to become historic, is being formed. The old Quaker farms, purchased by newcomers, are fast losing their agri-

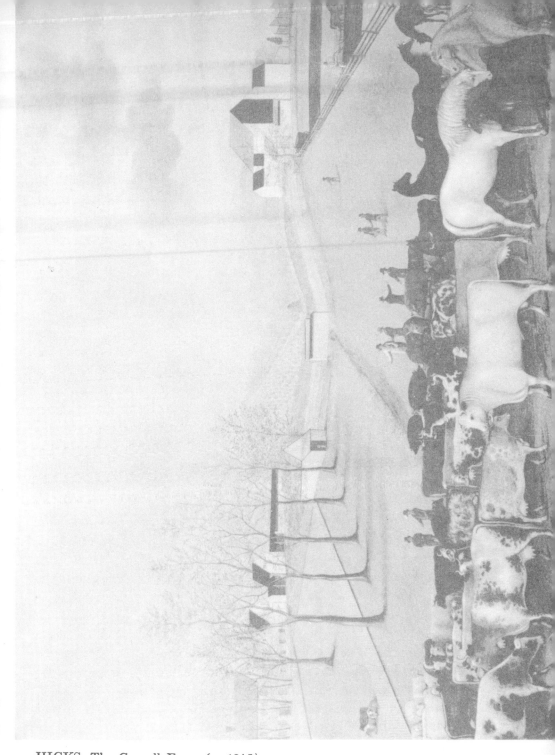

HICKS, The Cornell Farm *(c. 1845)*
Mr. and Mrs. J. Stanley Lee;
Frick Art Reference Library Photograph

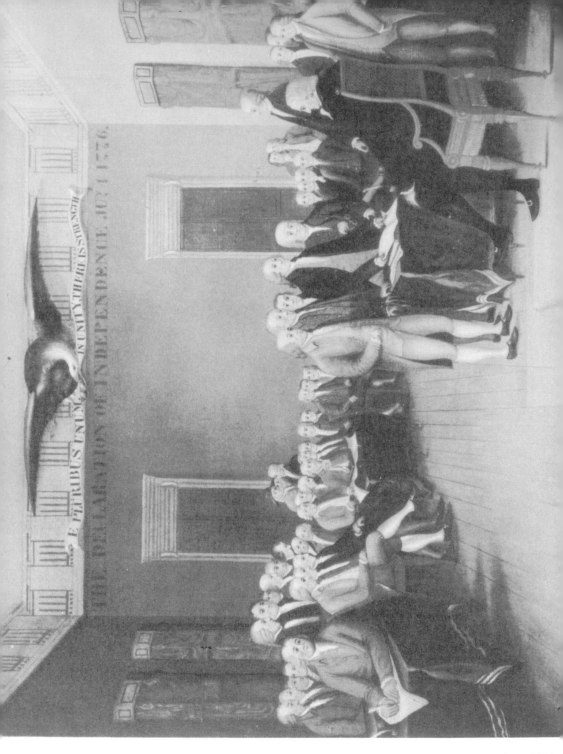

HICKS, The Declaration of Independence (c. 1845)
Jean and Howard Lipman

cultural character; but, fortunately, the well-proportioned farmhouses are being treasured for their dignity and quietude. One may well ask, if the simple spirit of such a man as Edward Hicks could brood over them, would not these artists foster an American tradition of life which, in a symbolic sense, the painter visioned?

ARTHUR EDWIN BYE

Mary Ann Willson

A UNIQUE find in the field of American painting is a portfolio of primitive watercolors discovered in 1943 by the Harry Stone Gallery. The watercolors were executed by one Mary Ann Willson during the first quarter of the nineteenth century. Other than that she worked in Greene County, New York, about 1810-1825, little is known of her life and career.

Her paintings, with the exception of isolated examples and a contemporary group by Eunice Pinney of Connecticut, are the earliest primitive watercolors found to date. They are without exception the most primitive.

A letter written about 1850 by "An Admirer of Art" accompanies the portfolio of Miss Willson's watercolors, and gives us a first-hand account of the odd ménage and partnership of two lady pioneers, Miss Willson and a Miss Brundage. They built themselves a log cabin in Greene County, New York, and managed ingeniously to support themselves; farmerette Brundage, it seems, "cultivated the land by the aid of neighbors," while Miss Willson produced salable "works of art." That the "Admirer" was radically unacademic in his art criticism is evidenced by his description of the watercolors as "the work of a native artist— uneducated of course, but a proof of the unnecessary waste of time under old Masters and Italian travel." Here indeed is one of the earliest positive criticisms of American primitive painting.

The rest of the letter tells us all we know of the life of Miss Willson:

"The artist, Miss Willson and her friend, Miss Brundage, came from one of the Eastern States and made their home in the Town of Greenville, Greene County, New York. They bought a few acres and built, or

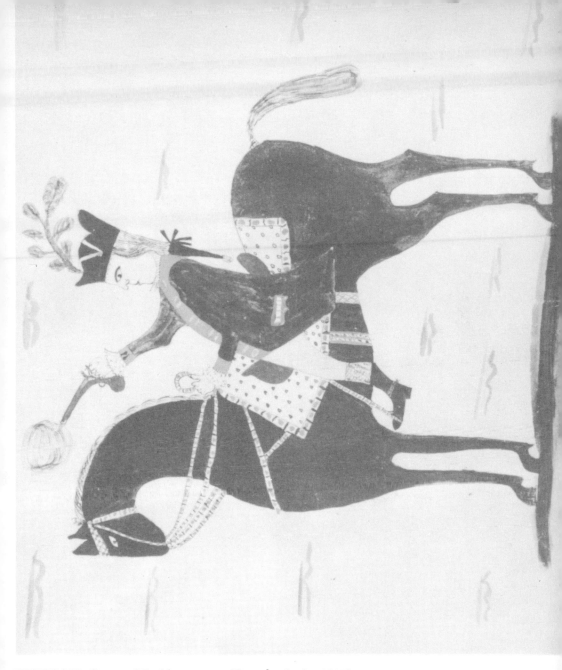

WILLSON, George Washington on Horseback *(c. 1820)*
Museum of Art, Rhode Island School of Design

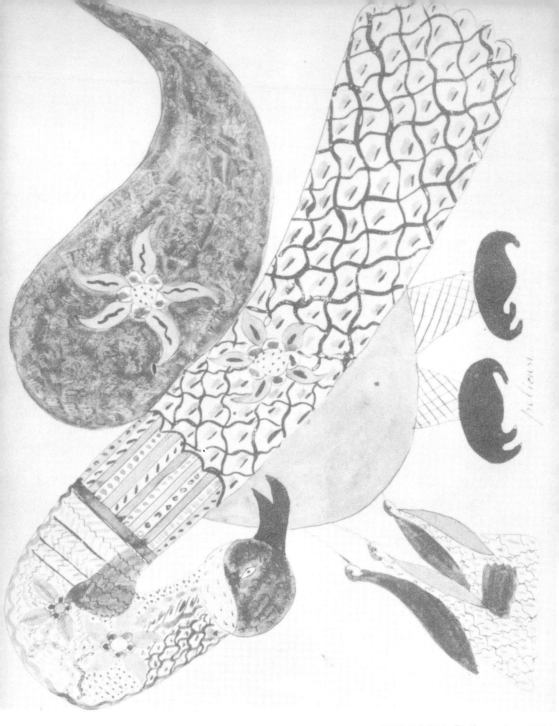

WILLSON, Pelican *(c. 1820)*
Museum of Art, Rhode Island School of Design

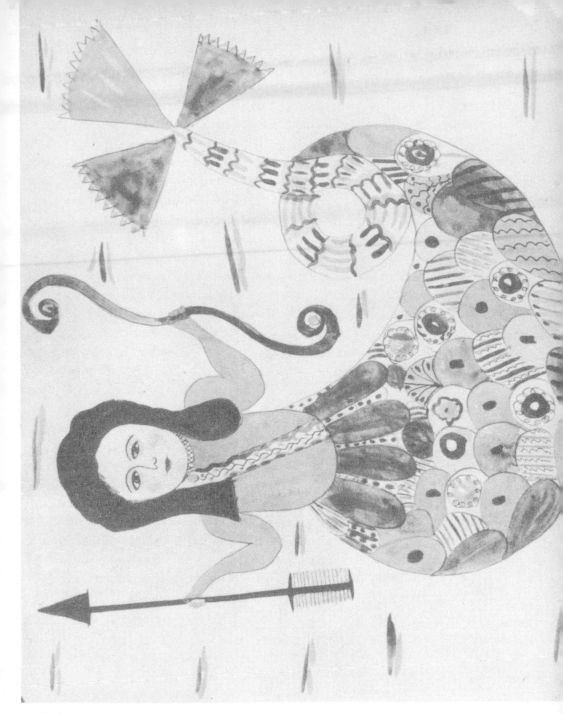

WILLSON, Mermaid *(c. 1820)*
Jean and Howard Lipman

formed their house, made of logs, on the land. Where they resided many years.—One was the farmer and cultivated the land by the aid of neighbors, occasionally doing some ploughing for them. This one planted, gathered in, and reaped, while the other made pictures which she sold to the farmers and others as rare and unique 'works of art.'—Their paints, or colours were of the simplest kind, berries, bricks, and occasional 'store paint' made up their wants for these elegant designs.

"These two maids left their home in the East with a romantic attachment for each other and which continued until the death of the 'farmer maid.' The artist was inconsolable, and after a brief time, removed to parts unknown.

"The writer of this often visited them, and takes great pleasure in testifying to their great simplicity and originality of character—their unqualified belief that these 'picters' were very beautiful, (and original) (they certainly were), boasting how greatly they were in demand. 'Why! They go way to Canada and clear to Mobile!' They had not the slightest ideas how ridiculous they were—Their perfect simplicity and honest earnestness made them and their works more interesting:—sui generis without design,—

"The writer of this little sketch does not mean to compare these mineral and vegetable compounds of fantastic taste with the more modern artistic works of a Cole, Durand, Huntingdon and others—but simply as the work of a native artist—uneducated of course, but a proof of the unnecessary waste of time under old Masters and Italian travel.

"The reader of this will bear in mind that nearly fifty years have passed since these rare exhibits were produced—before 'edecation' had taken such rapid strides in the 'picter' world—and now, asking no favors for my frinds, (as friends they were), let all imperfections be buried in their graves and shield these and them from other than kindly criticism—"

The recent popularity of American primitive painting, which was a generation ago ignored or slandered, is largely due to the fact that the primitive painters unconsciously achieved a non-realistic style which is very close to the deliberately abstract style of modern art. Of all the primitives which have come to my attention, none are so strikingly akin to sophisticated modern art as Miss Willson's artless watercolors. Critics brought up on the modern "isms" relish the complete abandon, the blithe

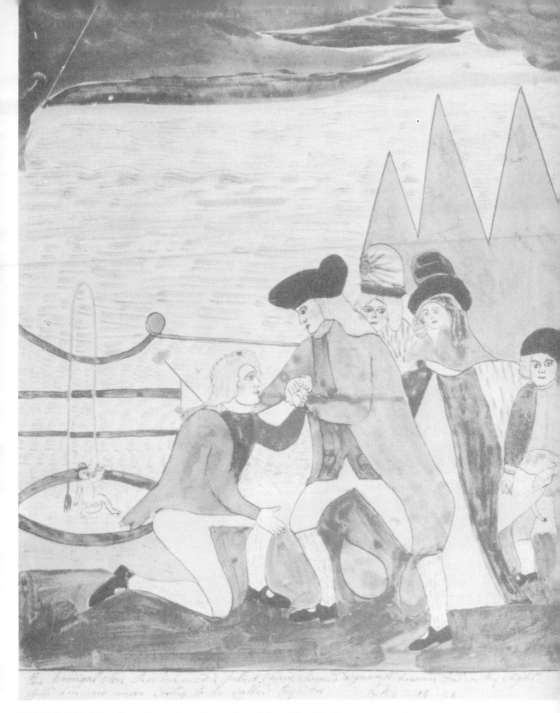

WILLSON, The Prodigal Son Reclaimed by His Father *(c. 1820)*
Colonel and Mrs. E. W. Garbisch

freedom from prosaic reality, which distinguish Miss Willson's work. That these paintings were executed for sale and were greatly in demand in their own time seems less understandable.

A much discussed question concerning the style of the American primitive has been that of its abstract and decorative quality. Most critics have insisted that a primitive painting was never deliberately decorative, its abstract effect merely an incidental result of the untutored artist's inability to paint realistically. It has always been my belief that this explanation misses the vital point that the primitive artist's inability to paint realistically also made way for a compensating *interest in* and *emphasis on* abstract design. This emphasis accounts for our twentieth-century enthusiasm for the American primitive.

Surely no one will claim that Miss Willson was trying to be realistic and that her futile attempts at realism resulted in an unconsciously abstract style. She undoubtedly realized her technical limitations and, making no attempt at academic realism, felt herself free to develop color and pattern for their own sake. Her product is the most striking example that I know of the primitive tendency to exploit pure color and design. Distortions of scale, arbitrary color, the use of a composite scene where the outdoors and a room interior may occupy the same space—these also point to Miss Willson's painting as truly primitive, and as truly modern. Her colors, concocted of brick dust, vegetable dyes, and the juices of berries, are different from any of those commonly used by her contemporaries; they are primitive as those of the ancient Egyptians, and modern as those of Matisse.

Miss Willson's paintings cannot be considered as typical American primitives, or as individually great ones. Their interest lies in their unusually early date and extremely primitive style on one hand, and in their inship with twentieth-century painting on the other.

The sight of these strangely designed and brilliantly colored paintings is a shock even to the modern sophisticate; the first impression is of a cross between a psychotic's nightmare and the wildest compositions of the Fauves. One then realizes that the creator of these pictures was simply endowed with a teeming imagination, a bold taste for primary color and geometric design, and a total lack of inhibition—a combination which adds up to a style close indeed to that of modern abstract art.

JEAN LIPMAN

Rufus Porter

AMERICAN history is not made of dry dates and facts, but of the lives of our people. The way a great man lived and worked and thought is more than his personal story; it is the vital, living history of his time—a history we can ill afford to lose. Yet while the most insignificant dates and events in American history are recorded in thousands of volumes, many important lives have been entirely ignored. Such was that of **Rufus Porter** *(1792-1884)*. His very name is almost unknown today and details of his amazing career have never been published or publicized. Yet this man was one of our great New Englanders. It has seemed important to reconstruct his life because he pioneered and made outstanding contributions in the field of American art, and in science and journalism as well. His career richly illustrates the most progressive tendencies of nineteenth-century America, and his life makes vividly clear the transition from the colonial period to our modern day.

Rufus Porter's place in American art history is that of our chief early mural painter and one of our great native artists. As a portrait painter he was the first to conceive of the large-scale production of portraits for the people; as a landscape painter he was the first to realize the popular possibilities of the everyday American scene. From the perspective of the twentieth century his homespun art and art instruction emerge as a highly significant facet of his many-sided career, and as an enduring contribution to American cultural history.

Porter's life reads almost like a composite tale of the times, a personal embodiment of the era of itinerant adventure, of young invention, of scientific, industrial, and artistic enterprise. We see a New England farmer's son and shoemaker's apprentice voyaging to the Hawaiian Islands, becoming America's leading mural painter, founding the *Scientific American*

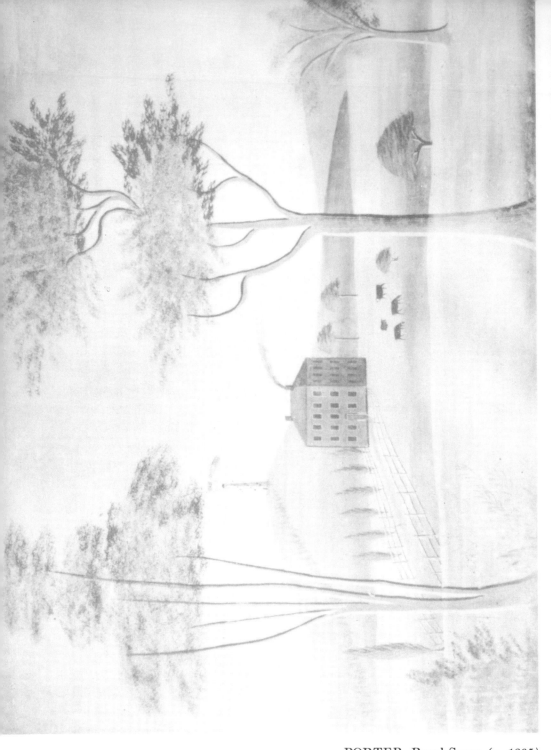

PORTER, Rural Scene *(c. 1825)*
Daniel Carr House, North Haverhill, New Hampshire

PORTER, Orchard Scene *(c. 1830)*
Old Barrows Homestead, Fryeburg, Maine

magazine, planning a "horseless carriage" and an airship designed to travel at a hundred miles an hour. In no other time or place than nineteenth-century America could such a life have been led.

Rufus Porter was born in West Boxford, Massachusetts, in 1792, the son of prosperous farmer folk. His higher education consisted of six months spent in the Fryeburg Academy in Maine at the age of twelve, and the next two years he lived as a farmer and amateur fiddler in Maine. According to an obituary account in the *Scientific American* his family decided when he was fifteen years old that "it would be best for him not to fiddle any longer for life" but to settle down to something solid and useful, and so apprenticed him to a shoemaker. Soon, however, he gave up this trade and began his itinerant career by walking to Porland where for three years he played the fife for military companies and the violin for dancing parties. He then became, successively, a house and sign painter, a painter of gunboats, sleighs, and drums, a drummer, and a teacher of drumming and drum painting. In 1814 he was, briefly, a member of the Portland Light Infantry. Next he taught school, built wind-driven grist mills, planned and copyrighted a music book, married, moved from Portland to New Haven, and began his career of portrait painting. Shortly after that we find him as "Professor Porter" running a dancing school. The following years, from 1817 to 1819, he seems to have been a member of the crew of a ship engaged on a trading voyage to the northwest coast and Hawaii.

Such was the youth of our young Jack-of-all-trades—the very spirit of freedom and adventure, trying out for himself a string of promising enterprises. He had the exuberant optimism of his time, the confidence in progress. Young, eager, welcoming change, he cheerfully assumed that anything was possible in the America of his day—and so it was! From shoemaker to fiddler, soldier, teacher, painter, sailor—a wealth of possibilities were open to this robust New England lad and opportunity was infinite.

Rufus Porter's father and grandfather and great-grandfather had owned and worked the same farm homestead in West Boxford. But young Rufus would have none of this dull, conservative régime. After trying out in rapid succession the various professions named he decided that no static life would suit him. In the early years of the new century he adopted the dual career of itinerant artist and inventor and so continued on the high-road of his free, adventurous life.

Rufus Porter carried the Yankee taste for itineracy to an extreme.

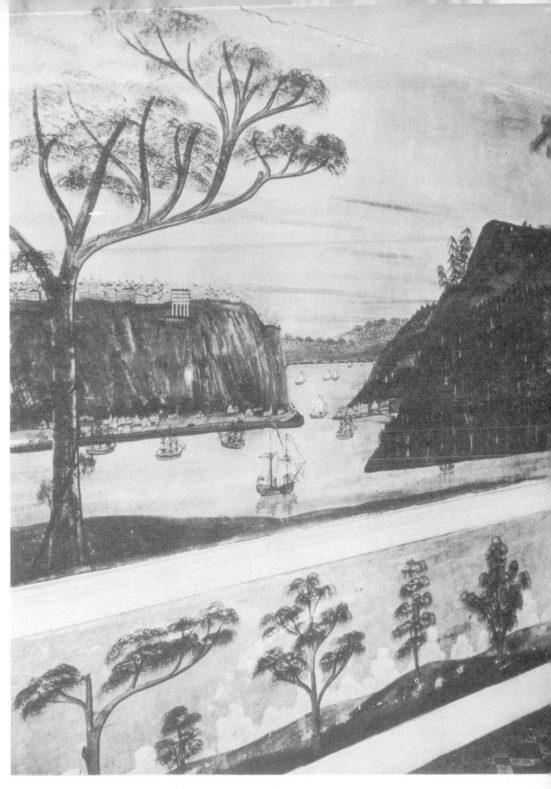

PORTER, Hudson River Highlands *(c. 1825)*
Tracy House, Greenfield, New Hampshire

He had begun a nomadic life when entering his teens, and he remained a wanderer till his last years, the highway his true home. A note in the *Porter Genealogy* published in 1878, when Rufus was eighty-six years old, reports: "Mr. Porter writes that he has good health, and walked seventeen miles the 3rd inst." He is evidently still footing it at eighty-six! At this date he is recorded as a resident of New Haven, but he had not yet settled down, and is found some years later in Bristol, Connecticut, where he spent his last years.

Among his minor claims to fame should be the title of America's most versatile and productive itinerant. In this role Rufus Porter devoted himself to the large-scale production of inexpensive portraits and murals, intended to adorn the homes and hostels of country folk. A generation before Messrs. Currier and Ives had become printmakers to the American people Porter had established a mobile one-man factory for original portraiture and interior decoration.

From 1815 to 1824 he worked pretty steadily at the trade of itinerant portrait painting, traveling during that time as far south as Virginia and all through New England. To speed up production he planned and made a camera obscura with which he could make portraits in fifteen minutes. The silhouette of the sitter was focused on a sheet of paper, the outline then sketched and rapidly filled in. These portraits, priced at a dollar, were in great demand and sold like hot cakes.

In 1825 Porter published a book called *Curious Arts*, an art instruction book mainly designed to give the amateur public quick and easy recipes for various types of art work.

Included in this book is a section on "Landscape Painting on Walls of Rooms"—and for the next twenty years Porter devoted himself chiefly to mural painting. His frescoes were executed in large scale on the dry plaster walls in a combination of free-hand painting and stenciling, some in full color, others in monochrome, with foliage occasionally stamped in with a cork stopper instead of painted with a brush. These methods, as well as stencil work, had been used for decorating plaster, woodwork and furniture, but Rufus Porter was the first to popularize them for landscape painting. His rapid technique and stock stencils reveal our inventive Yankee introducing time-and-labor-saving devices and mass-production methods in art as he did in industry. His simple murals provided a popular substitute for the elaborate, imported scenic wallpapers that were fashionable at the time, and though somewhat related to wallpaper designs,

PORTER, Sacrifice of Isaac *(c. 1845)*
Senigo House, East Weymouth, Massachusetts

Porter's scenes always have a fresh, native flavor. I have recorded nearly a hundred New England houses decorated with the wall paintings executed by Porter and his pupils, and it seems safe to assume that more than that number remain undiscovered or have been destroyed during the last hundred years.

Attributing the frescoes, fortunately, presents few difficulties. The Porter and Porter-school murals are distinguished by a typical style and content which makes them easy for anyone to identify. Their most obvious characteristics are their large scale, clear, bright colors, and bold design and execution. The three most frequently recurring scenes are harbor views much like Portland harbor as seen from Munjoy Hill with houses, ships, and islands, mountains in the distance, and large "featherduster" elm trees and small shrubs in the immediate foreground; mountain-climbing or hunting scenes used for stairway decorations; and farm-village scenes, most often used for the overmantel fresco, with buildings, fields, fences, roads, and again the large elms and small stylized shrubs in the foreground. The large trees invariably occupy almost the entire height of the painted wall and establish the first plane of the picture in a composition which Porter repeatedly used. Other earmarks of his murals include the use of stencils for many details such as houses and boats, the billowing, round clouds, the clear reflections of objects in water, and the sharp shading of the darkened sides of houses and trees. Occasional exotic details such as tropical trees and vines, based on recollections of Hawaiian scenery, are also characteristic of the frescoes.

In a series of articles published in the first volume of the *Scientific American* Porter discussed the mural painter's approach to his art. Here we find him enthusiastically recommending for subject matter, American farm scenery; for style, deliberate abstraction. This was indeed a revolutionary combination for a mid-nineteenth-century artist to have advanced. I quote:

> There can be no scenery found in the world which presents a more gay and lively appearance in a painting, than an American farm, on a swell of land, and with various colored fields well arranged . . . In finishing up landscape scenery, it is neither necessary nor expedient, in all cases, to imitate nature. There are a great variety of beautiful designs, which are easily and quickly produced with the brush, and which excel nature itself in picturesque brilliancy, and richly embellish the work though not in perfect imitation of anything.

Rufus Porter's outstanding trait was his total independence of the more conventional ideas and fashions of his day. He felt himself free to live as he would, to think as he would, to paint as he would. This accounts both for the bold originality of his ideas as an inventor and for his free approach to the art of painting. His awareness of the simple beauty of New England farms and villages, his dislike of academic realism, and his personal, deliberately abstract style, his unconventional designs and gay color schemes, his rapid, bold brushwork—all this adds up to a quite modern art. Porter was at the same time the most typically native and the most radically modern of the early American landscape artists.

During the years of Porter's work as an itinerant artist he actively practiced a subsidiary profession—that of inventor. His inventions were generally directed toward saving time and labor, and his liking for the itinerant life caused him to specialize in devices which would improve means of locomotion. He was actually the first to visualize the possibilities and to draw up specific plans for the automobile, the elevated train, and the passenger plane. Rufus porteralso concentrated on developing table mechanisms and this adjective is prominent in the newspaper titles of his inventions. We find plans for "Porter's Portable Horse Power," a portable fence and portable boat, a pocket chair, and even a car for moving houses. There is nothing stodgy or static in Porter's scheme of things. He was a forward-looking devotee of variety, change, speed. His life, art, writings, and inventions are entirely consistent; all typify the changing trends of his times and predicate to an amazing degree our twentieth-century tempo.

Throughout his life Porter was interested not only in doing but in teaching. He had the instincts of the leader, the crusader, and sought at every turn to promote and propagate the ideas and skills which he developed. When in his youth he became an accomplished drummer and drum painter he also became a teacher of drumming and drum painting. In his early twenties he was a school teacher and a "professor" of dancing, and planned though never carried out a music instruction book. Throughout his career as an artist he was an active teacher, publishing a popular art primer, writing series of articles on the art of painting and working with a small school of pupils who learned and practiced his methods of mural painting. A practical inventor, he was always aware of the broader implication of his ideas. After drawing up specifications for a high-speed flying machine he published in 1849, neatly timed for the gold rush, a book

called *Aerial Navigation, the Practicability of Traveling Pleasantly and Safely from New York to California in Three Days.*

In the latter part of his life as a magazine editor and pamphleteer Rufus Porter sought to instruct and lead public opinion. The several scientific journals which he founded and edited discuss, besides scientific material, everything from education to politics. His journals, representing the interests of mechanics and farmers, are boldly independent and progressive; the religious articles which he wrote and published in his later days can only be termed revolutionary. As journalist and so commentator on his times Porter in his mature years crystalized the ideals of freedom, equality and progress in the young democracy in which he had played so varied and active a part.

<div align="right">

JEAN LIPMAN

</div>

James Sanford Ellsworth

T HE Connecticut miniature painter, James Sanford Ellsworth, son of John Ellsworth, was born in Windsor early in 1802. He first displayed a taste for art by making several copies in oils of one of Gilbert Stuart's full-length portraits of Washington, one of which is still preserved in the Wadsworth Atheneum at Hartford. By the time he had reached his early twenties he was painting the miniature profile portraits for which he is known today.

Ellsworth lived for a number of years in Hartford on Trumbull Street, and married Mary Ann Driggs of that city, May 23, 1830. He was an eccentric young man and kept himself generally aloof from society, his chief diversion being the reading and study of Shakespeare's plays. His marriage proved unhappy and soon thereafter, possibly in a year or two, he departed from Hartford without warning for the west. There he appeared first in Saint Louis where he painted a picture called *A Wounded Grecian Racer,* which created much comment. It was regarded by artists as "a wild conception, good in color, fine in drawing and altogether praiseworthy." Apparently he traveled about considerably in the west, painting as he went.

He returned to Connecticut sometime between 1835 and 1840. Mr. H. W. French in his *Art and Artists of Connecticut* says that "he reappeared in the role of a weather-beaten wanderer, followed by an old dog, which he said was his only friend on earth." He continued to paint his portrait miniatures in towns widely separated about the state of Connecticut, and in Berkshire and Hampden Counties, Massachusetts, for many years thereafter. Quite possibly there is some truth in the story of his stopping at a farmhouse near Hartford and offering to paint the family in exchange for food and old clothes. In his old age Ellsworth moved finally

to Pittsburgh, Pennsylvania, where he died in an almshouse in 1873 or 1874.

Mr. French also says that too much Shakespeare and his unhappy marriage had made Ellsworth mad before he departed unceremoniously from home in his youth. This, I think, is stretching the truth. Ellsworth seems to have been always something of an eccentric and a solitary soul, and probably always impecunious. Doubtless he was considered a ne'er-do-well by his contemporaries. But to us his little portraits are quaint and charming. The best of them were all done after about 1835, and they could hardly have been painted by any other than a sane and very competent draftsman.

The earliest of Ellsworth's miniatures known to me are those of Mr. and Mrs. Rufus Winthrop and their three children which were painted, if I am not mistaken, in the artist's early twenties, before he went west. These reveal certain peculiarities that became characteristic of his style, notably the stiff, erect attitude in which he portrayed his sitters and his custom of painting them in profile. Perhaps Ellsworth felt that he had a particular gift for profile drawing, or perhaps he found it easier than full face. In an age when silhouettes were popular his patrons probably liked his profiles and it is even possible that his art had begun with the cutting of silhouettes in his boyhood and early youth. At any rate, he adhered to that style with very few exceptions to the end of his life.

One exception is a little boy of the Rufus Winthrop family, who is painted in full fame. Another is a little boy of the Raphael Winfield Harrington family. The latter is one of six miniatures all mounted in one frame, showing father and mother, two daughters, the son, and a tombstone beneath a weeping willow in memory of a fourth child.

The likeness of Mrs. Enfield Johnston, who was the first white woman married in the state of Kentucky, is the only Ellsworth miniature on ivory that I have ever seen. All the others are in watercolor on paper. The one of Mrs. Johnston must have been painted in his early thirties while he was in the west, for it was done in Louisville.

It was immediately after his return from the west to his native state that the best of his miniatures were produced. He had improved immensely, especially in the modeling of the faces. This improvement adds a new interest in his portraiture during the next few years. His drawing is more assured and meticulous in its attention to minute detail, as noticeable in the lace caps and collars of his women. He is freer and surer in his use

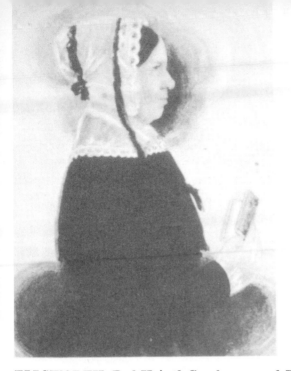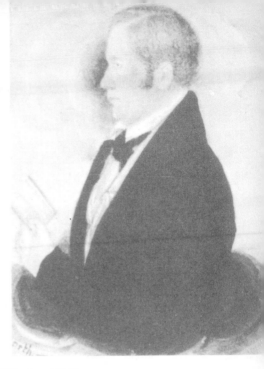

ELLSWORTH, Red-Haired Gentleman and Wife *(c. 1840)*
Formerly Frederic Fairchild Sherman

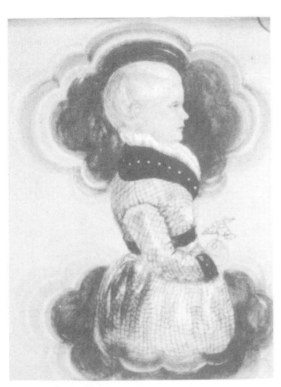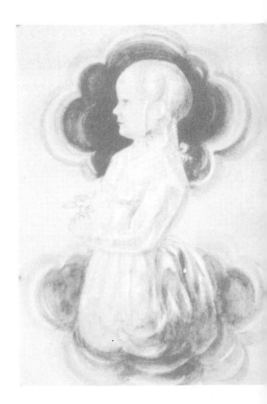

ELLSWORTH, Children *(c. 1840)*
Mrs. Allen Rogers

ELLSWORTH, Unidentified Boy *(c. 1840)*
Privately Owned

ELLSWORTH, Mrs. Jennie Post *(c. 1835)*
Formerly Frederic Fairchild Sherman

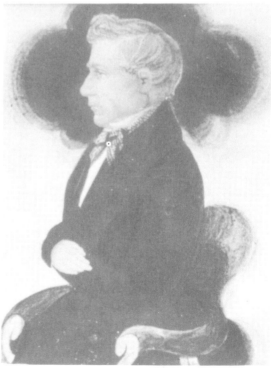

ELLSWORTH, Couple *(c. 1850)*
Formerly Frederic Fairchild Sherman

of color as evidenced in the flesh tones and in the dress of his sitters. Browns, a rich blue and yellow, and other hues appear. The finest of his miniatures that I have encountered are those of Mrs. Jennie Post of Guilford, Connecticut, and of an unknown elderly lady, both of this period.

After 1840 Ellsworth invented an altogether personal style of representation, in which the sitter is shown seated in a chair. The individual characteristics of this type are found in the Victorian chairs which are all much alike, heavily curved and scrolled, and in a conventional, cloud-like background for the heads, shaped like a clover leaf. It is a curious but engaging and entirely original scheme for portrait miniatures. Since examples of this type portray subjects in Connecticut and Massachusetts, and one pair is signed and dated *March 12th 1852*, I believe that his miniatures in this style date from about 1840 to 1860. The drawing and modeling of these late miniatures, painted after the artist was forty, are as fine as in those done ten or fifteen years earlier.

Though Ellsworth developed an original style, it was not unique. There was at least one other itinerant artist who produced very similar small profile portraits, in watercolor, with the same distinctive cloud-like halo behind the heads, and often with the subject seated in similar curlicued furniture. This was Josiah Brown King *(1831-1889)*, whose life and work were recorded by Julia D. S. Snow in *Antiques* for March 1932. King was born in the Berkshires, in Massachusetts, and spent his life in that region and in nearby southern Vermont. His painting period was limited to the years 1849-1863. Since Ellsworth was painting in that region at just about the same time, it is more than likely that King knew his works if not the man himself, and that he was a conscious imitator of the Connecticut itinerant's profiles.

If I am not mistaken Ellsworth was entirely self-taught, his art an outgrowth of an early aptitude in the cutting of silhouettes. While he was certainly not a great miniaturist in any sense, his work had exceptional individuality. Historically it preserves in a remarkable degree the spirit of its time—prim New England women with their quaint and lovely lace collars and caps, men in their Sunday black, with black stocks, and the curious and ugly Victorian furniture. Little things like the wart below one Mr. Marcum's ear are evidence that the artist was very literal and painstaking in his portraiture, and something of a realist.

FREDERIC FAIRCHILD SHERMAN

Erastus Salisbury Field

NINETY-FIVE years of living is in itself an accomplishment, but when at least seventy-five of those years are devoted to the art of painting portraits and imaginative scenes and painting them well, then certainly more than cursory comment is warranted. The ninety-five years stretch from 1805 to 1900, and they are the life span of Erastus Salisbury Field, now recognized as one of the outstanding primitive artists of the nineteenth century.

He and his twin sister, born May 19, 1805, were the children of Erastus and Salome Ashley Field of Leverett, Massachusetts. Family tradition, based on the painter's own stories and substantiated by the following notation from the diary of Samuel Finley Breese Morse, shows that the young Field at the age of nineteen received three months' instruction in Morse's studio in New York: "December 17, 1824. I have everything comfortable in my rooms. My two pupils Mr. Agate and Mr. Field are very tractable and useful." This period of tuition was broken short by lack of funds but it was nevertheless long enough to effect a change in the personal style and technique developed by the painter even at that early age. Incidentally, it was at this time, December 1824 and January and February 1825, that Morse had sittings from Lafayette. In later life, it is said, Field frequently mentioned these visits.

Six years after his return from New York, on December 29, 1831, Field married Phebe, daughter of David and Mary Moore Gilmore of Ware, Massachusetts. They settled in Hartford, Connecticut, where they stayed but a year before moving on to Monson, Massachusetts. Here Henrietta, their only child, was born on November 6, 1832. After a brief period in Monson, Field moved on to the neighboring town of Palmer setting up his studio in the Cross Block. The patronage of Palmer

having been absorbed, the Fields returned to Leverett, the town of the artist's birth, finally moving to the adjacent town of Sunderland in 1859 where they presided at "Plumtrees." In that year the wife Phebe died, leaving the artist to be cared for by his daughter till his death in 1900.

Field built a little studio against the side of a hill on a Plumtrees lane. When the weather was warm and fine, he painted in the barn of the Caleb Hubbard Tavern, surrounded by a crowd of curious youngsters. When it grew colder, he retired to his own studio where, warmed by a small stove, he worked on through the winter months. He was primarily a portrait painter, and there is little doubt that Major Caleb Hubbard and the members of his family were his favorite subjects, for as late as 1940 ten portraits were owned by descendants of the Major who still lived at the Tavern.

On the basis of his portraits known it is possible to say that Field had four main styles of painting. The first is represented by the portraits of his brother, *Phineas Field (1809-1877)*, and their grandmother, *Elizabeth Billings Ashley (1745-1826)*. Of his various stylistic periods this is the most astonishing, considering his lack of training and contact with other artists. These pictures were almost certainly done before his New York visit. Yet the precision of his drawing and the surety of his brushwork indicate considerable previous work, no trace of which seems to be known. It is more than probable that this was based on some formula for procedure learned first-hand from an itinerant, or developed after the study of paintings owned locally but now lost.

These two early works show Field working in a meticulous and tight manner. He models the facial forms with minute detail, building up shadows by the introduction of a green tone over which he lays glazes of warmer colors. The surface texture is almost enamel-like in its smoothness, a marked contrast to his work of a later date. Certain characteristics seen also in the portraits of his later phases are likewise apparent. Square-ended fingers, a slight astigmatism in the eyes, and the introduction of an area of brilliant red somewhere in the composition are three of the most apparent.

The artist's second period, which might be more correctly described as a period of transition, began after the three months' training in Morse's studio had introduced some new elements into his style and technique. The gap between these two periods is marked, particularly from a technical point of view, yet Field's early use of green tones for shading per-

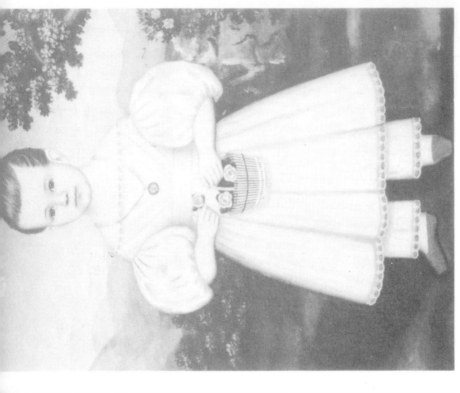

FIELD, Ellen Virtue Field (c. 1838)
Springfield Museum of Fine Arts

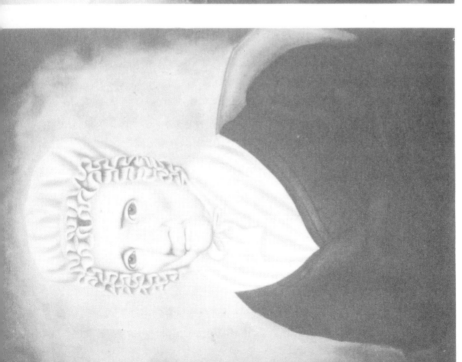

FIELD, Elizabeth Billings Ashley (c. 1824)
Springfield Museum of Fine Arts

oiots for some years, as is evidenced by the portrait of Ellen Virtue Field *(1835-1916)*, painted when she was about three years old.

This is certainly one of the artist's most delightful and charming works. All the mannerisms noticed in his first period are again encountered with the addition of still another individual characteristic. Here for the first time one finds a method of lace painting peculiar to the artist and utilized continually throughout his later work. The openwork in the lace which edges the neckline and the bottom of the dress, as well as the edging for the pantalets, is simulated by dots of black paint, at times unevenly applied. The dots frequently overlap the boundaries of the lace design. The fluid and rapid brush strokes used in indicating the puffed sleeves of Ellen's dress are again a definite departure from his earlier method of rendering textiles. The meticulous smoothness of the first period where all brush strokes are lost in the minute technique has now completely given way to a broader and more rapid handling.

In Field's third and seemingly longest period, the use of a green tone for shadows and the smooth technique are totally discarded. However, all the other characteristics are repeated—the square fingers, the astigmatism, the fluid painting of the drapery folds, the spot of red, and the black dots for the lace. The surface texture of the face is now rough with a spotting of the colors rather than the smooth glazes of the earliest style. The shadows and the highlights of cheek, nose, and chin are rendered by small dots or splashes of color. It is this introduction of an almost *pointilliste* technique into part of the flesh rendering which may be considered the characteristic of the third period. Other mannerisms are used again and again. The breadth of the nostrils is stressed, the lips have a tendency to pout. The use of reticule, book, or other object held in the hand is now invariable. The leather of the book covers, the mahogany veneer of the furniture, and the leg-of-mutton sleeves of the dresses are painted with easy, fluid strokes. At times stark truthfulness to all facial detail produces a not entirely pleasant result, as when a wart or mole is realistically depicted. No less than nine of approximately two dozen portraits discovered fall into this third period. All are closely similar in handling and general style.

Field's fourth and last phase of portrait painting was evidently introduced about 1870. The influence of the daguerreotype with its rigid and precise manner becomes apparent. An almost photographic quality is developed by the minute and smooth technique of the painting. There

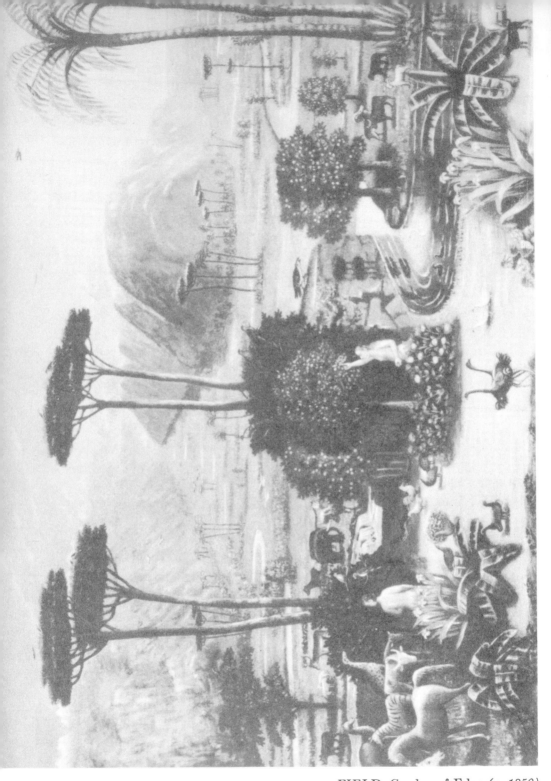

FIELD, Garden of Eden *(c. 1850)*
M. and M. Karolik Collection,
Museum of Fine Arts, Boston, Massachusetts

FIELD, Historical Monument of the American Republic (c. 1875 and later)
Mrs. H. S. Williams

is a reminiscence of Field's first style in the dexterity with which the pigment is handled, producing an enamel-like texture instead of the granular quality of the second and third periods.

This cannot be, however, an end to the discussion of Field's unusual talents. The imaginative scenes drawn from classical mythology and Biblical narrative are as interesting as his portraits and perhaps show even better the creative genius of the artist. Of the scenes so far discovered, the *Garden of Eden,* known in two examples, is by far the most fascinating. Trees, mountains, birds, and animals are all shown in pairs, along with Adam and Eve, in the midst of a bountiful nature comparable in many respects to a Rousseau jungle scene. Important to note, to, is the completely individualistic concept of the scene. Though in folk idiom, Field's *Garden of Eden* is unique and highly personal in design, color, and idea. In one of these paintings, as in some others, Field has painted a decorative border to simulate an elaborate black and gold frame.

Field also painted the plagues of Egypt, several examples of which have been found. Here again his imaginative capacity shows itself to be unbounded. Using as a source for his inspiration the passages from Exodus 12:23-30 concerning the death of the first born, Field illustrates not the actual dying of the first born, but the mass funeral which he logically concludes to be the aftermath. Through a street lined with an extraordinary array of would-be Egyptian architectural and sculptural constructions, the people of Egypt march with white-draped coffins on their shoulders.

Field's interest in classical mythology is represented by the painting *The Embarcation of Ulysses.* Here again his architectural background, in this instance an attempt at classical forms, makes up for its improbability through the wild freedom of interpretation. Ulysses is seen standing in the bow of a most unusual war-vessel, viewing the rest of the Greek fleet spread over a harbor surrounded by porticoed temples and palaces.

By far the greatest of the scenic paintings both in size and in narrative content is Field's late work, the *Historical Monument of the American Republic,* done sometime prior to 1876 with additions made later. This amazing canvas, 13 by 9 feet, shows nine main towers rising drum on drum, supported by colonnaded arcades, from a fountain-studded park. At the very top are seven exposition towers connected by steel bridges over which trains run to carry the spectators through the galleries in a manner evidently not again suspected until Norman Bel Geddes designed the General Motors exhibit of 1940. These buildings, for the display of new develop-

ments in American life, are placed on the platforms of the main towers labeled *T. T. B.*, "The True Base." Field's concept of The True Base was the actual historic background of the United States, and through sculptured ornamentation the walls of the towers tell of the history of the country. The extraordinary quality of the imagination displayed, the infinite patience, and the detailed historic knowledge of the artist are unequaled. A smaller tower directly in the center of the whole composition brings the total to ten and is labeled, *In memory of Abraham Lincoln.* This is the tower of the Constitution, and the scenes and figures sculptured on it give the full story of this document. This composition is outstanding in the field of folk art, and, even more important, it provides further insight into the philosophy and thought of nineteenth-century America.

FREDERICK B. ROBINSON

X

William Matthew Prior

WILLIAM MATTHEW PRIOR was one of the most versatile artists of mid-nineteenth-century New England. His portraits on glass, and his "flat" likenesses done in tempera on artist's board, are well known to students and collectors of American primitive paintings. Less often found are his landscapes and his large portraits in oil. The latter show him to have been capable of producing results far superior to those usually credited to him. The theory has been advanced that he changed his style abruptly, and inexplicably, some time during the 1840's while working in the vicinity of New Bedford, Fall River, and Sturbridge, Massachusetts. Therefore, these unshaded delineations, and many others which are not signed but follow a similar pattern, are sometimes grouped together under the generic name of the "Fall River-Sturbridge school of painting" (Clara Endicott Sears, *Some American Primitives*). The fact is that Prior could paint well when he wished to, or when it was financially profitable, but for his less affluent patrons he early adopted a style which provided a passable likeness with the least possible expenditure of his own time and effort. Such is the real explanation of the great dissimilarity which exists among various examples of his signed work. Proof of this has come to light in a series of newspaper advertisements and in a rare label found on the back of one of his typical "flat" portraits.

From the family Bibles we learn that the first Benjamin Prior came from England to Duxbury, Massachusetts, in 1638. The second Benjamin was born there in 1699, and the third Benjamin in 1740. His son Matthew, shipmaster and father of the artist, was born in 1774. He married Sarah Bryant of Duxbury in 1797 and was lost at sea in 1816. Their second son was William Matthew, born in Bath, Maine, on May 16, 1806. Of his childhood and early youth no details have survived, except the

80

story that as a small boy he painted the portrait of a neighbor on a nearby barn door, causing quite a stir in the community. If he received any formal training there is no record of it, but a small portrait of a young man done on a white pine panel, signed and dated *Portland, Aug. 14, 1824*, indicates that he was already traveling and painting professionally at the modest age of eighteen years.

On June 5, 1827, when he was twenty-one years old, Prior inserted the following notice in the *Maine Inquirer:* "Ornamental painting, old tea trays, waiters re-japanned and ornamented in a very tasty style. Bronzing, oil guilding and varnishing by Wm. M. Prior, Bath. No. 1 Middle Street." The following summer he advertised again: "Wm. Prior, fancy, sign, and ornamental painting. Also drawings of machineries of every description executed in good order and on shortest possible notice." (In this connection it is interesting to note that the first steam mill on Trufant's Point, Bath, was built in 1821, and that the Bath Furnace Company was casting machinery in pig iron at this same period.)

In 1828 we find Prior's first mention of himself as a limner. Under date of February 28, and continuing for some months thereafter, appears this notice: "Portrait painter, Wm. M. Prior, offers his services to the public. Those who wish for a likeness at a reasonable price are invited to call soon. Side views and profiles of children at reduced prices." Here is the first suggestion of a price scale based on type of work. In 1830 he was still carrying on as a general decorator· "Military, standard, sign and ornamental painting as usual." Coupled with this is an interesting statement of the values of his portraits, which ranged from $10 to $25 with gilt frames from $3 to $10. Therefore his most expensive likeness with the best frame would have cost the sitter $35, a not inconsiderable charge for a young man still in his twenties, at a time when other artists were doing large family portraits for as low as $10.

Several competent portraits are attributable to this period. One of an unknown young man is signed *By Wm. Prior, 1829;* the figure is set in an oval, quite unusual for Prior. In 1831 he painted the picture of H. B. Webb, Esq., of Bath which now hangs at Fruitlands and the Wayside Museums Incorporated at Harvard, Massachusetts. In the same year he exhibited at the Boston Athenaeum his portrait of A. Hammett of Bath. This is his only appearance in the catalogues of the Athenaeum.

On April 5, 1831, appears the last advertisement in the *Inquirer:* "Fancy pieces painted, either designed or copied to suit the customer,

enameling on glass tablets for looking glasses and time pieces . . . " Here can be discerned the beginnings of what later developed into his very successful line of glass portraiture. Although he came of seafaring ancestry and lived all his life on the New England coast no marine paintings are credited to him, and the following is his only reference to any work connected with ships: "Lettering of every description, imitation carved work for vessels, trail boards and stearn moldings painted in bold style." It is the closing sentence of this advertisement, however, which merits special attention, for here in his own words we find reference to the pictures which have come to typify Prior's work to the average collector: *"Persons wishing for a flat picture can have a likeness without shade or shadow at one quarter price."*

On the back of the frame of one of Prior's "flat pictures" is a rare printed label that reads: "PORTRAITS/ PAINTED IN THIS STYLE!/ Done in about an hour's sitting./ Price $2.92, including Frame, Glass, &c./ Please call at Trenton Street/ East Boston/ WM. M. PRIOR." Here we have corroboration of the fact that this type of painting resulted from the small amount of time and money to be expended by the sitter rather than from a potential lack of skill on the artist's part.

It appears that Prior moved his family to Portland, Maine, sometime between 1831 and 1834. On April 28, 1828, he had been married to Rosamond Clark Hamblen in Bath. Their two eldest children, Rosamond Clark and Gilbert Stuart, were born in Bath in 1829 and 1831 respectively, while Rienzi Willey, William Matthew Jr., and Jane Willey were all born in Portland between 1836 and 1840.

In 1834 "William Prior, portrait painter" first appears in Portland residing with his brother-in-law, Nathaniel Hamblen, painter, on Green Street. Before long he established his own residence, and in 1836 his wife's brothers Joseph G. and Sturtevant J. Hamblen, painters, are living "at Wm. Prior's." About three years later the Hamblens and Priors moved together to Boston. In 1841 they were living there together in Nathaniel Hamblen's house at 12 Chambers Street, and in 1842, moved to Marion Street, East Boston, where they remained together until 1844.

During the next two years Prior's name does not appear in the city directories. Perhaps he was away on one of his long tours painting pictures wherever he could find sitters or families who would offer bed and board in return for his labors. It is said that at one time he owned a horse and wagon in which he took his wife and two elder children traveling through

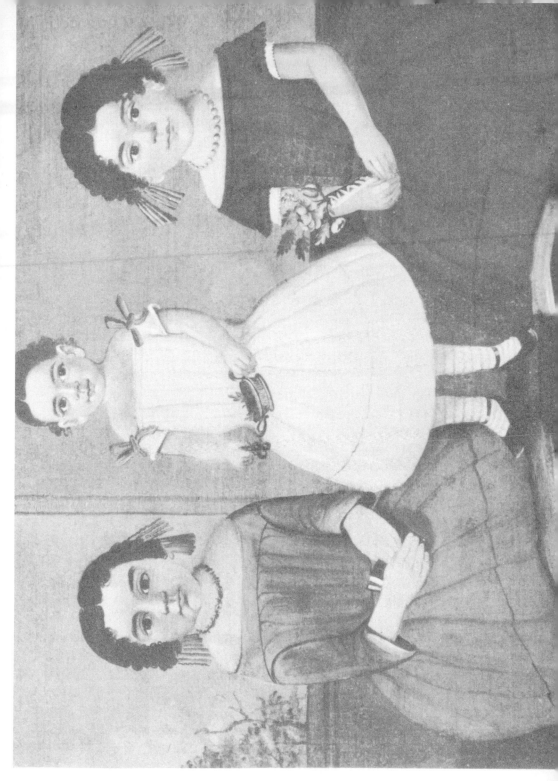

PRIOR, Three Sisters of the Coplan Family *(1854)*
M. and M. Karolik Collection,
Museum of Fine Arts, Boston, Massachusetts

New England and adjoining states. In later years he used to pack forty canvases into a large wooden chest which measured 51 by 22 inches, put it on the train, and leave it stored in the depot when he came to the end of his journey. Then carrying as many canvases as he could, he would set off on foot into the nearby countryside, hoping to stay at the homes of prospective clients. In 1849 he painted seven children in one Newport, Rhode Island, family, ranging in ages from two to seventeen years, while remaining in their home for many weeks. His son Matthew traveled the New England coast with him, going as far south as Baltimore where pictures have been found signed with his name and bearing the address, *272 E. Monument St., Balto.* He peddled his pictures to workers in the East Boston shipyards as well as to patrons of an old hotel on Elm Street in Boston, and it is said that during Dickens' visit to Boston he painted his picture.

Prior lived at a time when painters' materials were not as easily come by as they are today. He prepared his own canvases, ground his own paint, and with the help of his sons, Gilbert and Matthew, made many of his own frames in the cellar of his Trenton Street house. A few of his signed pictures have been found on bed ticking, but according to his sons he usually employed a type of cotton drilling which was stretched, primed, then scratched with a palette knife, and primed and scraped again, until a satisfactorily firm texture had been obtained. Another duty of the younger Priors was to turn the paint mill for the grinding of the colors, a tedious occupation. Prior made the frames on the portraits of himself and his first wife, now owned by his granddaughter, which are of wide mahogany veneer with an inner gold line. The type of frame supplied for the "flat pictures" was of plain beveled wood, two inches in width, while his portraits on glass were given simple gilt moldings.

After considerable effort Prior succeeded in persuading the Boston Athenaeum to allow him to make a copy of their portrait of Washington by Gilbert Stuart. He had long been an admirer of Stuart's work and had named his eldest son after him. Prior's picture is signed: *Copy from G. Stuart by Wm. M. Prior, 1850.* From this model he made many copies on glass, using the technique of enameling with which he had decorated mirrors and clocks as a young man in Bath. These ranged in size from 18 by 22 to 22 by 25 inches. He did many other well-known personages in this medium, among whom were Mrs. Washington, Webster, Lincoln, Theodore Parker, and Napoleon. Signed *W. M. Prior*, they sold for $3 or $4 each.

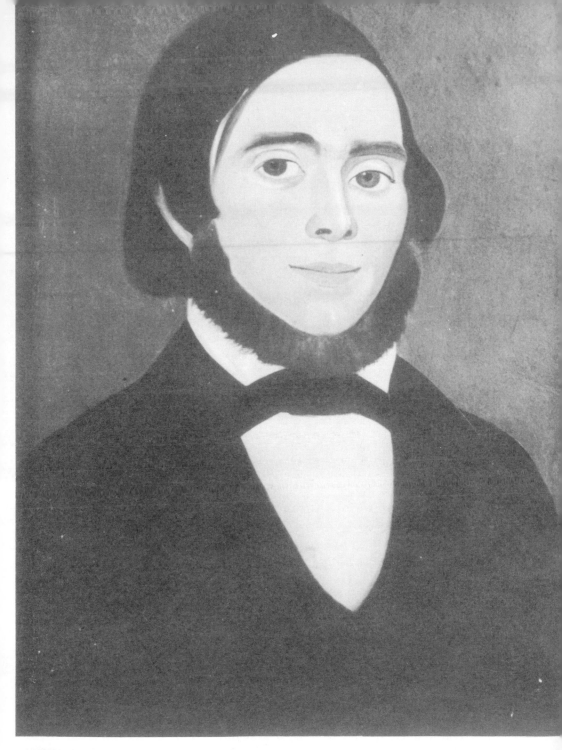

PRIOR, Unidentified Portrait *(c. 1840)*
Mr. and Mrs. Robert Greene Inman

During the second quarter of the nineteenth century the Advent Movement was originated by a dynamic man named William Miller who came to believe, from a study of prophetic chronology, that the second coming of Christ and the end of the world would occur between March 21, 1843, and the same date in 1844. In 1831 he began to speak in support of his theories to many denominations throughout New England. He lectured with great success for thirteen days in the Casco Street Christian Church in Portland during March of 1840, and on October 13 of that year the Millerites held a large conference in Boston. It is probable that Prior attended both conclaves; in any event he and his brother-in-law, Joseph G. Hamblen, became ardent followers of the movement and Prior named one of his daughters Balona Miller after the chronologist. He attended as many of the gatherings as he could, often becoming greatly excited at the meetings. It would be surprising indeed if he had not painted the man for whom he held such admiration and respect, but it was only in December 1948 that a hitherto unknown portrait of Miller was discovered and attributed to Prior. In 1862 he published a book entitled *The King's Vesture, Evidence from Scripture and History Comparatively Applied to William Miller, the Chronologist of 1843*. This complicated treatise is an attempt to prove by interpretation of scriptural prophecy that Miller was himself Christ in his second coming. On the same subject he wrote *The Empyrean Canopy* (1868) in which he tells of painting a chronological chart under the direction of Miller, and of being moved to paint his portrait.

By 1846 Prior had purchased a house at 36 Trenton Street, East Boston, which he called "The Painting Garret." Over the door he hung one of his large pictures as a combination sign and advertisement, and here he continued to live and work until his death in 1873. Sometimes he would have a great many pictures piled up waiting to be finished, and the last touches were often applied by his son Matthew. His wife died August 25, 1849, a year after the birth of her eighth child, and about a year later he married Hannah Frances Walworth of Andover, Massachusetts.

Prior tried his hand at landscapes but apparently they were not in as great demand as portraits, and he seems to have confined himself mostly to adaptations of prints, or to stock subjects of which he made many copies. His view of *Mount Vernon and Washington's Tomb* is not in any way distinguished from many others of its period. Another subject which he painted many times was called *Moonlight*, and he also did winter scenes. Two views bearing the Baltimore address, one dated 1855, appear to be

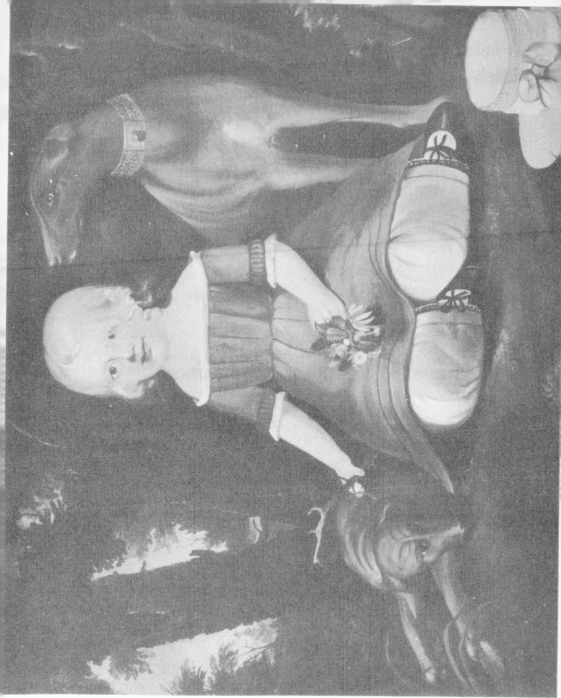

PRIOR, William Allen with Greyhounds *(1843)*
M. and M. Karolik Collection,
Museum of Fine Arts, Boston, Massachusetts

purely imaginary, combining castles, cottages, and streams, populated with gaily dressed peasants and fishermen. One of his more unusual landscapes, intended to be definitely topographical, is entitled *View off Mattapoissett, Mass*. This may be one of the "fancy pieces" mentioned in his advertisements, as the scene is placed within an oval and a narrow gold line surrounding the entire composition serves as a frame. In addition to the title the reverse bears this inscription in Prior's easily recognized hand: *Warranted Oil Colours, by Wm. M. Prior. No. 1370. Price $2.50.*

Mention should be made of a few of the other varied inscriptions found on his pictures which make a study of Prior's work both interesting and amusing. Many are carefully signed with the name of the artist, the place of origin, and the day, month, and year in which the work was presumably completed. Sometimes other valuable information is included, such as the price, or the age of the sitter. The portrait of Eli Hamblen is signed: *Portrait of Capt. Elie Hamblen, AE 34, painted by William Mat. Prior, Portland, April 12, 1838.* The likeness of one of his sons is inscribed: *Matthew Prior, painted by his Father, 1870, author of the King's Vesture and . . .* On the back of his daughter's picture he wrote: *Rosamond C. Prior, Age 16, Painted by Wm. M. Prior, 1846. Retouched age 20, May 30, 1850.* Three portraits are known which are identified on the front in small block letters. Two, dated *May 1843*, are of a colored man and his wife, and are unusual because of the landscape which appears through a window in the background. These and another signed picture, dated *September 1854*, of three little colored children indicate that Negroes were numbered among Prior's clientele; this fact recalls his connection with the Millerites, many of whose leaders supported the Abolitionist cause. Perhaps the most intriguing inscription is found on the reverse of one of his large "flat pictures." This reads: *By Wm. M. Prior. Mr. Turner paid $4.00, Mr. Sawin $4.00. May 1851.* The two figures are evenly disposed on the canvas, and the half of the picture paid for by each gentleman is clearly defined by an unmistakable line drawn down the background between the lady and the child. A printed label used by Prior has already been noted, and a stamp is sometimes found which reads: *Painting Garret/ No. 36 Renton Street/ East Boston/ W. M. Prior.*

In summing up the pictorial achievements of William Matthew Prior it may fairly be said that he neither exhibited great artistic talent, nor excelled in imaginative composition. He could, however, execute portraits with a considerable degree of competence when occasion demanded. His

flat likenesses are perhaps more interesting as examples of a conscious effort to give the public what it wanted at a price it was willing to pay, than for their inherent merit. Nevertheless he was an able and varied craftsman, combining a knowledge of general decorating with commercial, portrait, and landscape painting, all of which he pursued throughout an active and colorful career. His many signed pictures afford ample material for a study of the scope of his work, which deserves a recognized place among that of the other provincial artists of the 1800's.

NINA FLETCHER LITTLE

Deborah Goldsmith

DEBORAH GOLDSMITH THROOP *(1808-1836)* is the first nineteenth-century lady itinerant to be presented to the twentieth-century public. The records of her life and work have been lovingly preserved by her granddaughter, Mrs. Olive Cole Smith, whose warm appreciation of the past has made this account possible. Deborah Goldsmith Throop died long before Mrs. Smith was born. But an old traveling bag, pushed back under attic eaves, was found full of letters from three generations. Its contents, including a series of letters which Deborah and her husband, George Throop, exchanged before their marriage, were arranged by Mrs. Smith and privately printed in 1934 as *The Old Traveling Bag*. Deborah's two albums were carefully preserved, with their rich contents of sentiments written by friends and her own poems and watercolors dating from 1826 to 1832. Mrs. Smith has kept her grandmother's worktable and brushes, her oil paints, still soft, each color in a small bladder, and the powders for the watercolors, wrapped in tiny newspaper packets. Photographs are still being assembled of all of Deborah's known portraits. And so we are privileged to examine the exemplary life and unique career of Deborah Goldsmith when with few exceptions the work done by the talented gentlewoman-painters of a hundred years ago has been scattered, and usually remains anonymous.

Deborah Goldsmith, who habitually signed her work *D. Goldsmith*, was born in North Brookfield, New York, in 1808, and died in 1836 in Hamilton, New York. Her parents, Ruth Miner and Richard Goldsmith, came there in ox-drawn covered wagons from Guilford, Connecticut, a few years before she, their youngest child, was born. The first watercolor in Deborah's second album is a portrait of Oliver Goldsmith copied from Reynolds' portrait, *via* a print, and there is a family tradition that Deborah Goldsmith's ancestors came from the same English family.

When Deborah was about twenty-one her older brothers and sisters were married and living in homes of their own, while poverty was threatening her aging parents. Quoting Mrs. Smith's comments in *The Old Traveling Bag:*

To Deborah, with her sensitive nature and her enjoyment of the refinements of life, poverty was a dread spectre. She had managed some way to improve her natural gift for painting. As a portrait painter she supported herself and helped her parents. It was the custom, then, to go to the homes of patrons and remain until the family portraits were painted. It was thus she went [to Hamilton] to the home of the Throops in 1831 to paint the family pictures. Probably while she painted his picture George made up his mind that he loved the sweet, quiet, serious young artist, that his future happiness depended on winning her to be his wife.

In the series of letters exchanged by Deborah and George during their courtship in 1832 we get a glimpse of the same charm, candor, and naïveté which distinguish Deborah's paintings. George, just twenty-one, had written his "declaration," enclosed with an essay on *Friendship and Spring.* Here it is:

That you may not mistake my meaning, I now declare unto you in words, my sole object in engaging your company. It is to obtain a friend, a friend to share with me the joys and sorrow of life; to cheer in the hour of gloom and be glad in the hour of joy; to gain heart and hand, and travel with me down the declivity of life, and, when fortune frowns and I am buffeted about on the stormy ocean of adversity, one who can look with a smile and console the tempest-beaten bosom with cheering conversation.

Yes, Deborah, this is all that urges me forward, and will it surprise thee when I declare that in thee my desires center, and all my hopes of earth happiness have an end? After mature consideration and closely examining my own heart, I find that thy friendship and thy presence will ever be delightful. To know that thou art willing to comply with this request and impart thy virtue in increasing the happiness of one who respects virtue's innocence, is all that will make life delightful to me. I claim no perfection: such as I am, I offer myself and thus make manifest my desire.

Deborah, I wish not to draw from thee a hasty and inconsiderate answer. No, take your own time to consider. It is an important point; on it hangs all our future happiness. But this I claim: 'Tis truth I send, and truth I ask in return. Perhaps you may think I am asking too much, but please to inform me if I am on right ground, or not. So I add no more. Adieu.

Yours sincerely,
George A. Throop

91

P.S. Friends in health. Write soon as convenient.

PP.S.—Died on the 19th inst. of the billious fever, Mr. Hiram Niles, aged about 32. He left a wife and two little children. His sudden death is truly afflicting to the sorrowing friends, and to all rendered more so by the state of his mind. Lived about two miles south.

George

To this letter Deborah answered from Toddsville, where she had gone to execute some portrait commissions:

I do not know how long I shall stay in this place. I have business enough for the present, and for some reason or other, Mr. and Mrs. Lloyd seem to be over-anxious for me to remain here through the summer. A lady was here a few days since from Hartford. She thought I would do better there than here, and I may possibly go there, or to Cooperstown village, but I do not know yet, for I think I shall stay here as long as I can get portrait painting.

In this letter she concludes that if George will consult his mother and "obtain her approbation," she "will make no further objections" but comply with his request for her hand in marriage. Among the "objections" to which she refers are modest doubts as to whether her suitor will always remain steadfast through long years of prosperity and adversity, whether he will bear with all her weaknesses. And, answering his plea for candor, she prefaces her acceptance with this paragraph:

Some things I want to remind you of, that you may weigh them well (even now, before it is too late), I do not know but you have, but permit me to name them. Your religious sentiments and mine are different. Do you think that this difference will ever be the cause of unpleasant feeling? Your age and mine differ. I do not know your age exactly, but I believe that I am nearly two years older than you. And now, permit me to ask, has this ever been an objection in your mind? And another thing which I expect you already know is, that my teeth are partly artificial. Nature gave me as many teeth as She usually gives her children, but not as durable ones as some are blessed with. Some people think it is wrong to have anything artificial, but I will let that subject go.

George and Deborah were happily married that same year, after a lengthy correspondence, with George's letters to Deborah addressed to a number of New York towns—for she evidently continued her career of

GOLDSMITH, George Addison Throop *(1831)*
Mrs. Olive Cole Smith

GOLDSMITH, Self-Portrait *(1831)*
Mrs. Clara Cole Carothers

itinerant portrait painting until her marriage. A letter from George addressed to her at Burlington Flats in June says, "to learn that you are in health and successful in your business or otherwise, would be a great satisfaction to my feelings." In July Deborah writes from Brookfield, and ten days later George addresses her in East Hamilton. In a letter written in Brookfield in October Deborah mentions that she has been to Lebanon. Besides the dozen or so portraits owned by Deborah Goldsmith's descendants, there may be some still extant in the vicinity of these towns.

In December 1832 George Addison Throop and Deborah Goldsmith were married, and settled in Hamilton. They had two children, Cordelia and James Addison, and in March 1836, Deborah died at the age of twenty-seven. Her mother's diary of Deborah's last sickness, also published by Mrs. Smith, details day by day the young painter's uncomplaining suffering and her pious and peaceful end. This mournful diary highlights the attitude of an era which produced countless "sob pictures" and memorial verses.

The contents of Deborah's two albums likewise mirror the sentiments of her times. They contain a delightful assortment of quotations, original poems, drawings, and watercolors. Keeping these diaries, albums, and painting portfolios was a genteel hobby much in vogue among young ladies a century ago, and a number of them have come down to us. Deborah Goldsmith's albums are notable for the variety and quality of their contents. As nineteenth-century source material they merit complete reproduction in color.

Verse was a favored mode of expression in those days. In Deborah's first album, whose contents date from 1826 to 1829, Deborah and her friends—and even her grandmother—wrote short rhymed sentiments, which Deborah decorated in watercolor with such motifs as little birds, flowers, Bacchus, cupids, pierced hearts, and miniature landscapes.

The second album, dating from 1829 to 1832, contains sentiments from relatives and friends up to and including Deborah's wedding day, more of Deborah's poems, and a number of her finished drawings and watercolors, including several fine small portraits. The titles of some of the watercolors are *The Sisters, Childhood, Lady of Ruthven, The Young Spartan, The Silesian Girl.* Among the portraits are those of the artist's friend Catharine Noble, Dan Throop IV, and Sarah Stanton Mason Throop. The titles of the poems, which give some idea of their tenor, include *A Wish, I Think of Thee, Choice of Employment, Destiny, Thoughts*

GOLDSMITH, The Talcott Family *(1832)*
Mrs. John Law Robertson

of the Past, To the Moon, and *Solitude.* In the album we also find scattered bits such as the following, dated 1829: "Innocently to amuse the imagination in this dream of life is wisdom." Deborah was then twenty-one years old!

It seems extraordinary that this serious young poetess and philosopher was also a professional itinerant, a portrait painter who traveled from town to town with her small wooden chest of painting equipment, executing an order ivory miniatures, oils or watercolors.

The delicate drawing of Deborah's pictures, the sense of design and liking for pattern, and the naïve approach to the art of portraiture scarcely need comment. There is no record of any art lessons for Deborah, and while her itinerant career classifies her as a professional rather than an amateur painter, her work exemplifies the untutored early American art now variously termed "primitive," "provincial" and "pioneer." In this case, all three of those terms apply. Deborah Goldsmith's painting was provincial in origin and primitive in style; while she, keeping the wolf from the door by itinerant portrait painting, might typify the American pioneer spirit.

JEAN LIPMAN

Joseph H. Davis

THAT there were two Joseph Davises in town did not confuse the hard-working farm people of Newfield, Maine. Joe B. was their kind of man. He was down-to-earth, reliable, a man of consistent action. When the town voted him on the school committee, it knew what it was doing. As selectman too, Joe B. was trustworthy, and he was elected year after year.

But Pine Hill Joe—that was another matter. What could the town do with a man who, when spring came and it was planting time, suddenly took a notion to go wandering? He might be gone for weeks or even months, traveling down towards the coast into Lebanon and the Berwicks, or over into New Hampshire to Brookfield, Farmington, Strafford, and other towns. What hope was there for a man who neglected his farm work just because he had an itch to draw pictures? What kind of work was it for a full-grown person to go from farm to farm painting pictures of people on little sheets of paper?

Joe B. and Pine Hill Joe were both Davises, but there was no mistaking one for the other in Newfield, Maine, 115 years ago.

Such is the tradition, now barely alive, handed down through several generations, about a Joseph Davis who liked colors, who was always dabbling with paints, and who was taken at times with an irresistible urge to wander.

Whatever the legend may be about Pine Hill Joseph Davis of Newfield, there does exist today a group of more than one hundred watercolor portraits painted in rural Maine and New Hampshire between 1832 and 1837 by a man who signed himself *Joseph H. Davis Left Hand Painter*. It is with this back-country artist whose works now hang in the Museum of Modern Art, in the New-York Historical Society, at Williamsburg, at the Rhode Island School of Design, and in many private collections, it is with this Joe Davis, the one of fact, not legend, that we have to deal.

Inland from Portsmouth, New Hampshire, some twenty miles and roughly parallel to the coast runs a band of small country towns. In the 1830's, before the railroad came and before the great mill towns along the Merrimac to the south had drained their population into factories, the villages along this belt were thriving farm communities. From Epping in New Hampshire to North Berwick in Maine one passed through villages bearing names such as Lee, Nottingham, Newmarket, Durham, Barrington, Strafford, Deerfield, and Northwood. Still further inland people from Dover and nearby towns had pushed up country into Rochester, Lebanon, Farmington, Milton, Brookfield, and Wakefield. Travel was difficult. Commerce between this region and centers to the south in Massachusetts was limited chiefly to farm and forest products. Most people stayed at home, on farms or in villages, self-sufficient to a degree forgotten now. Local men made the clocks, tables, beds, chairs, and chests that furnished the plain farm homes. Life was simple, hard, and demanding of dawn-to-dusk effort. Still there were moments of relaxation, a husking bee, a barn raising, visits from peddlers who came from the outside world laden with packs of bright cloth, fancy combs, cheap finery, and a refreshing chatter of news and gossip. And occasionally there appeared at the door a traveling portrait painter with samples of his work and a tempting offer to paint a likeness guaranteed to be recognizable.

The desire to have one's features perpetuated is a compelling urge. Before Daguerre contrived his magical technique of using light and chemicals to record a face, the profile cutter did a brisk business snipping silhouettes. For those with a better equipped pocketbook and a more powerful impulse towards immortality the limner with his stock of wooden panels or canvas-covered frames could be commissioned to preserve one's features in oil. That both were popular and well patronized is attested by the huge mass of portraiture, good, bad, and indifferent, that has survived from the pre-photographic era.

Joseph H. Davis, an itinerant portrait artist of this back country region, hit upon a happy compromise between the cheap but detail-lacking profile and the more costly oil painting. From 1832 to 1837, traveling through the towns and farm sections, winter and summer, this local artist made hundreds of portraits using pencil, watercolor, and pen and ink on paper. His work was an extension of the silhouette-cutter's ability to capture a profile. In place of scissors Davis used a pencil and carefully delineated his subject's features. To this profile head was added a body.

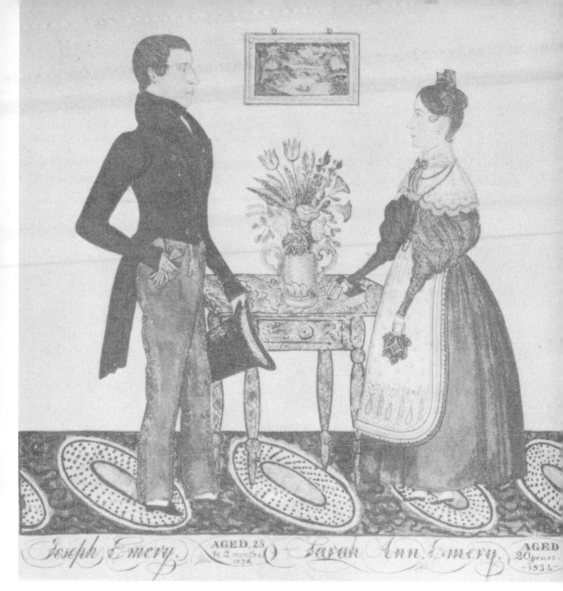

DAVIS, Joseph and Sarah Ann Emery *(1834)*
Jean and Howard Lipman

The figure was placed in a setting with furniture, wall decorations, and a floor covering to make a full-fledged picture, a kind of inexpensive version of a portrait in oils. It had all the features of the oil painting, full-length treatment, background, accessories, everything necessary to a real picture —and it cost only a fraction as much. According to local tradition Davis charged a dollar and a half for a portrait. This figure, compared to the cost of a painting in oil, could be a matter of real importance to a sorely-tempted farmer with little cash in his pocket and a clamoring horde of nine children demanding that their likenesses be made too. One finds few series of portraits in oil that include separate pictures of all members of a family from the newest infant up to the parents. Davis did it and in at least one instance made a family register listing them all as a sort of guide to the portrait gallery.

In arranging his subjects in the design of his picture, Davis developed a set of poses that covered nearly every situation he was likely to meet. A husband and wife, for example, were almost invariably portrayed seated at either end of a table facing each other, the man always at the left, the woman always at the right, their faces in profile, their bodies turned slightly toward the viewer so one may glimpse details of a vest or apron. On the table stands a bouquet of flowers or a basket of fruit, several books, one of which is visibly titled *Holy Bible*, and frequently the man's tall beaver hat. Sometimes the man is holding a newspaper, or there may be on the table before him a manuscript, an open book, a drawing, or some object intended to suggest his interest or occupation. Above the table is a clock or picture draped with a green garland. Often a cat sits beneath the table. While the details of this scene may vary slightly one feature is never absent. Tilted slightly, in defiance of perspective, to insure a full view of its intricate and vividly-colored design, a carpet covers the floor. On his carpets, dazzling in hue and bewildering in detailed geometric design, Davis lavished all the loving care that a counterfeiter bestows upon engraving the plate of a thousand-dollar bill. Once seen a Davis carpet is unmistakable and provides a means of identification as sure as the artist's signature.

Within this composition, vaguely reminiscent of the elaborate "conversation pieces" of English and Continental family group silhouettes, Davis placed minor accessories characteristic of the subjects' interests or activities. Thus the portrait of James Tuttle and his wife has a picture of a sawmill over the table. Investigation into the history of James Tuttle,

100

DAVIS, Bartholomew Van Dame *(1836)*
Martha Hale Shackford

whose portrait was painted at Strafford, New Hampshire, in January 1836, reveals that he was the owner of a local mill purchased a few years earlier. Bartholomew Van Dame, whose portrait is one of the three signed paintings that have come to light, was a schoolmaster, ardent student, and indefatigable writer of diaries. He is shown burning the midnight candle, books piled on his table, with a manuscript journal in each hand. One can be sure that Trueworthy Chamberlin of Brookfield, whose portrait was done in 1835, was in full agreement with the politics of *The National Intelligencer,* the newspaper he is reading, just as one is certain that Thomas York of Lee was a strong Free Will Baptist from the fact that he holds a copy of *The Morning Star,* a religious paper of that denomination published in nearby Dover.

Single figures were treated much more simply by Davis. The usual pose for a child, young woman, or single man was to stand the figure on the ever-present carpet without benefit of wall decorations, furniture, or other accessories. On occasion certain individuals were permitted to sit at a small table, possibly a concession to advanced age as in the case of Hannah Monroe, who was seventy-six when Davis did her portrait, or to the demands of the subject's occupation as in the portrait of Van Dame.

An intriguing feature of Davis's single-figure portraits is that without exception the subjects' faces are presented with their profiles facing to the right of the picture. The one signature in which Davis specified that he was a "Left Hand Painter" explains this consistency. In working on a portrait a left-handed artist must start at the right and move to the left thus keeping his completed work visible, not concealed by his working hand. When Davis was called upon to do a family picture, the profiles, of course, had to face each other across the table. This was a source of difficulty for the country artist. The profile facing left, invariably the woman's profile, would be drawn first, but after the facial outline and features were outlined the artist had then to work on the lady's hairdo and bonnet. His left hand covered the face as he worked on the rest of the head. This was awkward.

In at least one instance the woman's profile proved to be a fatal stumbling block to Davis. On the back of the completed portrait of Trueworthy Chamberlin and his wife is a partly-drawn pencil sketch of Mrs. Chamberlin. It is evident that the artist commenced the portrait by striving to capture a successful profile of the lady. Her features are done in great detail. Also nearly finished is the sketch of her hair and bonnet. The

DAVIS, Henry Laurens Roberts (1831)
Maxim Karolik Private Collection

DAVIS, Esther Tuttle (1835)
New York Historical Society

rest of her figure is only roughly sketched. For some reason the drawing failed to satisfy the artist, or possibly the subject. This beginning was abandoned. Davis turned the sheet of paper over and made a new start, this time succeeding in his effort.

The Chamberlin unfinished sketch reveals another fact about Davis's method. So stereotyped are the poses of his subjects that it is easy to assume that the artist may have prepared a whole portfolio of nearly completed portraits before setting out on his perambulations through the countryside. With everything in the picture except the heads it would have been an easy matter to fill in the blank spaces in a short time. Other itinerants are believed to have employed this method with the result that a number of different ladies appear to have owned the same wardrobe. From the evidence of the Chamberlin drawing, however, it is clear that Davis began each commission with a blank piece of paper before him.

It seems probable that when Davis had persuaded a family to have a series of portraits executed, the artist stayed in the home until they were done, a task that might run on for a number of days. The portrait of James Tuttle and his wife is dated January 25, 1836. The Tuttles were a large family. At least two of the children were painted by Davis. Esther Tuttle's portrait is dated January 18, an indication that the artist was busy in the Tuttle household at least a week.

While every portrait from the hand of Davis bears an unmistakable stamp of the artist's individuality, it connot be assumed that Davis was original in the development of the idea of full-length portraits in watercolor derived from the silhouette. I recently saw two similar watercolors, complete even to an underlying carpet. While clearly not the work of Davis, the composition of each was startling in its likeness to the production of that American artist. These portraits were painted in Scotland at about the same time that Davis was working in rural Maine and New Hampshire! They were brought to this country only fifteen years ago.

Davis's watercolor-on-paper compromise between the cheap but unsatisfactory blank-faced silhouette of the profile-cutter and the more costly oil portrait seems to have been enthusiastically endorsed by the farm and village people of New Hampshire and Maine. That more than a hundred of these fragile creations have survived fires, movings, changing fashions, house cleanings, the advent of photography, leaky roofs, and destructive rodents, small children, and adults suggests that the artist produced many times this number in the few years of his activity. Who can

guess what fraction of his total output the known examples represent? That so many have escaped destruction is not only testimony to his popular appeal down through the years; the pictures themselves remain as the sole source of information about the artist. A thorough search of records so far has revealed no documentary evidence about Joseph H. Davis. Where he was born, where he lived, when and where he died, how he came to take up his work, all these facts are elusive. Only the portraits demonstrate his existence and from these alone can be deduced the barest outline of his career.

While Davis rarely put his own name on his work, in most instances the portraits contain inscriptions identifying the subjects, giving their ages at the time of the sitting, and sometimes stating the place and date of the work itself. From these data, supplemented by information about the individuals derived from Probate Court records, Register of Deeds listings, maps, town records, local histories, and genealogies, it has proved feasible to trace the wanderings of the itinerant artist as he followed his trade.

Starting in Newfield, Maine, where his earliest portraits are dated in 1832, Davis worked down the Maine-New Hampshire border towns, painting rural worthies in Lebanon, North Berwick, and Berwick in 1833 and 1834. In 1835 he was active in Brookfield, New Hampshire, moving gradually into Farmington, Strafford, and Barrington by 1836. These, on the basis of the number of portraits surviving from this period, seem to have been his most productive years. From Barrington, Davis ventured along the roads of Northwood, Nottingham, and Deerfield, striking at least once into Candia. In 1837 the artist was knocking at farmhouse doors in Lee, Epping, Newmarket, and Durham. One portrait was painted in Atkinson close to Haverhill, Massachusetts. Then without explanation there are no more pictures. 1837 is the final date. After that, nothing. The work stops. The least complicated assumption is that after five years of traveling through more than twenty villages, death overtook the wayfarer on some country road.

This then is the incomplete story of "Joseph H. Davis Left Hand Painter" who for the few years between 1832 and 1837 painted watercolor silhouette portraits of farm people in the back country districts of southern Maine and eastern New Hampshire—only this, and the Newfield legend of Pine Hill Joe.

FRANK O. SPINNEY

Thomas Chambers

I~N~ November 1942, a small but potentially important exhibition of
landscape painting was held at the Macbeth Gallery in New York City.
This brought together for the first time the work of one artist whose bold
use of color and design distinguished his pictures from those of his mid-
nineteenth-century contemporaries. Through signatures on a few canvases
his name has been identified as T. Chambers, but no further information
about him has been available despite careful search in certain towns of
New York State where it is thought that he may have lived. Since that
exhibition additional pictures attributable to him have come to light so
that now between forty and fifty are known, forming one of the most in-
teresting and colorful groups in American nineteenth-century art.

Chambers painted landscapes (many of them along the Hudson
River), harbor views, and marines. All are characterized by a brilliance of
palette which renders them recognizable, although he undoubtedly had
followers whose style resembled his to a considerable degree. In his land-
scapes he was fond of vigorous repetition of masses. Cliffs, hills, and mul-
tiple rock formations combine to produce sweeping and rhythmic compo-
sitions. He specialized in bold cloud effects heightened by the use of orange
and yellow in the background, and both figures and foliage follow similar
patterns throughout his work. One feels that these stylized pictures were
intended to be decorative, rather than literal, representations of the scenes
which they portrayed.

Many interesting conjectures have been made concerning Chambers
and his work. Because of the strength and daring of his colors it has been
suggested that he might have been a Negro. Another theory holds that he
was a European who did his painting abroad for the American market. A
third contends that he worked entirely in his studio copying his subjects

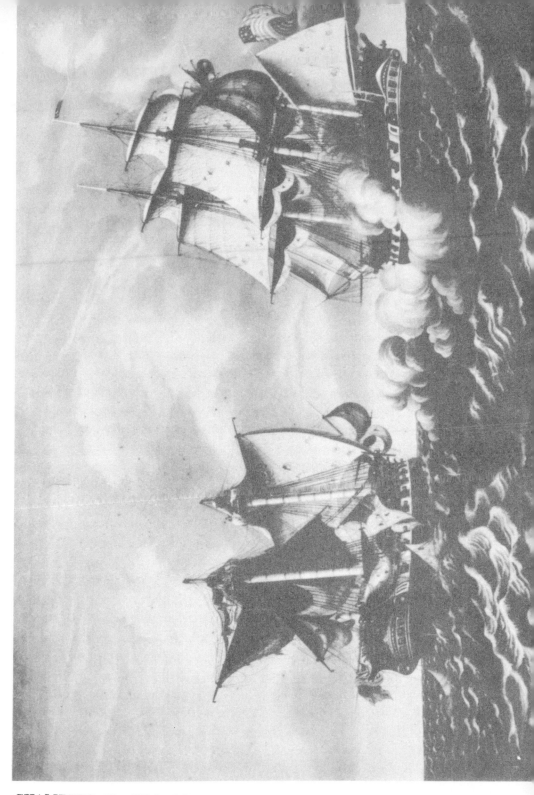

CHAMBERS, The "United States" and the "Macedonian" (1852)
Harry Shaw Newman Gallery

from those used in contemporary prints and engravings. It is true that some of his compositions were not original, but many are known for which there appears to be no printed source. From lack of documentary evidence of his existence in the neighborhood of Newburgh and Kingston, there has arisen the most challenging supposition—that the name T. Chambers cannot be proved to have belonged to any actual individual who was living, or painting, in the vicinity of the Hudson River during the period to which these pictures belong.

It can now be stated, however, that T. Chambers was not a myth, nor was he a foreigner who never visited our shores. If he did not paint from nature it was not for lack of opportunity, as he lived at one time adjacent both to the Hudson and to New York Bay where so many of his scenes were laid. Recent research has determined the localities where he worked for sixteen years, the types of painting in which he specialized, the media which he employed, and the fact that he was not a Negro.

Whether Thomas Chambers was already earning his living as a painter before he came to New York City we do not know, but in 1834 *Longworth's Almanac* lists him as "landscape painter," living at 80 Anthony Street. The following year, according to the city directories, he moved to 330 Broadway, but returned in 1836 to Anthony Street. In 1837 he was still specializing in the landscapes with which his name has been generally associated, having moved again, this time to 213 Greene Street. In 1838, however, he apparently decided to try a new line of artistic endeavor, for he changed his professional designation to "marine painter." As such he continued during 1839 and 1840, while occupying a dwelling on Vesey Street, one end of which overlooked the Bay.

The earliest signed and dated picture by Thomas Chambers that has been recorded is a view of the recapture from the Spaniards of the British frigate *Hermione* by the boats of H. M. S. *Surprise* at Puerto Cabello, Venezuela, in 1799. The details of this painting are unquestionably derived from contemporary prints, as is evidenced by a colored aquatint of 1799 after R. Dodd which depicts the same subject, although Chambers' version differs in composition. It is inscribed on the back, presumably by the artist, with the title and description of the subject and the words *Painted by T. Chambers 1835.*

Several other seascapes and harbor scenes by Chambers, some of them executed at a later time, are known today and prove that he had a practical knowledge of ships and the sea. His painting of the engagement be-

CHAMBERS, River Scene *(c. 1835)*
Mr. and Mrs. Thomas A. Larremore;
Frick Art Reference Library Photograph

tween the *United States* and the *Macedonian* is signed on the face *T. Chambers, 1852*. The battle of the *Constitution* and *Guerrière*, also signed, was shown in the exhibition of 1942. In one of his views of New York Bay we see the northerly side of Castle Garden with Castle William in the distance. In another, a pilot boat is anchored beside the old fort on Bedloe's Island. In the background a tall ship coming through the Narrows under full sail serves to illustrate, by its lack of proportion to the rest of the picture, this artist's usual willingness to subordinate exact representation to a desired decorative effect.

Thomas Chambers appears not to have been a member either of the National Academy or of the Apollo Association, but a William Chambers who termed himself "artist" and "portrait painter" showed watercolor copies of European masters at an exhibition of the latter in 1839. He lived in New York for approximately the same period as Thomas, and it is conceivable that they were brothers.

In 1841, after seven years' residence in Manhattan, Thomas Chambers' name disappears completely from the New York directories, and we would be at a loss to trace his further whereabouts were it not for an unusually fortunate clue which appears on the back of the canvas of his *Villa on the Hudson, near Weehawken*. This is in the form of an old inscription which reads *By Wm. M. Prior, 1849*. Prior was a portrait and landscape painter who worked in Boston between 1840 and 1873. Since this picture is obviously in the style of Chambers rather than of Prior and the signature is not in the latter's handwriting, it appeared that the work of the two men had originally been confused because they lived near one another. This led to an examination of the city directories which provided ample proof that Chambers took up his residence in Boston in 1843, where he was *not* included under the heading "People of Color." The absence of his name from the Registry of Deeds indicates that he rented his house at 21 Brighton Street, which overlooked the lower end of the Charles River. There he remained for the following nine years. During this time he dropped the designations of "landscape painter" and "marine painter" and used only the general title of "artist." Apparently, however, he continued to paint in his former manner, as a handsome representation of the *Constitution* and other ships in New York Bay is signed and dated 1847, a year which falls within his New England period. Only one picture known to me has been identified as a Boston view, a harbor scene which is illustrated in *American Pioneer Arts and Artists* by Carl W. Drepperd.

110

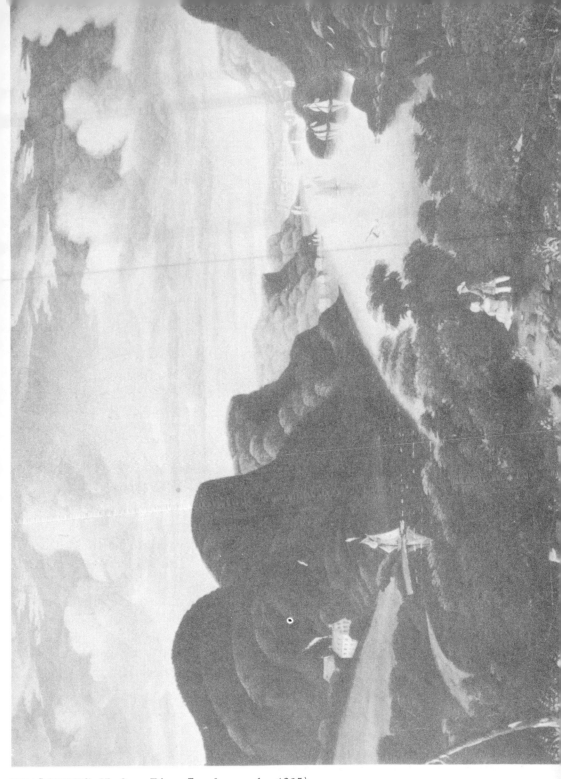

CHAMBERS, Hudson River Landscape *(c. 1835)*
Mrs. Max Seltzer

The first Chambers pictures to be recognized were all compositions in oil on canvas. His *Cutting Out of H. M. S. Hermione*, however, is in oil on a wood panel. An interesting sketch has been found which indicates that he worked also in pencil and watercolor. It is a signed wash drawing, its subject, unlike his others, being a landscape which is neither a battle nor a harbor scene. In the collection of Mr. and Mrs. Thomas A. Larremore is a watercolor of a river scene. Though unsigned, it is undoubtedly of the Chambers school, and, if not by the artist himself, clearly shows contemporary influence. In it are incorporated several of his familiar stylistic elements, but the total effect is not as strong in design as we have come to expect from his known work in oils.

A search through the genealogical records of the Chambers family which came to America from Yorkshire, England, and of others of the name who settled in Virginia, Connecticut, and elsewhere in New England, has failed to reveal specific reference to the artist. No Thomas Chambers with comparable dates has been located, with the exception of the great-great-grandson of Colonel Benjamin Chambers who came from County Antrim, Ireland, in the early years of the eighteenth century. This man was born in Chambersburg, Pennsylvania, on May 14, 1798, migrated to California at some unspecified date, and died there unmarried in 1885. There is no proof that he and our Thomas were the same, although a departure for the West might well explain the apparent disappearance of the latter during the 1850's.

His name is not listed in the exhibition catalogues of the Boston Athenaeum, and after 1851 it again disappears from the city directories. Examination of the Probate Records indicates that he did not die in Boston and this evidence is corroborated by two pictures which are dated 1852 and 1853. The discovery of his next location, whether in another New England town or California-bound on a fast clipper, must await further study.

NINA FLETCHER LITTLE

Joseph Whiting Stock

I<small>N</small> 1932, two exhibitions devoted to American folk art were held in New York, the first arranged by the Downtown Gallery, the second by the Museum of Modern Art. Both included paintings by Joseph Whiting Stock *(1815-1855)*. He received special mention from the critics, though at the time little was known about this artist, and few of his works had been identified.

An article in the Springfield, Massachusetts, *Union and Republican* for January 3, 1932, did something to establish Stock in a framework of reliable history, identifying him as "an obscure but gifted artist who lived and worked here in the first half of the nineteenth century." In the introductory note prepared by Holger Cahill for the catalogue of the Museum of Modern Art exhibition, certain data drawn from old Springfield records were thus summarized:

Joseph Stock was born and lived his forty years of life in Springfield, Massachusetts. He was a cripple, and had to get about in a wheel chair. It appears that he was self-taught. Very little else is known about him.

The "very little else" refers to certain advertisements that appeared in local newspapers of 1846 and 1849, and in the directory of 1852. Since 1932, however, the artist's personal diary has come to light. Happily its sequence of entries is preceded by an autobiographical introduction in which the author acquaints us with the chief circumstances and events of his life, from his birth in Springfield, Massachusetts, January 30, 1815, until the age of twenty-seven, when he found himself in New Bedford and conceived the "intention, henceforth, to keep a brief journal of my life and business."

John Stock, Joseph's father, was born in 1789. In 1809 he married Martha Whiting of East Bridgewater. Apparently the family had come to Springfield only a year or two before Joseph's birth. John Stock was employed at the United States Armory; but his position must have been of minor importance, for he was always poor. His financial status was not improved by the fact that between 1810 and 1835 his wife generously presented him with thirteen children. Of these, Joseph Whiting Stock was the fourth. In his diary he dismisses his family by saying, "My parents were poor, married early, and have had a large family to support, but have ever maintained a respectable standing in society by their honest and industrious habits."

Stock's youth as he describes it was apparently no different from that of any other boy. He attended the common schools and was an active and healthy youngster. Just after his eleventh birthday—April 9, 1826, to be exact—he suffered an injury that changed the entire course of his existence. I can do no better than to quote his own account of the accident, whose tragedy is but accentuated by the simplicity with which it is described.

"My brother Isaac, Philos B. Tyler and myself were standing near the body of an ox-cart which leaned nearly upright against the barn, very intently engaged in conversation when suddenly I perceived it falling, which, instead of endeavoring to avoid, I attempted to push back, and was crushed under it. The boys, unaided, lifted the cart and drew me from under it. I experienced no pain at the time, and no other sensation than a heaviness and prickling numbness in my legs, which were powerless and led me to exclaim that they were broken. My mother was soon called, (my father was gone to meeting) who carried me into the house where all the medical men in town were soon gathered.

Stock continues with a somewhat technical exposition of the extent and nature of his injury. His nervous system from the hips down had been destroyed. Thereafter he was never able to walk, and it was many years before a chair could be constructed that would permit him to sit upright.

His diary as preserved was probably begun in 1842, during a stay in New Bedford. The calf-bound volume in which it is written was purchased in that town. Following the first entry composed in New Bedford, November 14, the record continues with fair regularity during the three succeeding years. To its introduction we owe our knowledge of the cripple's strug-

STOCK, Luther Stock *(1833)*
 Lucy Stock Chapin

gle to find some means of livelihood possible to a virtually bedridden person.

His physician, Doctor Loring, wisely directed him to the field of painting, and in 1832 he began to study art. Regular lessons were out of the question, but Francis White, a young pupil of Chester Harding, called frequently and showed the paralyzed lad how to prepare colors and lay them on canvas. Again I quote from the diary:

I followed this course some months, when I attempted my sister Eliza's portrait, and made so good a likeness as to induce my friends to encourage me by their patronage.

During the next two years young Stock turned out fifty-one paintings, of which more than half were copies. He seemed to enjoy depicting such famous figures as Napoleon and Josephine, John Randolph, Andrew Jackson, Sir Walter Scott. Many of the subjects that he records are accompanied by the words "fancy piece." From the year 1833 come two paintings, *Luther Stock, my brother,* and *Lucy Stock his wife.* Luther was born in 1811. Lucy, two years older, had been, prior to her marriage, Lucy Gould of Springfield. The likenesses of this couple were accomplished when Stock was only nineteen, and, though he was still bedridden, are amazingly well handled.

The dramatic situation of the young artist, the helpful zeal of friends, and his low scale of prices all conspired to bring him a moderate success. In 1836 he began a series of anatomical drawings for a Dr. Swan. This work increased his earnings throughout his life. He was indebted to Dr. Swan on yet another account, for it was this ingenious physician who eventually devised a movable chair which gave Joseph Stock his freedom. By 1836 the invalid's health had so improved that, for the first time in ten years, he left his father's house, and visited North Wilbraham to try his fortune at portrait painting. This was the first of many trips to neighboring towns—trips which eventually took him as far afield as New Haven and Providence. During 1836, he produced one hundred and forty-three portraits. His usual charge for a likeness was eight dollars; but often he bartered his talents for food, lodging, clothing, or much-needed materials.

For some years the retrospective entries in his diary are little more than brief, prosaic records of his expeditions and their pictorial fruits. Then in 1839 he suffered a second serious misadventure. Again very simply he confides to his diary the story of this shocking experience:

On the evening of the first of January, 1839, I was preparing some mastic varnish and was in the act of turning it off hot, when it took fire from the light and contacted my dress, and I was soon involved in the flames. It was soon extinguished but my hands, face and neck were badly burned, so that at the time my physician thought me in considerable danger.

Stock was barely recovering from the burns when his hip bone became seriously infected and he had to have a major operation. For six months he could not paint at all, and for the rest of that year he accomplished little. However, on November 1, 1841, in response to "a letter from A. B. L. Meyers, offering flattering prospect of business in his place of residence, Warren, R. I.," the indomitable man set forth and two days later arrived in Warren. For a year thereafter he alternated his residence between Warren and Bristol, and eventually, November 14, 1842, moved to New Bedford. Although in his diary he comments more than once on the industrial depression, on the slump in cotton manufacturing, and on the inactivity of shipping, he lists over two hundred portraits. Not all of these were in oils, for about this time he begins to note orders placed in Boston for ivories and other materials for miniatures. His New Bedford sojourn unquestionably marked the high point of his career. In 1844, he returned to Springfield, where he occupied rooms on Main Street in company with a daguerreotype artist, O. H. Cooley. This partnership was frequently dissolved and as frequently re-established. This city directory of 1846 carries the following advertisement:

STOCK AND COOLEY

Portrait and Daguerrean Gallery, opposite Chicopee Bank, Main Street, where the public are respectfully invited to call and examine their specimens of painting and superb colored daguerreotype. Likenesses taken in a superior manner on large or small size plates, and in groups from two to seven persons. A perfect and satisfactory likeness guaranteed. Likenesses taken of deceased persons. Instructions carefully given, and pupils furnished with everything necessary for the business at prices varying from $.75 to $1.50. Photographs put up in breastpins, lockets, cases, frames, from $8 to $25.

TO DAGUERREOTYPE OPERATORS:

German cameras, lockets, plates, cases, chemicals, polishing materials and all articles used in the business furnished to order.

The last entry in Joseph Stock's diary is dated August 4, 1845. By this time the list of his portraits had reached the amazing total of 912. Thereafter we may follow the artist's career only in such public records as the quoted advertisement; a directory reference indicating that Stock had his own studio on East State Street; another advertisement, of 1849, when he was located in the Foot block; and finally another directory listing of 1852. It is probable that the valiant cripple's health, such as it was, began to fail about 1850. His entire family had been susceptible to tuberculosis, and it was to this disease that Joseph Stock succumbed, June 28, 1855.

His self-portrait, still extant, shows him in his early thirties. It is remarkably well-painted. If we accept this likeness as a factual delineation, we must conclude that the man was by nature highly romantic—a truly sensitive and creative person. On the other hand, in this personal revelation Stock may well have tried to suggest something of the inner flame that had enabled him to surmount poverty and tragic physical impairment, and therewithal to gain not only a living by his own effort, but a reputation for his artistic capabilities. He lived in a sentimental era and may have considered it necessary to represent himself in the unmistakable guise of genius.

His diary conveys a distinct impression of reticence and objectivity concerning himself and his affairs. Only one entry in the volume even hints of self-dramatization, and so trite a line is it that it may almost be discounted:

This day completes 28 years of my life. It is a long period to contemplate, yet brief in remembrance are the revolutions of time. It seems but as yesterday when I was a boy and roamed the fields as free and gay as a lark or anything. Within that period is embraced much of suffering and affliction, much of sorrow and pain, not unmingled, however, with much of joy and happiness.

Though he never mentions the reading of books, he must have been interested in literature. Of this the style of his diary affords evidence. And from the literary figures whom he liked to portray—Sir Walter Scott, Byron, and the English romantics—we may surmise where he found vicarious adventure, high fellowship with heroes, and, perhaps, the anguish and uplift of great love.

In appraising Stock's actual accomplishment as a painter we must at once admit that he produced "good likenesses." Like those of many other painters of his day, his portraits are flat and their color is generally

STOCK, Jane Henrietta Russell (1844)
Maxim Karolik Private Collection

STOCK, The Fisherman With His Dog (c. 1850)
Springfield Museum of Fine Arts

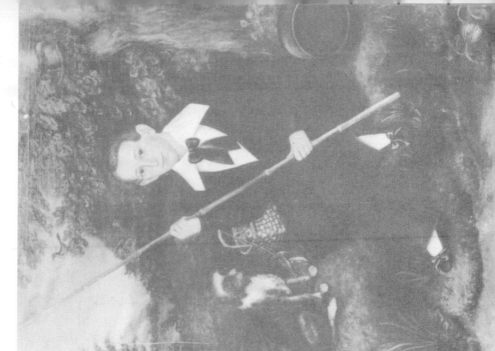

poor. We observe a constant straining for realistic appearances. Where his draftsmanship is inadequate, stiffness invades the work. Although Stock's color is poor, it may be truthfully said that he was never afraid to use it. More often than not, he introduced raw, brilliant hues into his compositions. His lack of training is more apparent in this respect than in almost any other. Yet his later portraits clearly indicate that he gradually taught himself better methods of handling color.

Another characteristic that places him in a slightly different category from the general run of limners is his fearlessness in attempting new compositions. He never adopted a stereotyped pose or style, but tried everything from portrait heads to full-length figures, and experimented with various attitudes of his subjects. Though his favorite size of canvas measured 25 by 30 inches, his diary lists an amazing variety of dimensions, ranging from 8 by 10 inches to 40 by 50 inches.

The same diary records a number of landscapes, both copies and originals. When in the coast towns, the artist even tried marines, introducing famous whaling vessels and clipper ships. None of these works have thus far come to light, and the landscape backgrounds of his portraits give us no idea of his abilities in this direction. Nevertheless, that he tried his hand in so many ways signifies that his interests were broad and diversified.

As the number of Joseph Stock's authenticated pictures increases and as his extraordinary career becomes more widely known, the artist is finding his rightful place among the more significant members of the once-lost battalion of American primitive painters.

JOHN LEE CLARKE, JR.

120

James and John Bard

ALTHOUGH the graceful sailing vessel and the mighty ocean liner have been more attractive subjects for most marine artists, the less imposing river steamboat and lowly towboat have not been entirely neglected. Posterity can pay tribute to James and John Bard of New York, modest, self-taught artists whose quiet lives were devoted to portraying these lesser craft.

Like other primitive artists, the Bard brothers made no pretense at competition with their more academic contemporaries. Their self-appointed task was to depict a given vessel as faithfully as possible. Had their inability to place these vessels in realistic surroundings embarrassed them, they might have accomplished far less. As it is they have left behind an enviable record as American primitive artists and, since their pictures describe better than words the steamboats of their day, they deserve perhaps even greater credit as marine historians.

Yet when James Bard died, only a marine journal noted the fact. An obituary published in the April 1, 1897, issue of *Seaboard* magazine gives the only biographical notes we have of him and his twin brother:

"Mr. James Bard, the last of New York's oldtime marine artists, died at his home in White Plains, N. Y., on Friday last, March 26, in his 82nd year. He survived his wife but a short time, she having passed away on January 5 of this year. Mr. Bard was born in 1815, in a little house overlooking the Hudson, in what was then the suburban village of Chelsea; his early home stood on the land which is now bounded by 20th and 21st streets, and 9th and 10th avenues, New York City. His twin brother, John, died in 1856. Mr. Bard leaves a daughter, Ellen, to mourn his loss, she being the youngest and only surviving. member of six children. Mr. Bard made his first painting in 1827, finishing in that year a picture of the *Bellona*, the first steamboat owned by Commodore Vanderbilt, with

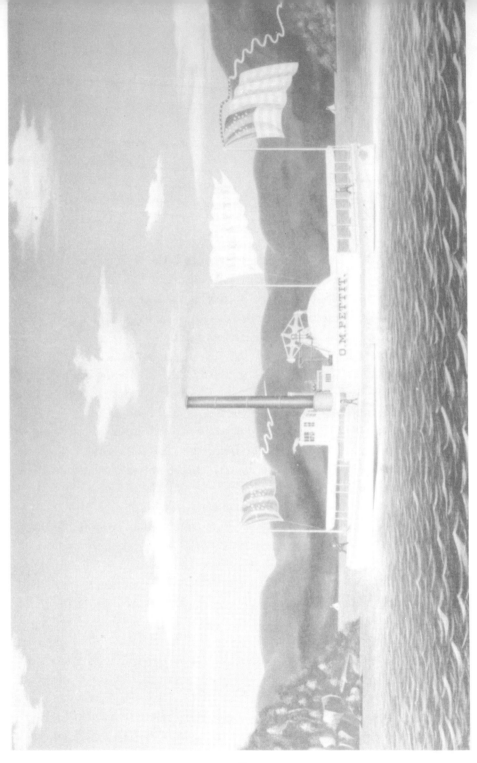

BARD, Tugboat "O. M. Pettit" *(1857)*
New York Historical Society

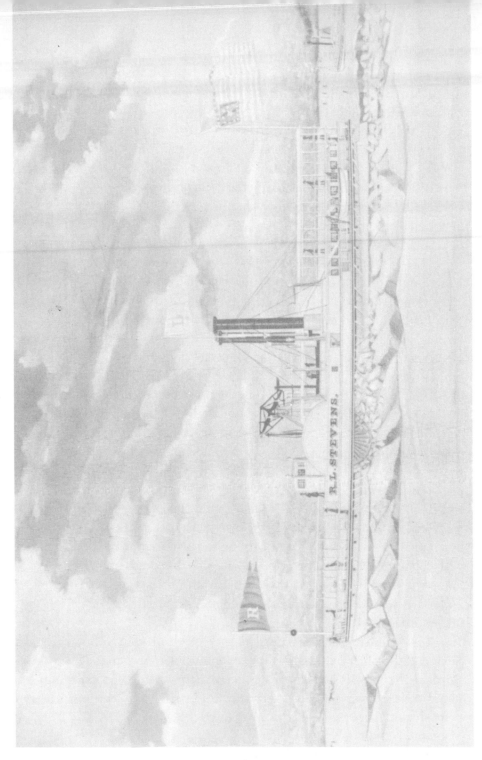

BARD, Hudson River Day Line Sidewheel Passenger Steamboat
"Robert L. Stevens" Breaking Ice in the Hudson River *(c. 1845)*
The Mariners' Museum, Newport News, Virginia

whom he was well acquainted. From 1827 to within a few years of his death Mr. Bard made drawings of almost every steamer that was built at or owned around the port of New York, the total number of these productions being about 4,000. Probably Mr. Bard was without a parallel in the faithfulness of delineation in his drawings of vessels. His methods of work, the minuteness of detail, and the absolute truthfulness of every part of a steamboat which characterized his productions, cannot but cause wonder in these days of rapid work. His pictures were always side views, and this often made faulty perspective, yet a Bard picture will ever be held in esteem for its correctness and the beauty of drawing.

"Living during the time of the days when shipbuilding at this port was the greatest of any in the country, and when myriads of beautiful river, sound and ocean craft were turned out every month, Mr. Bard with his talent, had opportunities of becoming acquainted with all of the leading shipbuilders and vessel owners in the days before the [Civil] war. He knew them all, and was held in high regard by them, and shipbuilders have said that they could lay down the plans of a boat from one of his pictures, so correct were they in their proportions. Before making his drawing, Mr. Bard would measure the boat to be pictured from end to end, and not a panel, stanchion or other part of the vessel, distinguishable from the outside, was omitted; each portion was measured and drawn to a scale.

"His life work is finished, and the world is richer for it. Were it not for the pictures to be found here and there—and now fast disappearing— we would not know what beautiful specimens of steam vessel architecture our forefathers were capable of turning out. No one in his time compared with James Bard in the matter of making drawings of vessels, and his name will ever be associated with the lists of artists of this country who make a specialty of painting pictures of vessels. In the art he was the father of them all."

This tribute to James Bard is indicative of contemporary esteem. Such enthusiasm would naturally wane, however, and the memory of the Bards perhaps be lost but for the fact that many of their paintings have found their way into various museums and private collections. The most extensive of these is the Elwin M. Eldredge Collection in The Mariners' Museum, Newport News, Virginia.

Some three hundred Bard pictures are recorded in the check list compiled by Alexander Crosby Brown and published in *Art in America*

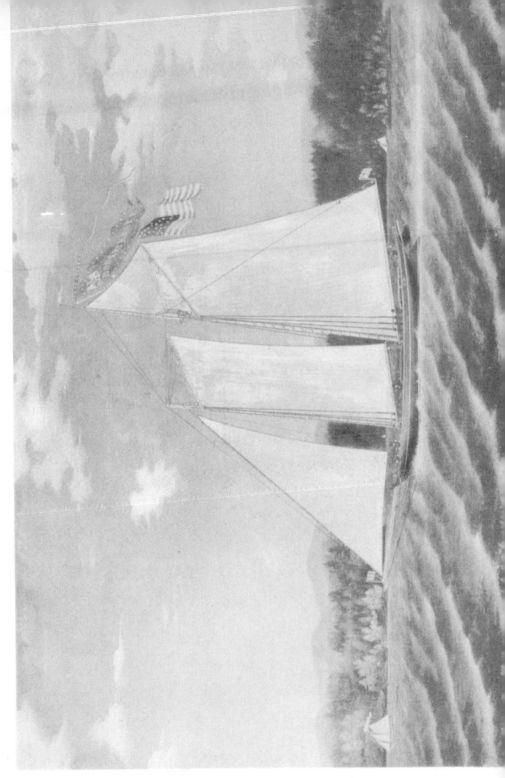

BARD, Hudson River Schooner "Robert Knapp" *(1854)*
The Mariners' Museum

in 1949. It seems difficult, therefore, to give credence to the statement that Bard paintings and drawings numbered as many as four thousand, even though the mortality of Bard works has been high.

Unfortunately the drawing of the *Bellona*, mentioned as being the first (1826) Bard picture, apparently has been lost. The earliest which has been preserved is the watercolor drawing in The Mariners' Museum of the little steamboat *Fanny*. Though undated, this picture must have been made before 1831 when this vessel departed from New York waters; the Bards were then aged sixteen.

The early works were usually signed *J. & J. Bard*. Over two dozen of the known paintings were done by the two brothers, the latest one being of the steamboat *Wilson G. Hunt*, dated 1849. A few of the pictures signed *J. Bard, Painters* also suggest their working together. John Bard's share of the output was, however, of small volume and consequence compared to that of his brother who survived him forty-one years.

In signing most of his work, James Bard usually included his complete address as well, a practical note obviously designed to bring more clients to his door. This serves to inform us that in 1851 and 1852 James Bard was living at 688 Washington Street, and, after 1854, at 162 Perry Street, both in lower Manhattan, appropriately near the downtown docks along the Hudson River. His birthplace at Chelsea and his home at White Plains, as noted in the obituary, are the only other indications of his residence.

Bard's pictures of vessels bear so much resemblance to mechanical drawings that it has been conjectured that he might have been a shipyard draftsman or copied draftsmen's work. We know that he frequented the shipyards which constructed the vessels he painted. The dates of many of his paintings coincide with the dates of building of the vessels and in one case he made a drawing of the *Jacob H. Vanderbilt*, the name of which was changed to *General Sedgwick* before the vessel was completed. However, no evidence has been found to show that he was actually employed by the yards as a draftsman, and there are reasons to question the theory that his work was copied.

We know that Bard actually took measurements from the hull of the steamboat *City of Troy* for his drawing of it. The originality of his work is further indicated by its complete lack of standardization of scale. In fact, it is evident that he used no constant scale at all, but rather made one up for each drawing. He seems to have begun with a sketch

of the ship's hull up to the main deck, choosing whatever length suited his paper, his fancy, or his client's specifications. Then he divided the length of the main deck into equal sections, based on the actual length of the vessel. Thus, if it should measure 180 feet long, he divided his drawing into eighteen equal sections. Marks along the guards to indicate this practice may be seen in many of his drawings. One of these ten-foot sections (usually the third or fourth from the bow) was divided into ten equal spaces to give an even foot measurement and in a few instances he divided his scale into one-half-foot lengths. That Bard did not copy plans seems to be further indicated by the many scratch notes which appear on his unfinished drawings. The following illustrative notes are quoted from his drawing of the double-ended steam ferry *Southfield* (1882-1912):

Smoke pipe 26 ft. long 3½ Sections . . . the windows are 3 ft. 9 inches long 3 lights in them . . . skylight is only 20 inches from Center Back of the Pilate House . . . Brass rail is 4 ft. 6 in. above round skylight deck . . .

This is indicative of James Bard's meticulousness. Since it was his particular aim to produce an absolutely correct drawing, he hastened to promise correction when a mistake was discovered in any of his preliminary studies. For example, on the drawing of the ferry *Jay Gould*, built in 1868, he wrote:

This side house is short by 6 ft. as the Extra Window is not made which is 16th one . . . There is 6 ft. more room wanting for the name place or 6 ft. more distance between the windows where the name is . . . The smoke pipe is not in the right place as it is 24 ft. from its Center to the Center of Beam Frame . . . the other parts of the draft of Cabin stair House is right and so is the Steam Pipe and wistle also right yet I will show the pipe so as to draft on the Canvasses.

The word "canvasses," of course, refers to the oil paintings he contemplated as the finished product. Having carefully worked up his drawing on paper, he probably submitted it to his client for corrections and approval, upon the receipt of which he proceeded with the painting of the final work. The proud builders, captains, and owners of the vessels Bard painted were his principal clients: the Crarys, Collyers, Allisons, and many others. In some cases the client had his own name painted on the canvas.

Apparently Bard did his coloring in the studio and not from life, for his drawings also include copious color notes arrowed in at various points. Sometimes, however, he would write a separate paragraph for his own guidance such as the following, quoted in part from the drawing of the towboat *Eliza Hancox:*

The bits are green. The deck rail is flesh couler, the Fender or guard is Indian red. Blinds in Pilate House yellow. Whell [wheel] tops yellow, upper deck yellow. Working Beam is oak . . .

Generally Bard's finished work was in oils on canvas, although not infrequently he would merely color the preliminary drawing itself with watercolor or tempera. There are also extant drawings which have been shaded faintly with crayon. Many of his drawings have been mounted on canvas, perhaps by him, perhaps by later owners.

As was the custom in advertising prints, but rarely encountered in paintings, Bard often gave explicit particulars regarding the manufacturers and builders of the vessels he depicted. Steamboat owners of the mid-nineteenth century and later were responsible for a large volume of advertising prints, of which the greater number were after paintings by Charles R. Parsons, lithographed by Endicott and Company. To the best of our knowledge, only two Bard drawings ever served as the basis of advertising prints. One of these lithographs was issued by F. Palmer & Company and depicts the short-lived Hudson River steamboat *Reindeer,* built in 1850 and destroyed two years later. The other lithograph, published by H. R. Robinson, New York, depicts the Gulf of Mexico steamboat *California,* built in 1847. It seems likely also that the lithographs of Brooklyn ferry steamers, first reproduced in *Valentine's Manual* for 1859, were made from the J. & J. Bard paintings now in the Long Island Historical Society. In all these examples, a more sophisticated artist has painted the background and otherwise eliminated the typical "hall marks" of Bard's work.

The characteristics of a James Bard painting are so definite that little skill would be required to recognize an unsigned example. An avoidance of any but the simplest perspective is typical. Never did he attempt a bow or quarter view of a vessel, always picturing the craft from the broadside and, except in some of the earlier works done in collaboration with his brother, almost invariably the port side. Thus his boats steam from right to left and apparently at full speed. None show

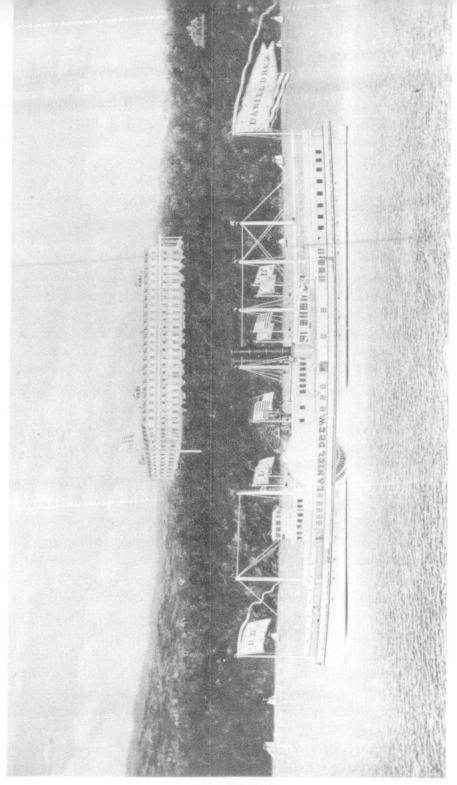

BARD, Hudson River Steamboat "Daniel Drew,"
Prospect House in Background *(c. 1862)*
Owner unknown; from a negative owned by Elwin M. Eldredge

at anchor or alongside a wharf. In the case of side-wheel vessels, his most common subjects, his point of perspective was usually taken from slightly forward of the paddlebox. Anything in the ship's construction which called for perspective drawing was apparently difficult for him to handle convincingly. When steering wheels show through pilot-house windows, they generally appear as though mounted fore and aft instead of athwart-ships!

But the most noticeable and perhaps the most charming Bard "hall mark" consists of a unique stippling of the water at the ship's bow. For a considerable area ahead of his vessels, the water seems to bubble like soda water. The same effervescent treatment is seen in the backwash of the paddle wheel and in the ship's wake. In some paintings depicting a rougher sea, the same style is used in handling breaking waves, although generally Bard steamboats sail placid waters.

The backgrounds usually represent river scenes, as might be expected since so many of the subjects are Hudson River craft. A typical Bard vessel stands out in vivid white, silhouetted against crude river shores. The masses of ill-defined trees and lofty hills are dotted occasionally with many two-dimensional houses appearing as if cut out and carelessly pinned in place. Nearly all are of the same size regardless of distance. Against these neutral backgrounds Bard's splendid boats stand out in contrast, creating remarkably decorative design.

There are, of course, exceptions to the general rule, such as an early J. & J. Bard painting of the steamboat *Robert L. Stevens.* Instead of placidly steaming through calm waters, she is depicted as if crashing through thick ice, her frail paddle wheels effortlessly breaking rock-like chunks of ice into small bits. In another instance Bard departs from the incidentalism of his backgrounds. The painting of the *Daniel Drew* shows Prospect House in the Catskill Mountains, prominently and in great detail. Here the artist's lack of realistic perspective is evident.

Nearly all Bard paintings portray but a single vessel. Two, however, depict two vessels with almost equal prominence, the *Catherine* and *Rattler,* and the *Hero* and *North America.* Named steamers are often included in the background of Bard pictures, drawn with studied care. The monotony of nearly every Bard background is broken by tiny white sails of small craft. In five known instances he ventured into the field of sailing-vessel portraiture, modestly confining himself to the lesser sailing craft of the Hudson River.

One of the outstanding primitive characteristics of Bard's work is in his handling of the human figure. Odd characters man and travel on his vessels. Whether deck hands or passengers, they almost invariably wear high silk hats and long black frock coats. Occasionally one chances to be normally proportioned, but the majority are grotesque caricatures of men with long bodies and short legs, and some, especially when uninhibited by a deck above, are extraordinarily tall. Nearly all of them seem uncomfortable and decidedly out of place on shipboard. Of female figures there are very few. Bard's later paintings and drawings show but few people, often only the man at the wheel. In some instances, the vessel proceeds up the river completely unattended. And then there is the *Jay Gould,* a double-ended ferryboat, undecided as to which way to go, with a quartermaster at each wheel, one in a top hat, the other in a derby!

The two last known works of James Bard, both painted in 1890, depict with the same skill of his earlier works virtually identical portraits of the steamer *Saugerties.* With pardonable pride and charming simplicity the old gentleman signs one of these paintings, "J. Bard, N. Y. 1890. 75 years."

HAROLD S. SNIFFEN

Joseph H. Hidley

Joseph Hidley *(1830-1872)* lived in Poestenkill, a picturesque town near Troy, New York, and painted in that vicinity a series of unique scenes of New York villages. These town scapes, of which less than a dozen have been identified, are among the most remarkable achievements of nineteenth-century American folk art. They are vivid geographical documents as well, for the views of these New York towns, evidently painted between 1848 and about 1870, are accurate pictorial records, with each building neatly drawn and fields carefully mapped out. The life of the town is suggested in each scene through animated bits of genre—grazing cows, horses and buggies, wagon loads of wood, fishermen, villagers in the streets.

In the view of *Poestenkill in Winter* one-horse sleighs are moving briskly down side streets. A horse-drawn wagon on runners is pulled up in front of the hotel and another is seen going down the road. Another horse, unharnessed, is tethered in front of what appears to be a shop in the foreground, while, nearby, two wagons retaining their wheels are stuck in the snow. A man at the left is rolling a wagon wheel toward the side of his house and wheels lean up against this house and the shop just mentioned. Apparently a heavy snow has just fallen, requiring a change to runners. In the companion view, *Poestenkill in Summer*, the same wagons, now on wheels, are seen again, this time carrying loads of hay and wood. The men are in shirt sleeves instead of topcoats and cows graze behind the houses.

Although the buildings are emphasized in all the views, each picture reflects the life of the town and, we must assume, the life of the painter. The *View of Fort Plain* especially concentrates on architectural aspects, yet here also genre motives have been introduced—a locomotive puffing along at the extreme left in the foreground; a strolling couple and a wagon

HIDLEY, Poestenkill, New York; Winter *(c. 1850)*
J. Stuart Halladay and Herrel George Thomas

HIDLEY, Poestenkill, New York, Summer *(c. 1850)*
J. Stuart Halladay and Herrel George Thomas

HIDLEY, Glass House Lake *(c. 1850)*
J. Stuart Halladay and Herrel George Thomas

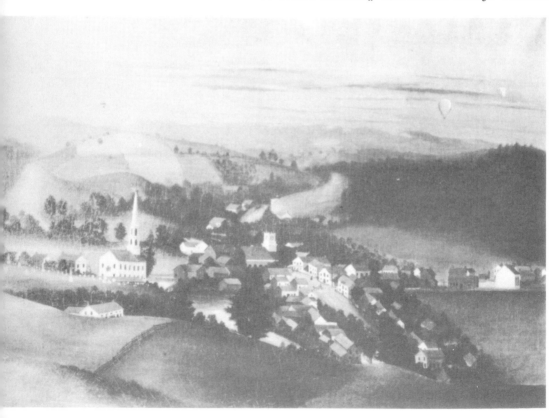

HIDLEY, West Sand Lake *(c. 1860)*
J. Stuart Halladay and Herrel George Thomas

hauling wood in the center foreground; a horse and surrey and a bevy of people in a street just beyond, with more people farther down the street. The *View of West Sand Lake* seems at first glance pure landscape but if we add up the genre elements it contains we find five cows in the foreground, three wagons and four people on the main road and, surprisingly, a balloon ascending in the sky at the right.

It is interesting to observe the evolution of Hidley's townscapes from the earliest, about 1848-50, to the latest, about 1865-70. The three early scenes of Poestenkill in winter and in summer and of *Glass House Lake*, all painted within a few years of 1850, are true primitives. They are naïve in design, executed in a crisp, linear style and full of crudely drawn, animated genre incidents. The later three—dating from about 1860-70—are less conventional than the academic landscape painting of the time but they are not strictly primitive. There is some feeling for aerial perspective, some illusionism in the representation, and a degree of sophistication in the concept of a view. The drawing is less sharp than in the earlier scenes and the tonality less staccato in effect. The genre elements are minimized. The entire landscape is larger in conception and broader in style.

While each scene is individual in design and there are minor variations of style within the group, there is evident in the series a consistent, personal attitude toward landscape painting. The common denominator of Hidley's style outweighs the individual differences and makes of his six known townscapes a homogeneous series. There is a similar scale, a similar handling of space and perspective, and a characteristic color range which tends to be lighter in key than in the typical landscape paintings of the period. The scenes are painted on wooden panels or canvas and range from 21 to 33 inches in length. In each instance the view appears to have been taken from a high vantage point, so that the towns are seen not only from a slight distance but from above, which accounts for much of the character of the design—the high horizon, the lively, angular pattern of rooftops, and the compact grouping of houses in a self-contained unit. The rail, picket and worm fences carry the eye like signposts into the heart of each town. The small figures and animals are treated as varied accents that liven up the larger rhythms made by the cubes and rectangles of houses and rooftops.

It is perhaps inevitable that we should consider these town scenes not only as accurately depicted records of their time but, more primarily,

as finely integrated landscapes. The artist clearly enjoyed the composite look of a town as well as its content. He deliberately accented the crisp repeat patterns made by light and shade on the sides of houses and he effectively juxtaposed the staccato architectural rhythms of his villages with the open spaces of fields and sky around them. He subordinated color to the tonal contrasts and emphasized the linear contours, which again tend to heighten the effect of formal design in each of his town-scapes.

It may be fruitful to note the place of Hidley's townscapes in the history of American landscape painting, for they well represent our native tradition in the nineteenth century. This series of landscapes is indeed typical of our best home-grown art—unpretentious, simple, direct, vigorous, and vital. The lineal ancestors of Hidley's scenes, going back to the eighteenth century, are straightforward, provincial landscapes such as those by Winthrop Chandler and Ralph Earl. Again, in the first quarter of the nineteenth century, one finds a number of primitive overmantel panels that seem akin to Hidley's early town scenes. One called *Amen Street*, painted over the mantel of the Wade-Tinker House in Old Lyme, Connecticut, is especially close in feeling to the early Hidleys, although it is several degrees more primitive and was done almost half a century earlier. There is another overmantel, painted about 1820 for the Palmer House in Canterbury, Connecticut, which is also in a sense a "townscape," and in which the houses, church, and lighthouse are briskly patterned against a landscape in much the style of Hidley's early views. There are also a few isolated primitive scenes datable around the middle of the nineteenth century which are distinguished by the same robust spirit as Hidley's paintings.

By the third quarter of the century the itinerant landscape-and-lithograph artist had become an established fixture in America and during that time large numbers of landscapes and views of cities, towns, and villages were painted and published. It is probable that Hidley was acquainted with the popular books of his generation containing town views, such as those by John Warner Barber; yet it is apparent that he did not model his townscapes after these prints. Even his later scenes, which are relatively finished in technique, remain fresh and entirely original in design. Hidley's views are quite underivative, a homely, individual contribution to the landscape art of his time. He was one of the pioneers in this field.

HIDLEY, Fort Plain, New York *(c. 1865)*
Jean and Howard Lipman

Hidley painted a few allegorical and Biblical scenes as well as views of towns, but they are much less interesting from the point of view of subject and design. His scenes of New York towns merit attention as outstanding examples of native American painting.

JEAN LIPMAN

XVII

Olaf Krans

O_{NE} hundred and sixty miles southwest of Chicago, on U.S. Highway 34, a marker erected by the State of Illinois reads:

BISHOP HILL

At Bishop Hill, two miles north of here, Eric Jansen and Jonas Olson founded a colony of Swedish religious dissenters in 1846. Organized on communistic lines, the colony at one time had 1100 members and property worth a million dollars. Dissolution and the end of the venture came in 1862.

Erected by the State of Illinois
1934

At the entrance to Bishop Hill, the highway is arched with fine old shade trees which canopy its course to the center of the little village of a couple of hundred inhabitants. Here the park, tree-filled, is surrounded by buildings whose size and unique structure give evidence of a tale that should be told.

The story which the old trees or the old buildings might tell is, briefly, this. Early in the nineteenth century a group of Swedish men and women, under their leader Eric Janson, found the conditions existing in the established Church of Sweden intolerable. In 1848 Janson, with some of his followers, migrated to Illinois. Others came from time to time until the colony at Bishop Hill numbered more than a thousand. The settlement was a Christian communistic organization, so property, responsibility, and work were shared. Starting with sixty acres, the project accumulated a "balance stock on hand" of $770,630.94 according to the treasurer's report in the annual statement of the Board of Trustees on January 9, 1860. All this was accomplished by the hard work and

persistence of the men, women, and children—the last mentioned were assigned specific duties, and explicit obedience and excellence of performance were required of them.

Since agriculture was the means by which the colonists sought to establish their independence, their first task was to break the prairie. They planted and tilled and harvested their crops, they prepared their building materials of wood, brick, and adobe and erected their buildings, they raised sheep and spun and wove the wool, they raised flax and manufactured their linens.

Their methods of work were laborious. Though none now survive to tell the tale from personal experience, fortunately a unique record of the primitive activities of these pioneers exists. In the Colony Church there is a collection of paintings done by one man. Many of these paintings are portraits of colonists, but the most interesting ones are a few scenes of colony days, and, whether by design or accident, these are very fittingly depicted in a simple primitive style.

One canvas shows the ravine with the few log cabins and the twelve dugouts in which the early settlers lived when the tents which they had first occupied had to be vacated because of the rigor of the climate; winter had come on before they found time to construct more substantial and permanent shelters.

Several scenes deal with a series of agricultural pursuits. In one, the breaking of a gently rolling prairie is shown against a peaceful sky. Two strips of plowing in the field are growing wider under two red-handled plows, each of which is drawn by six yoke of very sturdy oxen. A boy attends each yoke of oxen carrying a whip with a sixteen-foot lash.

The plows, drawn by horses, appear against the horizon in another picture where three men are sowing grain. These men scatter their handfuls of seed from bags slung over their shoulders. The firmness of their tread as they definitely advance, and their facial expressions, indicate the determination that had to be a basic characteristic of these pioneers if they were to survive. In the extreme right foreground a colony woman bears a staff to mark the progress of the sowers. She wears the distinctive garb of colony women—a fitted bodice with long tight sleeves, and a full skirt reaching to the plowed ground. A long apron gathered into a tightly tied waistband, a big neckerchief knotted at the throat, and a sunbonnet with a generous cape complete the costume. In this picture the dress is blue; the apron and sunbonnet are white.

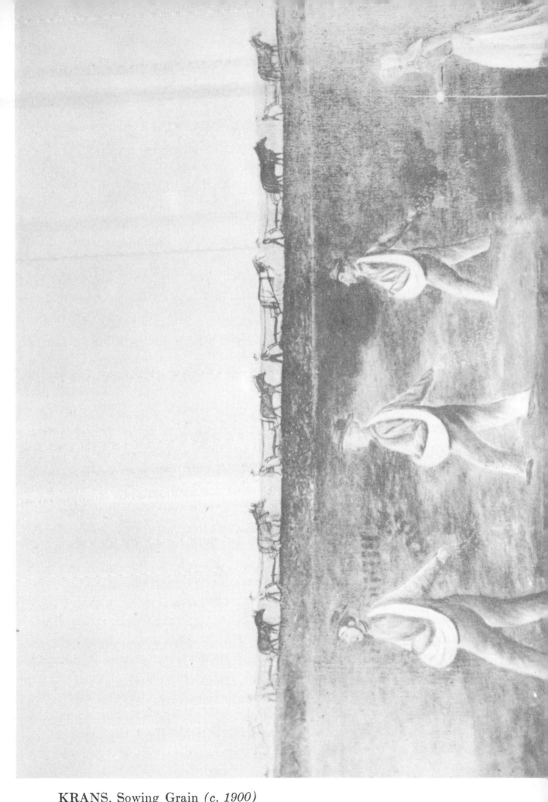

KRANS, Sowing Grain *(c. 1900)*
Old Colony Church, Bishop Hill, Illinois

Similar dresses, some blue and some brown, are worn by the twenty-four women who are corn planters in another picture, but they wear short aprons of pocket-style to hold the kernels of corn. The original method of corn planting in the colony is shown here. Two sharp sticks, joined by a rope of a certain length, and each with a projecting prong to reach forward and mark the next row, are carried by two men who plunge them into the earth and thus mark the row to be planted. At regular spaces on the rope, twenty-four little knots of colored cotton are tied, which indicate to each woman where to make her hole with her hoe, drop in her three or four kernels, and cover them up, before the men move forward with the rope for a repetition of the process. The planting goes on under a benign sky of blue with white clouds, and a soft glow at the horizon.

The agricultural series concludes with the sunny scene of harvest. Seven men, identical in appearance and in stance, are cradling the grain, and a dozen women, following them, are binding the sheaves. There is action here, and rhythm, and a sense of restrained contentment in the harvest of an abundant crop.

Happily, the artist also chose to record lighter moments in colony life. One of the smallest paintings, *Butcher Boys on a Bender*, is full of zest. It is one of the few given a name by the painter, and it is also inscribed *O. Krans at 70, 1908*. The scene is cold; there is snow—a great deal of it; trees are a bare, bleak gray, but in a bobsled with a green box mounted on bright red runners, five butcher boys sit, all warmly clad, all exactly alike. It is a biographical fact that the painter, himself, shared this lively time, and his enjoyment of it may be judged by the gaiety of the two oxen in his painting. The oxen are running, their legs and tails indicating excitement and speed.

A strictly narrative scene, also named by the painter, shows new-mown hay being loaded on two hayracks, each drawn by a double yoke of oxen in charge of ox-boys. A woman and a man are on each load, while two men on the ground are pitching. Attitudes all suggest haste. This picture is unique for its important background, which is sharply separated from the foreground by a rail fence. Behind the fence are trees, dark in ominous shade. The sky is cut by a straight line, one portion remaining clear and calm, the other drenched with sheets of pelting rain. The naïve name of this picture is *It Will Soon be Here*.

The Old Mill, Pile Driving, Bishop Hill as Seen from North of the

Edwards in 1855, The Indian and Hellbom, The Sea Captain, The Monument in Red Oak Grove and innumerable portraits are some of the other interesting pictures in this gallery.

What is known of the man who left this important pictorial record of an experiment in colonization which has few counterparts?

Olaf Krans was born Olaf Olson, on November 2, 1838, the eldest son of Eric Olafson, and his wife, Beatta. His birthplace was Selja, Nora parish, Vestmanland, Sweden.

Very early Olaf showed a talent for drawing. Before he was twelve years old, his father, having decided to emigrate to America, visited a shipwright in Gefle to ascertain the value of a boat and skiff which constituted part of the property he had to sell. Each member of the colony was required to sell his possessions and to contribute the proceeds to the common fund. The shipwright wanted to see what the property looked like, so the father made some sketches. Olaf, who had accompanied his father, glanced at the drawings, remarked that they were not correct, and proceeded to draw the boat and skiff with the comment, "This is the way they look." The shipwright scanned the picture, looked intently at the little boy, then turned to the father, and said: "Let me have him, and I shall give him an education and he will make his mark in the world." But the father would not think of giving him up.

Instead, in August 1850, with a group of eighty people, Olaf and his parents, three brothers, and two sisters set sail for America on the good ship *Condor*, which was loaded with iron. Finally, reaching the American shore after a voyage of three months, this little group progressed, first by steamboat on the Hudson River to Albany, thence by canal boat to Buffalo on the Erie Canal—a nine-day trip which was broken occasionally by walks and visits to apple orchards along the way when the boat stopped at the locks. From Buffalo another boat took them via the Great Lakes to Chicago.

From Chicago to Aurora, Illinois, a train carried the travelers westward. At this point, some got into wagons for the trip to Bishop Hill; others walked the last hundred miles of this long journey, which brought them to their destination in the month of December, only two years after the founding of the colony.

For two winters Olaf attended English School in Bishop Hill, conducted in the Colony Church, where there were no blackboards, wall maps, charts, or desks. The pupils sat on benches around long tables. The school

term was short because as soon as the weather permitted, children were taken out to clear the fields and get the land ready to plow. Olaf was one of the ox-boys whose role in the colony's history he later depicted on canvas.

When he grew older, Olaf worked in the paint shop, and later in the blacksmith shop, for several years. He enlisted in Company D, 57th Regiment, Illinois Volunteer Infantry on September 14, 1861. It was at this time that he, born Olaf Olson, took the name of Krans—the same one his father had borne while performing army service in Sweden. He retained the name the rest of his life in preference to the more common one of Olson, and the other members of his family also chose to be called Krans.

Taken sick after the Battle of Fort Donelson, Sergeant Olaf Krans was removed to a hospital in Louisville, Kentucky, and was discharged for disability on June 3, 1862. During his war service, he wrote considerable Swedish poetry, inspired by nostalgic thoughts of his sweetheart, who all his life kept her place in his heart, though she did not return his love and he found her married to another when he came back from war.

After returning to Bishop Hill, Olaf Krans clerked in the store of Swan Bjorklund for some years, and then for a while he had charge of a photograph gallery on wheels. He found readjustment difficult after the war; he was apathetic, and disappointment in love was hard on him. Dr. Babcock felt that he was ill in mind and spirit more than in body, and one of his experimental treatments consisted of taking his patient far out into the country on a cold, snowy day, leaving him, and forcing him to walk back.

Moving to Galesburg, Olaf Krans became a painter. There he married Christina Aspequist, and in 1867 the couple moved to Galva, Illinois. They had three sons, Frank, Carl, and Ole, and a daughter who died in infancy.

In Galva, Olaf engaged in house-painting and other outdoor paint jobs, and in interior decorating. He was very original if left to work out schemes of design, and many of the good homes in Galva were adorned by his brush. He did a great deal of graining, which he frequently augmented by a finely detailed design of something which simulated inlay. A vine pattern also pleased him. In one home he made vines grow on all the sills and panels of wood, while the ceiling was painted to represent a series of arches. The Swedish Methodist Church in Galva had vines trailing on the ends of the pews, and the old Swedish Lutheran Church was arched by a ceiling of azure blue, studded with gold stars, done by Krans. He was

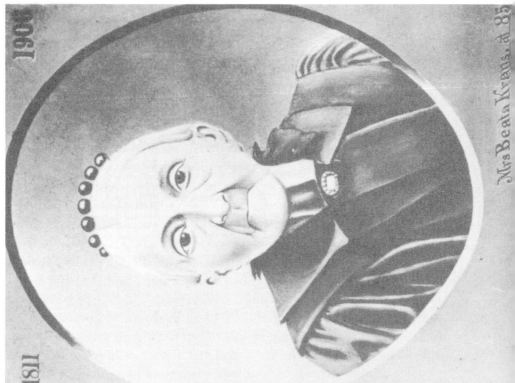

KRANS, Mrs. Beta Krans *(c. 1900)*
Old Colony Church, Bishop Hill, Illinois

KRANS, Self-Portrait *(c. 1900)*
Old Colony Church, Bishop Hill, Illinois

very generous with his work. He contributed many backdrops and curtains for special performances at the Galva Opera House, to the great advantage of the flourishing dramatic organization in that town.

Olaf Krans' mind was keenly active and his interests found expression in a variety of ways. He was important in the Galva Fire Department, which he helped organize. He was among the first members of the Galva Band and he played the bass horn. He liked to wear a uniform, whether it was that of a fireman, a bandsman, or of the Grand Army of the Republic.

In the field of roadside advertising Olaf Krans was a pioneer. Each sign was the direct work of his hands, and there were many advertisements, handsomely lettered and quaintly styled. One survived west of Galva for years, but like the others it was finally obliterated. It read:

> Norling bröder saljer piller
> Som pa engang plagor stiller
> Afvon bar de linnementer
> Som ungdom gör of gamla jäntor.

> (Norling brothers sell pills
> Which immediately quiet pains.
> They also have liniments which
> Make young folks out of old ones.)

It was when Olaf Krans was convalescing from a leg injury—due to a fall which partially crippled him for a time—that he started painting the Bishop Hill pictures, engaging in it as a pleasant pastime. He reproduced all the colony scenes from memory, but he had the aid and criticism of his sister, Katharine (Mrs. Nyberg of Galva) who corrected his work as it progressed. Unfortunately, he did not date many of these pictures, but they were done within a relatively short time. The painting of the ravine bears the date 1896 and *Butcher Boys on a Bender* is dated 1908. *Bishop Hill as Seen from North of the Edwards in 1855* was painted in 1911, but this is a reproduction of an earlier painting of the same scene done by Krans on a drop curtain in the village auditorium, originally the brewery. *Monument in Memory of the Departed Pioneers* is also dated 1911. Most of the portraits, several score of them, were painted from photographs at later dates, and Mr. Krans added to these as long as he

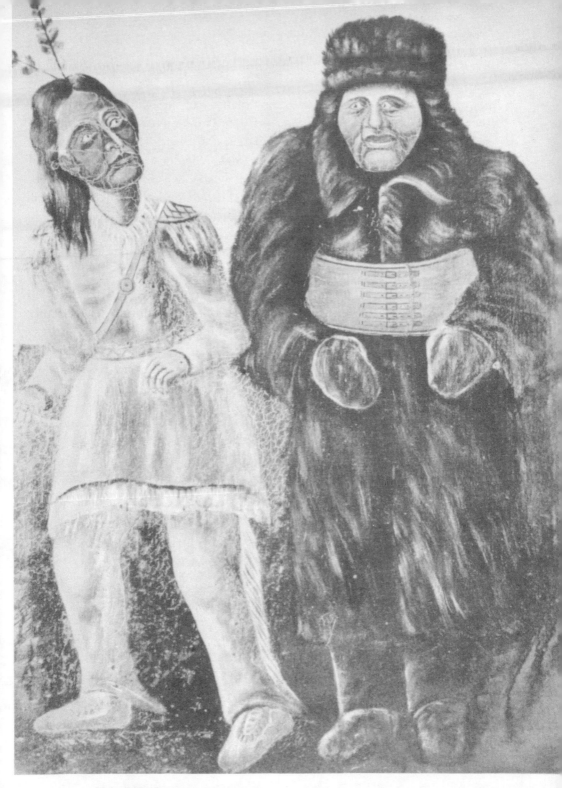

KRANS, Indians *(c. 1900)*
Old Colony Church, Bishop Hill, Illinois

lived, modestly reserving a self-portrait till well along toward the end of his life.

Certain characteristics of Krans' work are noteworthy. He had no technical training but he reproduced a faithful picture of what he had seen. He painted three sowers, seven reapers, twenty-four corn planters because he had seen such groups at work in colony days. He was not striving for any approved technique, nor was he conforming to any established principles. In several scenes he showed a fondness for the same horizon line, as if his pictorial stories all occurred at the same place. He did not develop background except in a few cases, but this, too, was probably because he recalled the prairie as reaching to the horizon. He transmitted a sense of atmosphere in a few of his paintings—warmth on the day of harvest, chilliness of autumn in the pile-driving scene, and dreary cold in the Red Oak picture. Most significant is his recording of the manner in which labor was shared by men and women in this colonial enterprise.

Olaf Krans had a keen mind, a creative urge active to the point of restlessness, and a jovial disposition. He was a good story-teller and he liked to talk about his boyhood days. There was nothing mean or small about him; although he never amassed any great possessions he was very generous with all he had. His good nature made him many friends.

The latter part of his life was spent at Altoona, Illinois, and it was there that his death occurred in January 1916. Since that time the interest in his paintings has constantly increased, and scarcely a day passes without visitors to the Colony Church in Bishop Hill, who look at the Krans paintings and wonder at the strange story they tell of life in this village almost a hundred years ago.

MARGARET E. JACOBSON

XVIII

Paul Seifert

PAUL A. SEIFERT *(1840-1921)* was one of our most remarkable primitive painters, and his gay, finely designed farm scenes are American masterpieces. He painted portraits of Wisconsin farms over a period of about forty years—from the late 1870's to about 1915—but to date he is totally unknown, his name nowhere recorded. The discovery of an example of his signed farmscapes provided the point of departure for one of those fascinating art treasure hunts, in this case the treasure being the reconstruction of the painter's life for this article and the acquisition of a group of his paintings for the author's collection.

One granddaughter recalls Seifert as a kindly and indulgent man, whose early life held some mysterious secret, as he jealously guarded the details of his youth in Germany. "My own personal contact," she writes, "came when he was an elderly man, mellowed by age. By that time he had long ceased his drinking, his home on the banks of the Wisconsin River had been washed away, the myriads of flowers which made his home a show place were gone."

Another granddaughter whose mother, Seifert's daughter, is still living, has written a number of revealing letters about the painter's life and her recollections of his personality. In order to keep as closely as possible to first-hand information, I quote from her account:

"Paul A. Seifert was born June 11, 1840 in Dresden, Germany. He graduated from Leipsig college. Paul's early life in Germany, as much as we can gather from what he told us and his papers, was a life of wealth. His father was called Dr. Seifert—we have his picture and he was very distinguished looking. Then to further bear out this statement of wealth, sums of money, fine linens and jewelry were sent to my grandfather from his parents.

"Because Paul disliked the military training in his country, he ran away and came to America in 1867. At that time, men traveled on rafts on the Wisconsin River bringing logs from the north country. Paul Seifert came down the river on one of the rafts and stopped at a small village called Richland City. Laurence Kraft was the only resident who spoke the German language and my grandfather soon gained his friendship and later married his daughter, Elizabeth Kraft.

"At this time, Paul Seifert started his life work; for an occupation he raised flowers, small fruits, and vegetables, but as a hobby, he did the painting you wrote about in your letter, watercolor farm scenes. The natural resources of the country were very abundant at that time so he and his wife and four children lived a simple life in a log cabin.

"In later life, he set up a shop near Gotham, where he practiced his art of painting and taxidermy. Besides the watercolor work he did oil painting on glass. These were castle scenes, as he remembered them in his native land. He died in 1921.

"My grandfather was a small lean man with dark eyes and hair. He was alert, ambitious, highly sensitive, generous to the point of sacrifice. [His other granddaughter writes that Paul Seifert was "generous to a fault."] Many wayfarers received food and lodging at his home among the hills. The very decided change from a life of wealth to the most simple pioneer life must have irritated him at times, although he never showed class distinction for he even made friends with the peaceful Indians camped near his home. My grandmother did sewing for them in exchange for venison.

"Paul Seifert liked order in his life and disliked disorder or confusion. His gardens carried this same pattern of order.

"You asked if he painted at home or traveled to do his farm scenes. Sometimes he left home for days, walking from one farm to the other with his sketch book. Some sketches were brought home and painted, others, as I understand, were done at the farms. Along with his painting, he set out groves of shade trees at farms he visited, and started small fruit gardens for the farm folk, supplying the plants from his own garden.

"The farm scenes were all painted in watercolors. As money was very scarce in those days, not more than $2.50 was paid for the paintings. He did not have a shop until later. These were done at home or on the farms.

"His first shop was set up at Gotham, then later moved one and one half miles west of Gotham on this farm where I now live. The little shop, about 20 x 20, was painted a gay red with a white sign adorning the front, bearing the name of *Paul A. Seifert, Taxidermist* in black letters. Here my grandfather practiced many arts. It had two rooms and in one corner of the large room was a window and a table where he did his painting.

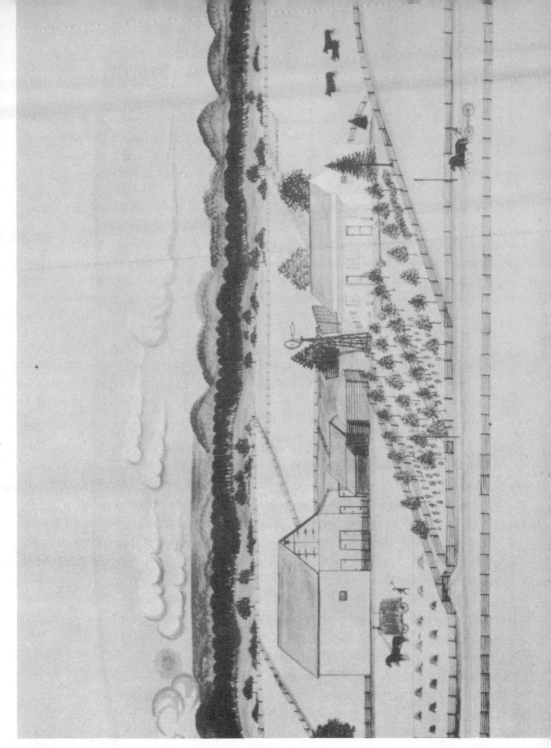

SEIFERT, Jacob Bennett Farm, Gotham, Winsconsin *(c. 1880)*
Jean and Howard Lipman

"To me, as a child, going into his shop was like going into a wonderland, where all his mounted subjects were on display and his colorful paintings hung on the walls.

In the shop he did the glass painting. The sketches were made on drawing board, then the glass 16 x 20 inches was laid over the board and scenes of lofty castles with gold and silver foil windows were painted with oil on the glass. Later on, he painted winter scenes of churches and country church-yards. These sold for $5.00, a small fee considering his work and the making of the frames, but the country people were his customers and could not afford higher prices.

"As for my grandfather making any remarks about art or painting, I asked my mother, his daughter, and she told me that he said: 'People like my work and I like to paint for them.' In this he found satisfaction. You will notice in the picture of the Nelson Bennett farm, he tried to pay attention to details, little personal things, such as the dinner bell on the woodshed. In the same picture, the little girl in the yard playing with the dog (supposed to be me) and my brothers with the pony are in front of the house. These little things, I think, made his work more personal to people that he painted for and we draw this conclusion: to the ordinary class of people, art that portrays scenes from everyday life, as people work and live, is most appreciated—and I think my grandfather knew this to be true."

Paul Seifert's primitive painting was popular art at its best. The simple farm scenes he painted are filled with anecdotal detail—people, animals, the orchards the farmer-painter had laid out—that must have pleased and interested his customers; but, from our critical point of view, they are much more than this. The freshness of vision, the clarity and beauty of the linear and tonal patterns, the energy that characterizes every detail, reveal a vital, individual style that is unique in American landscape painting.

Seifert's love of order, which his granddaughter remarks in connection with his flower gardens, also dictated the style of his painting. The lucidly planned design and clear color combine to make these farm scenes most remarkable. It is interesting to note that Seifert used colored paper for his scenes—tan or gray or blue—and this basic color determined the dominant tone of the painting in an original and arresting manner.

The Jacob Bennett farm scene on light blue cardboard is painted with foliage a vivid green, buildings gray and white, brown fences, and accents of vermilion, all set against pale blue fields and blue sky illumi-

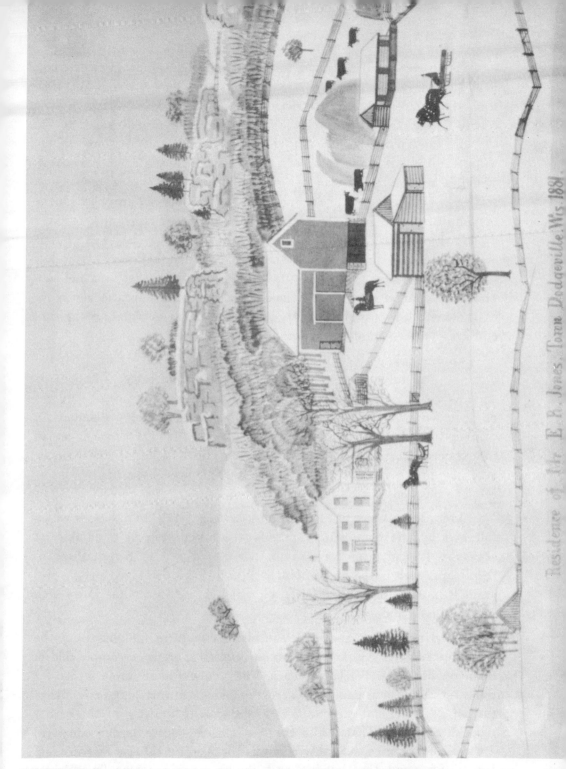

SEIFERT, Residence of Mr. E. R. Jones, Dodgeville, Wisconsin *(1881)*
Jean and Howard Lipman

nated with gilt-edged clouds—a color scheme as daring as any modernist would attempt. The Jones farm is depicted after an early snowfall, with ground and roofs covered with snow while the scrub oaks still retain their tawny foliage. In this painting the gray paper gives a wintry cast to the sky and foreground, while the bright red barn and green firs and orange oaks stand out in vivid contrast. The color scheme is again unconventional, a staccato pattern of red, orange, yellow, and green against the soft gray, blue and white of sky and ground. The Cooper Farm Scene takes maximum advantage of the tan color of the paper as a unifying tone, a good deal of the foreground remaining uncolored. Yellow-ochre buildings and lemon-yellow fields alternate with the neutral areas of the tan paper, accented by green hills and trees and haystacks, in a delicate point and counterpoint of quiet color. An unidentified farm achieves an opposite effect, robust and rich, through bold contrasts of dark red, green, and gray with emerald, gold and white.

An original and delightfully primitive aspect of Seifert's work is the gay use of metallic paints—gold, silver, copper, and bronze—for details such as a sun, evening clouds, a weathervane, or reflections of sunlight on windows. The painter often used, besides the metallic pigments, a combination of transparent watercolor, oil and tempera which gives an interesting textural variety to the surface. Such a mixed technique is typically primitive, and would not have been used by a painter interested in illusionistic realism.

As for the content of the paintings, certain details like the haywagon followed by the man with a pitchfork are repeated in a number of scenes in typical primitive fashion. Another aspect of Seifert's unacademic approach is the naïve manner in which he portrayed people and animals in exact profile, and often pictured the sky as ending in an arch just as small children do.

The late castle scenes and churchyard pictures, judging from the examples I have seen, do not seem as primitive, or to be comparable in quality with the earlier farm scenes. They show a loose, rapid style that indicates that these paintings were "quickies," turned out in quantity for popular sale, and the fine design and precise drawing of the earlier paintings are lost. That is also true, to a lesser degree, of the late farm scenes. These are considerably smaller—both in actual size and in creative vision—and the drawing and coloring are heavier. The Nelson

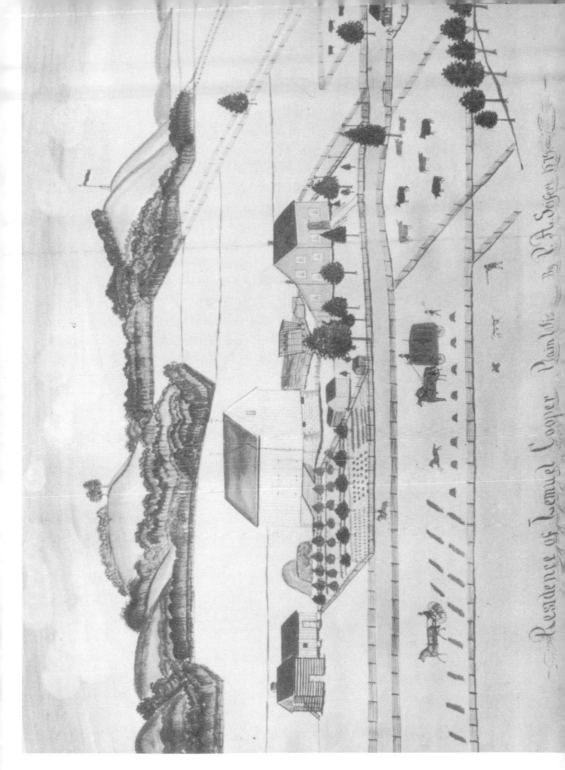

SEIFERT, Residence of Lemuel Cooper, Plain, Wisconsin *(1879)*
Jean and Howard Lipman

Bennett farm which the painter's granddaughter mentions, painted about 1910-1915, is a good farm landscape full of lively detail, but in comparison with the farm scenes of the seventies and eighties it seems quite ordinary.

The nineteenth-century farm scenes are among the finest American primitives that have come to light. The reproductions show the clarity and originality of Seifert's designs, the sureness of his draftsmanship, and the crisp tonal contrasts, but his fresh and vivid use of color is even more remarkable and cannot be adequately described. The scale of the large watercolors (they measure about 22 by 28 inches) is also lost in reproduction.

In my opinion Paul Seifert's farm scenes are as outstanding in the field of primitive watercolors as are Edward Hicks' *Peaceable Kingdoms* in that of oil painting; and in the case of each of these highly talented artists there is an infinite variety of design within the one compositional theme.

JEAN LIPMAN

156

Twentieth-Century Primitives

ABRAHAM LINCOLN, the self-made man of history, is the idol of American self-taught artists of today. The drama of the figure whose life was so touching and tragic and human, whose achievements were so profound, inevitably attracts them. The fact that almost every self-taught American painter I have encountered has painted a portrait of Abraham Lincoln may well be regarded as an interesting symbol of their activity. There is much in the significance of the life of Lincoln with which they can identify themselves. His obscure beginnings, his silent struggles with knowledge, and his open conflicts with life are their own. They wish for themselves the greatness that was his, and his martyrdom draws them close.

This vital group of painters living in America has had little encouragement or recognition. They come from all walks of life. Some are craftsmen—cabinetmakers, house painters, decorators, blacksmiths—but they may also be tradesmen, housewives, laborers. All of them are motivated by an inner drive to paint, and this they do in their spare time. On the Continent they have been affectionately called Sunday Painters.

These folk are not a phenomenon of our time. There have always been such artists among the people. Invariably they work quietly, away from any contact with Art. The world of art is desirable but as remote as a dream. Although they may contribute to it, they rarely become a part of it.

The greatest and most famous of them all, Douanier Rousseau, died in Paris in 1910. The public imagination has been greatly stimulated by the posthumous recognition of Rousseau, who was for the most part ridiculed except by a few perceiving artists and poets who admired him only near the end of his life. Understanding of the real character of this great artist's work, and subsequent acceptance of it by the world at large, have awakened interest in self-taught expression.

Perhaps this has resulted in a quickened awareness of the inherent qualities of our own self-taught artists, both contemporary and of the past.

Devotees of Americana constitute a receptive audience for our primitive itinerant painters and anonymous artists of the late eighteenth and early nineteenth centuries, although the approach of this group is often enough based on historical interest and national sentiment as well as esthetic evaluation. As a matter of fact, it is on that period that most of the interest in American self-taught artists is centered, for we find that primitives of the late nineteenth century and today do not share this recognition.

It would appear from the studies already made in this field that the tradition of art of the people, which flourished so profusely in America, reached an apotheosis in the second quarter of the nineteenth century and declined with the advent of a new era of science and industry. As the camera gained favor, the itinerant portrait painter, who had done the finest of this early self-taught work, was gradually eliminated from the scene. When the family album appeared on the table, ancestor paintings began to find their way to the attic, from the obscurity of which they were not to emerge until the second quarter of the twentieth century. The spaces left on the walls as these primitives came down were covered with lithographs and chromos, and the first period of Currier & Ives' great popular appeal had got under way.

Handcraftsmen, whose skills led them naturally into esthetic expression, were now separated from their crafts by the machine, and these hand skills went into disuse.

The tremendously increased speed of travel by land and by sea brought a resurgence of foreign influences in art, and the consumer interest now became divided between chromos and lithographs on the one hand, and a vast amount of derivative and banal art on the other, which at present reposes in the basements of so many of our museums.

All of this new activity, together with the upheaval caused by the Civil War and the period of reconstruction which followed it, seems to indicate that there had been a decline in self-taught expression, but the decline may actually have been one in appreciation rather than creation.

If for the most part the early American painters remained anonymous, it is probably because their work was not properly evaluated as art in their day, but was considered mainly as mere portraiture, com-

missioned for sentimental reasons. As already indicated, rediscovery of these early works today involves two facets of appreciation: one, their acceptance after a safe margin of time has elapsed; and the other, one of those unpredictable turns in esthetic appreciation which brings a new awareness.

It is therefore reasonable to assume that there may have been no decline at all, for the self-taught artist is a perennial worker, paying his tribute quietly to those sources deep within human nature from which the creative impulse springs. He thrives in spite of external conditions. He does not lean on an established painting tradition. He is spiritually independent.

Certainly the fact remains that today, in the midst of an age of highly specialized mechanization and industrialization, when it might be expected that this expression would be at low ebb, there are scores of self-taught painters of outstanding merit working among the people. They are worthy successors to our eighteenth- and nineteenth-century anonymous artists, and they work with an originality more varied, incorporating a much wider latitude of expression.

If a comprehensive research and appraisal of the field was not made and published in times past, the reasons for it may be understood. But there is no valid reason why such an important task should not be fully organized and carried on in connection with our contemporary self-taught artists.

Any appreciative activity in this field has until recently operated only through isolated efforts of individuals, organizations, and galleries. People with a generally developed appreciation and with contact with European works of this nature responded to men like John Kane and Joseph Pickett, the first of these 20th-century American painters to receive recognition. A few New York galleries exhibited the works of self-taught artists. These artists were also seen by chance at such general showings as the exhibits of the Society of Independent Artists, the Washington Square Outdoor Art Mart, the Southern Vermont Artists' Association at Manchester, where men like Branchard, Sullivan, Doriani, and Mulholland were found.

The first coordinated effort in this country to show them as a homogeneous group was in 1938, in the *Masters of Popular Painting* exhibit at the Museum of Modern Art. Here both European and American popu-

lar masters were shown, and the thirteen Americans included were for the most part already known.

In 1939 at an exhibition called *Contemporary Unknown American Painters* sponsored by the Advisory Committee of the Museum of Modern Art and shown in the Members' Rooms of that museum, sixteen new self-taught talents were introduced. My object in assembling the exhibition was to stimulate interest in unknowns, among whom might be artists of distinction whose merits were still to be properly evaluated. In this way, it was hoped, the inevitable time-lag between the creation of works of art and their appreciation might be shortened. For the living non-professional finds a public little prepared to encourage him since it has had only a limited opportunity to orient itself to his work, and he has for the most part yet to find his audience.

There is ample reason why lovers of art should be drawn to his work, but the audience need not be restricted to the world of art, for the self-taught artist expresses himself with a humility and an easily comprehended human quality that may be shared by everyone. The layman may also be attracted, for example, by the theme, by visual ideas that move close to his own experience, or by the human-interest aspect of the self-taught; he may be tempted to seek out such an artist, or perhaps even to paint. For the psychologist there is rich material in this field, because the expression, unhampered by a complex painting culture, is so direct and close to the surface that the functioning of psychological processes in general may be readily examined. For the same reason he may find a clearer path to the phenomenon of the creative process itself. And to those interested in art as, first and foremost, an authentic esthetic experience, there is also the adventure and pleasure of making vital discoveries.

The art of all time, and particularly the profound development in international painting which centered in Paris during the twentieth century, have demonstrated the wisdom of determining the validity of any expression on the basis of its own terms, not losing sight of the fact that there are constants in all art. This is true, whether the expression be one of a given culture or sub-culture, such as Assyrian, Etruscan, Coptic, or Gothic, or of individuals within a culture, as for example, Cezanne, Picasso, Duchamp, and Klee, who are close to each other in the same painting stream. It is essential that this attitude be brought to con-

KANE, Self-Portrait *(1929)*
Museum of Modern Art, New York City

temporary self-taught art, especially since each artists' work may be regarded as unique and must, in the main, be evaluated individually.

Whatever the reasons may be, there are people in the world who always retain an untouched quality, a spiritual innocence, regardless of their experiences in life. Somewhere within them is an impregnable quality carried over from childhood, which experience does not assail. It is a spontaneous, innate, uncommon sense which remains inviolate in the fact of outwardly imposed tensions and restraints. When these individuals paint, they rarely learn from a developed painting culture because it is far removed from their perception, and being removed, cannot touch them. Each creates in his own world. Often a surprising enterprise and courage are born of their very innocence. Not realizing the pitfalls, they are unafraid.

In the work of the most interesting of these artists, through sureness of intuition, a harmony is achieved between emotion and idea, and the medium through which they are expressed. Unlike either the work of the untutored child, which develops with his years, or that of the studied artist, which evolves in comprehension and craft, the paintings of the self-taught artist most frequently comes to virtual fruition with the making of his first picture.

Every child draws, as witness the sidewalks of New York, for drawing is a form of creative expression latent in every human being. Some people develop this by study and become professional artists. Or they may push it aside so that it remains hidden until specific drives bring it to the surface again. In this category are the self-taught artists. Before actually painting, they go through a series of rudimentary unconsummated painting gestures which help to mature them. Often these cursory gestures are tied up with their crafts, as in the case of house painters, sign painters, furniture finishers, cabinetmakers, decorators, needlecraft workers, who are naturally led into painting as an extension of already developed motor activity. It is interesting to note that many of the self-taught painters have such backgrounds, and frequently many aspects of their work spring directly from occupational activities. But others who do not, still have what may be called a "craft sense" about their tasks; conscientious, ingenious, deft, they obtain an esthetic gratification in the same way as do craftsmen in the execution of their crafts.

Reasons for their painting may also be found in their environment, which plays its part. In communities where they are surrounded by pro-

HIRSHFIELD, Tiger *(1940)*
Museum of Modern Art, New York City

fuse art activity, social condemnation is eliminated. They then paint either because others do or because they feel challenged by the work of others. In any event they leap their first hurdle.

Some specific drives to paint are very much the same as those of the professional artist. Aided and abetted by coordination between visual experience and manual dexterity, they may paint because they have a message to impart; bcause they have been painting pictures in their minds for years and are finally impelled to carry this into overt action; because they have psychological situations to resolve through sublimation or because frustration of a given talent must provide another outlet.

Unevenness in the work of the self-taught painter is greater than in the work of the studied artist. Moreover his fine pictures and his poor ones are apt to be equally acceptable to him. This critical innocence is responsible for his going to extremes in both directions. It is for this reason that those of his pictures which "come off" reach far into the field of distinction, compensating generously for the canvases that fail. With the more gifted painter the percentage of good painting is consistently high, ample proof, if proof be needed, that his achievements are not the result of accident.

Sometimes self-taught artists ardently desire to paint realistically, as Rousseau did when he admired Bourguereau and yearned to paint like him. It is apparent from what they say about their work that they believe they are faithfully recording reality. However, even cursory examination shows that a great disparity exists between what they believe and what they actually have accomplished. Although convinced that they have made a photographic reproduction of the world of reality, they have actually transmuted it into a new, pictorial reality. For whether painting reality, fantasy, allegory, or any of the endless types of art upon which a self-taught artist focuses, he functions with the utmost freedom. Forever finding himself in fresh and untried fields, he must forever invent, create, and discover.

Of course he does not always succeed. On the contrary much self-taught art is crude and sentimental in the extreme. Colored postcards, calendars, chromos, often make up the artist's environment, and his work may be only too frequently little more than imitative. But one encounters occasionally an artist able to borrow from even these dubious sources and elevate his material by inventive and creative handling.

Paradoxically, although the self-taught artist does not make a selec-

WILLIAMSON, The Veteran's Dream *(1945)*
Dallas Museum

FROST, Marblehead Harbor *(c. 1940)*
Marblehead Historical Society

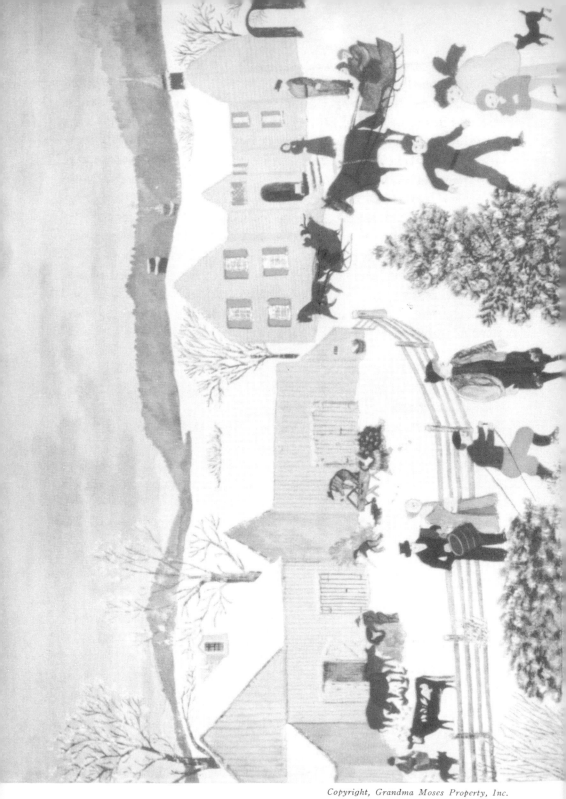

MOSES, Bringing in the Christmas Tree (1946)

Galerie St. Etienne

tion from the complex and developed painting tradition of today, he often independently achieves isolated results that parallel those of cultivated expressions. In his own way, he may quite unwittingly arrive at such results in the process of converting his concept into painting terms.

For instance, knowing nothing of Cubism, he may paint a picture in which a circulating viewpoint is used, or one that is counterpoised like a cubist painting. Knowing nothing of Surrealism, he may create enigmatic surface textures, use literary ideas and fantasies that are closely akin to Surrealism. Knowing nothing of Freud, he may undesignedly employ symbols similar to those Dali uses with specific intent.

With many of the self-taught painters, psychological factors which are tied up with inner conflicts of various kinds are of primary importance. The necessity for working out their psychological problems furnishes one of the mainsprings out of which their pictorial means flow, for through sublimation in paint, they resolve their doubts, their emotions and their beliefs. In men like Hirshfield, Sullivan, Samet, Frouchtben, it is at the root of their need to paint.

The primitive character in the works of contemporary self-taught painters is essentially unlike that in cave drawings, which are the product of primitive culture with primitive tools. Because of their striving for space ideas and sometimes because of their use of form and color, their work stands closer to the primitive paintings of the fourteenth century. It also has characteristics of folk art in its pleasing awkwardness and humble spirit. Still it bears the stamp of its own time. Not only do fashions in clothes, furniture, decorations, and the like, used in the paintings, reveal this, but attitudes of mind which inevitably come to these artists from the larger environment as well as from the commonplace experiences of their daily lives.

Outstanding primitive painters of the twentieth century are discussed in my book, *They Taught Themselves,* from whose introduction this chapter is taken. Among these are: Morris Hirshfield, William Doriani, Patrick J. Sullivan, John Kane, Henry Church, Joseph Pickett, Grandma Moses, Isreal Litwak, Patsy Santo, Lawrence Lebduska, Horace Pippin, Emile Branchard, Josephine Joy, George E. Lothrop, Pa Hunt, Cleo Crawford. Other recently discovered twentieth-century primitives are Clara Williamson and John Frost, examples of whose work are here illustrated.

SIDNEY JANIS

167

Record of Primitive Painters

This list of American primitive painters, begun for the author's book *American Primitive Painting*, has been compiled from all pertinent books, magazine articles, and exhibition catalogues, from verbal information, and from primitive pictures seen over a period of fifteen years.

A considerable number of the painters listed on the following pages are fairly well known today; some are known only by two or three pictures; many are merely identified because of having signed their names to an isolated painting. Listing a number of these typical primitive painters provides a cross-section for estimating the number of such painters active in the eighteenth, nineteenth and twentieth centuries, where and when the majority of them worked, what subjects they most frequently painted, and what media they chiefly used. A more important reason for listing these names is the possibility that some of them may prove to be the core around which a body of work will at some future time be assembled.

Unless otherwise specified, oils are on canvas, watercolors and pastels on paper. The dates followed by an asterisk signify birth and death dates; all other dates indicate approximate period of activity.

JEAN LIPMAN

Name	Date	Locale	Subject	Medium
John Abbe	1820	New York	Portraits	Watercolor
Charlotte Adams	1830	Amenia, N. Y.	Still life	Velvet painting
Olive M. Adams	1850	Middlesex, N. Y.	Landscape	Charcoal
Willis Seaver Adams		Springfield, Mass.	Portraits	
Jos. E. Adelman	1860	Yorktown, Va.	Scene	
G. Alden	1840	Mass.	Portraits	Oil
Noah Alden	1880	Middleboro, Mass.	Portraits	
Francis Alexander	b. 1800	Windham County, Conn.	Portraits	Oil, watercolor, & pastel
Mary Van Alstyne	1825	Mass.	Still life	Velvet
Peter Anderson	1835	Lowell, Mass.	Ship picture & townscape	Watercolor
George W. Appleton	1830	Maine	Portraits	
A. Arnold	1860	New York	Village scene	Oil
Ashbery		Chambersburg, Pa.	Scene	Oil on cardboard
Jeremiah Atwood		Mass.	Portraits	
Jean Aubry	1830-40	Mass.	Portraits	Oil
George Avlont	b. 1888	New York City	Genre	Oil
John Avery	1820	Wolfeboro, N. H.	Mural landscapes	Fresco
Amory L. Babcock	1920		Still life	Watercolor
Mary Ann Bacon	1850	Litchfield, Conn.	Landscape	
Nancy Badger	1834-44	Warner, N. H.	Still life	Watercolor
Stephen Badger	1825	Stoddard, N. H.	Landscape	Fresco

Name	Locale	Date	Subject	Medium
S. S. Bannon			Scenes	Oil
James Bard	New York City	1815-97*	Ship pictures	Oil
John Bard	New York City	c. 1856	Ship pictures	Oil
Lewis Bardick	New York	1870	Portrait of dog	Oil
Lucius Barnes	Middletown, Conn.	1810-30	Portraits	Watercolor
Julia Fuller Barnum	Kent, Conn.		Landscape	
Salome Barstow	Mass.	1820	Still life	Velvet painting
Lucy Bartlett	Mass.	1830	Memorial	Velvet painting
Wm. Thompson Bartol	Marblehead, Mass.	1817-59*	Portraits, mural landscapes	Oil and fresco
Ruth Henshaw Bascom	Franklin County, Mass.	1772-1880*	Portraits	Pastel
Mark Baum	New York City	b. 1903	Landscapes & scenes	Oil
O. I. Bears	New London, Conn.	1835	Portraits	Oil
Wm. Millett Beauchamp	Skaneateles, N. Y.	1830-65	Landscape	Water color & pencil
C. G. Beauregard	Mass.	1840	Portraits	Oil
Joseph Becker	Sacramento, Cal.	1841-1910*	Scene	Oil
Martha Stuart Beers	New Lebanon, N. Y	1830	Still life	Velvet painting
M. D. Belcher	Greenfield, Mass.	1830	Landscape	Watercolor
Zedekiah Belknap	Mass.	1810-40	Portraits of sea captains	Oil
Jonnie E. Berry		1865	Portraits	Pastel
David Bixler	Ephrata, Pa.	1830	Equestrian portrait	
E. W. Blake		1830	Portraits	Oil
John Blent		1830	Landscapes	Oil
Charles Bond	Boston, Mass. & Detroit, Mich.	1844	Portraits & landscapes	Oil
William Bonnell	New York	1830	Portraits	Oil
Sala Bosworth	Ohio	1830	Portraits	Oil on canvas & wood
Alexander Boudrou	Penn.	1850	Scenes	Oil
Boutwell	Groton, Mass.	1850	Mural scenes	Oil
M. Boyle	Carlisle, Pa.	1850	Historical scene & still life	Fresco
Gideon Bradbury	Salmon Falls, Me.	1850-75	Miscellaneous	Oil
I. Bradley	probably Philadelphia, Pa.	1830	Portrait	Oil
Mary Bradley	Lee, Mass.	1830	Still life	Oil
Emile Branchard	New York City	1881-1938*	Landscape	Velvet painting
Brewer	N. H. & Vt.		Landscape	Oil
John Brewster	Portland, Me.	1830	Children's portraits	Oil
Hugh Bridport	Mass.	1820	Children's portraits	Oil
L. A. Briggs	Boston, Mass.	1850	Portraits	Oil
Dr. Samuel Broadbent	Wethersfield, Conn.	b. 1759	Ship pictures	Watercolor
Catherine Bromfield		1830	Portraits	Oil
Newton Brooks	Mass. & N. H.		Miscellaneous	Watercolor
J. Brown	Salem, Mass.	1810	Portraits	Watercolor
William Browne	New York	before 1850	Landscape	Watercolor

Name	Locale	Date	Subject	Medium
William H. Buck	South	1878	Landscape	Oil
J. Buddington		1805	Portraits	Oil
A. Bullard	Westerly, R. I.	1850	Portraits	Pastel
C. Bullard		1830	Still life	Velvet
H. Bundy	Claremont, N. H.	1837-50	Portraits	Oil
Eliza Howard Burd	Philadelphia, Pa.	1840	Scenes	Watercolor
John Burgum	Concord, N. H.	1875	Portraits	Oil
Sophia Burpee	Amherst, N. H.	1805	Miscellaneous	Watercolor, Oil, Silk
Julia Burr	Stratford, Conn.	1825	Memorial	Watercolor on silk
Leonard Burr	Mass.	1840	Portraits	Oil
Burridge	St. Louis, Mo.	1865	Genre	Oil
Sarah A. Burroughs	Norwich, Conn.	1830	Landscape	Watercolor
Asa Bushby	Danvers, Mass.	1840	Portraits	
Esteria Butler	Maine	1820	Miniature portraits	Oil
Hannah P. Buxton	New York	1820	Memorial	Velvet painting
Emma Cady	New Lebanon, N. Y.	1820	Still life	Watercolor
Pryse Campbell		1770	Portraits	Oil
Vincent Canadé	New York City	b. 1880	Portraits & landscape	Oil
G. E. Candee	Conn.	1850	Genre	Watercolor
Azel Capen	Maine	1840	Portraits	Oil
Joseph Carey	Salem, Mass.	1785	Scene	Oil on wood
Miss Carpenter		1830	Miniature portraits	Watercolor
Cezeron	Ohio or Pa.	1810	Portraits	Oil on wood
Thomas Chambers	N. Y. C. & Boston	1835-55	Landscapes	Oil
Joseph Goodhue Chandler	Boston, Mass.	1840 b. 1813	Portraits	Oil
Winthrop Chandler	Mass. & Conn.	1747-99*	Portraits	Oil
Sarah F. Cheever	Salem, Mass.	1825	Landscape	Velvet
Chipman		1850	Still life	Oil
Henry Church	Chagrin Falls, Ohio	1896-1908*	Genre	Oil
Alvan Clark	Mass. & R. I.	1804-64*	Portraits	Oil & watercolor
Eliz. Potter Clark	New London, Conn.	1830	Still life	Velvet painting
F. C. Clark		1845	Landscape	Watercolor
Minerva Clark		1840	Portraits	Oil
David Clarke			Still life	Watercolor
Harriet B. Clarke	New York	1820	Memorial	Velvet painting
William P. Codman	Boston, Mass.	1805	Portraits	Oil
Elias V. Coe	Warwick, N. Y.	1840	Portraits	Oil
William A. Coffin			Portraits	Oil
A. C. Cole		1850	Historical piece	Watercolor
Charles Octavius Cole	Newburyport, Mass.	1830-40	Portraits of sea captains	Oil

Name	Dcte	Locale	Subject	Medium
Lyman Emerson Cole	1830-40	Newburyport, Mass.	Portraits of sea captains	Oil
Major Cole	1810	New Hampshire	Portraits	Oil
Maria Cole	1830	Cheshire, Mass.	Still life	Velvet painting
John Coles, Jr.	1807-20	Boston, Mass.	Portraits	Oil
C. Collins	1810	S. Hadley, Mass.	Memorial	Watercolor & embroidery
Miss Collis	1830	Rhode Island	Still life	Watercolor
Maria T. Conant	1840	Cambridge, N. Y.	Portraits	Oil
Morris Connor	1830	Henniker, N. Y.	Birth record	Watercolor
Henry Conover	1810-30	Monmouth County, N. J.	Portraits	Pastel
Mehitable J. Cook	1830	Maine	Portraits	Oil
J. D. Cortwright	1840	Lowell, Mass.	Portraits	Tempera
H. E. Covill	1885		Portraits	Oil
Eleanor L. Coward			Genre	Velvet painting
James Coyle		Mass.	Still life	
Aphia Crawford	1850		Portraits	Watercolor
Cleo Crawford	1892-1939*	Haverstraw, N. Y.	Scenes	Oil
S. Crehore	1806	Boston	Ship picture	Oil on wood
Hannah Crowninshield	1815	Mass.	Portraits	Oil
J. C. Cummings	1870		Landscape	Oil on cardboard
Charles Curtis	1820	Worcester, Mass.	Portraits & miniatures	Oil
H. B. Curtis	1840	New York City	Genre	Oil
Mary Cushman	1800	Rhode Island	Memorial	Watercolor on silk
J. Dalee	1890	Cambridge, N. Y.	Scene	Watercolor
M. J. Dalzell			Genre	Watercolor
Holy Daniel	1850	Illinois	Landscape	Watercolor
Maria Davenport	1836	Berlin, Conn.	Miniature portraits	Watercolor
Capt. Geo. Davidson	1790	Mass.	Portraits	Oil
Eben Davis	1860	Mass.	Portraits	Watercolor
Joseph H. Davis	1835	Maine & N. H.	Portraits	Watercolor
E. P. Davis	1820	Mass.	Scene	Watercolor
M. O. Davis	1820-30	Newburgh, N. Y.	Landscape	Velvet painting
Henry Dawkins	1775		Group Portrait	Watercolor
Polly C. Dean	1820	Mass.	Memorial	Velvet painting
Temperance Delano	1806	New Bedford, Mass.	Flowers	Watercolor
W. Dickson	1900	California	Townscape	Oil
Dobson	b. 1891	Mass.	Portraits	Oil
Doolittle	1877		Landscape	Oil
William Doriani	b. 1891	New York City	Genre	Oil
Lucy Douglas	1810		Religious picture	Watercolor
William M. S. Doyle	1820-35	Mass.	Portraits	Pastel

Name	Locale	Date	Subject	Medium
Augusta Draper	Brookline, Mass.	1846	Landscape	Oil
Clement Drew	Boston	1838-73	Seascapes	Oil
Anthony Drexel	Mass.	1830	Portraits	Oil
Rose Emma Drummond		1835	Portraits	Oil
H. Dundy	Vermont	1850	Portraits	Oil
C. F. Dunn	N. Litchfield, Me.	1850	Landscapes	Watercolor
John Durand	New York, Conn. & Va.	1870-80	Portraits	Oil
George.H. Durfee	New York	1865	Landscapes	Watercolor
Emily Eastman	Louden, N. H.	1820	Portraits	Watercolor
J. N. Eaton	Greene, N. Y.	1800	Conversation piece	Oil
Almira Edson	Halifax, Vt.	1830	Birth record	Watercolor
James Eights	Albany, N. Y.	1850	Landscape	Oil
Rachel E. Ellis	Franklin, N. Y.	1820	Memorial	Watercolor on silk
Orrin B. Ellison	Amesbury, Mass.	1880	Landscape	Oil on wood
James Sanford Ellsworth	Windsor & Norwich, Conn.	1811-74*	Miniature portraits	Watercolor
William S. Elwell	Springfield, Mass.	1810-81*	Portraits	Oil
I. L. Emerson			Ship picture	Oil
Ella Emory	Hingham, Mass.	1878	Interior	Watercolor
Alexander Hamilton Emmons	Norwich, Conn.	1816-79*	Portraits	Oil & watercolor
Joseph G. Ennin	Fairfield, Conn.	1850	Landscape	Oil on wood
Martha Esteline	Hershey, Pa.	1840	Landscape	Watercolor
J. M. Evans	Poughkeepsie, N. Y.	1850	Landscape	Oil
John Ewen, Jr.		late 18th C.	Scene	Oil on wood
C. L. Fenton	Vicinity of Dover, N. H.	1850	Portrait	Oil
R. Fibich	York Springs, Pa.	1850	Landscape	Oil
Erastus Salisbury Field	Mass.	1805-1900*	Portraits & scenes	Oil
E. E. Finch	Maine	1850	Portraits	Oil
Albert Fischer	Boston, Mass.	1792-1863*	Portraits	Oil
Charles Henry Fischer	Newark, N. J.	1860	Scenes	Oil
Jonathan Fisher	Blue Hill, Me.	1794-1837*	Portraits & landscapes	Oil & gouache
Fletcher	N. H. & Vt.		Portraits	Oil
Nicholas Foley	Conn.	1825	Romantic scene	Oil on wood
Abraham Folson	Dover, N. H.	1840	Portraits	Oil
Hannah Lucinda Forbes		1825	Memorial	Velvet
H. Fordham	Springfield, Mass.		Portraits	Oil
J. P. Francis	West Cornwall, Conn.	1895	Landscape	Oil
Geo. Fredenburg		1830	Still life	Watercolor
C. French	Mass.	1810	Portraits	Oil
O. E. S. Frink	Medford, Mass.		Portraits & landscapes	
John O. J. Frost	Marblehead, Mass.	1852-1929*	Landscapes and seascapes	Oil

Name	Locale	Date	Subject	Medium
James Frothingham	Boston & Salem, Mass. N. Y. C.	1786-1864*	Portraits	Oil
Bernard Frouchtben	New York City	b. 1870	Genre	Oil
Jacob Frymier	South	1800	Portraits	Oil
Augustus Fuller	Deerfield, Conn.	1812-76*	Portraits	Oil
John Mason Furnass	Mass.	1785	Portraits	Oil
Nancy Gage	Bradford, Mass.	1787-1845*	Miscellaneous	Oil
Sally Gardner	Nantucket, Mass.	1886	Portraits	Oil & watercolor
George Gasner	Mass.	1811-61*	Portraits & miniatures	Oil
S. S. Gephart	Pittsburgh, Pa.	1860	Landscape	Oil
H. R. Gibbs	Sherburn, Mass.	1865	Ship picture	Watercolor
Charles S. Gibson			Children's portraits	Oil
C. M. Giddings	Cleveland, Ohio	1840	Scenes	Oil
E. J. Gilbert	Maine	1850	Mural scenes	Fresco
J. Gilbert	New Bedford, Mass.		Portraits	
J. B. Giles	Vermont	1850	Portrait	Pen drawing
J. F. Gilman		1870	Landscape	Pen & wash drawing
A. W. S. Gilpin			Still life	Watercolor
Benj. Gladding	Providence, R. I.	1810	Genre	Oil
C. H. Golder		1880	Scene	Oil
Deborah Goldsmith	N. Brookfield, N. Y.	1803-36*	Portraits	Watercolor
J. C. Goodell	Malden Bridge, N. Y.	1830	Portraits	Oil
F. W. Goodwin	New York	1880	Portraits	Oil
William Goodwin	New London, Conn.	1880	Ship picture	Oil
William S. Gookin	Dover, N. H.	1885-60	Miscellaneous	Oil on canvas & wood
Joshua Gore	South	1860	Small portraits	Watercolor
Charles H. Granger	Maine	1840	Portraits	Oil
Benjamin Greenleaf	Phippsburg, Me.	1810-17	Portraits	Oil on canvas & glass
Charles Grimiss	Conn.		Portraits	
J. H. Grout			Portraits	
Thomas Gurney		1815	Memorials, valentines	Watercolor
Sara Hadley	Wilton, N. H.	1850	Landscape	Oil
A. Halkett		1850	Ship picture	Pencil drawing
Sylvester Hall	Wallingford, Conn.	1778	Mural landscape	Oil on wood
Dr. William Hallowell	Norristown, N. J.	1865	Animals	Pen drawing
L. J. Hamblin	Boston, Mass.	1840	Portraits	Tempera
Amos Hamilton	Mass.	1830	Portraits	Oil
Sophie Hamilton	New York	1820	Pastoral scene	Watercolor
Nathaniel Hancock	Boston & Salem, Mass.	1790-1808	Portraits	Oil
Jeremiah L. Harding	Mass.	1840	Portraits	Oil

Name	Locale	Date	Subject	Medium
Jeremiah P. Hardy	Maine	1840	Portraits	Oil
Ellen Harrington	Charlestown, Mass.	1850	Miscellaneous	Watercolor
Elihu Harris		19th cent.	Ship	Pen drawing
Harriet A. Harris		1880	Landscape	Oil
Alonzo Hartwell	Mass.	1835	Portraits	Oil
G. G. Hartwell		1850	Portrait	Oil
Elisha Hatch	Canaan, N. Y.	1840	Portraits	Watercolor
C. H. Hathaway	Conn.	1870	Genre	Oil on wood
Dr. Rufus Hathaway	Duxbury, Mass.	1790-1800	Portraits	Oil
Matilda A. Haviland			Still life	Velvet painting
Sarah E. Hawes	Mass.	1810	Memorial	Watercolor
Martha S. Hayse	Mass.	1810	Landscape	Watercolor
John Hazlitt	Hingham, Mass.	1767-1837*	Mural landscapes	Oil on wood
Asa Hemenway	Middlebury, Vt.	1889	Religious picture	Watercolor
Charles Adelbert Herp	Texas	1853-1943*	Genre	Watercolor
Hering	New Jersey	1785-1817	Portraits	Oil
J. Herring	Mass.	1820	Portrait	Oil on wood
Amasa Hewins	Dedham, Mass.	1806-1850	Portraits	
Philip Hewins	Hartford, Conn.	1780-1849*	Portraits	Oil
Edward Hicks	Bucks County, Pa.	1840-60	Miscellaneous	Oil
Joseph H. Hidley	New York	1830	Landscapes	Oil
William Hillyer	New Jersey	1872-1948*	Portraits	Oil
Morris Hirshfield	New York City	1860	Miscellaneous	Oil
C. W. Hoffman		1800-56	Genre	Watercolor
Albert Gallatin Hoit	Boston, Mass.	1838	Portraits	Oil
Jonas W. Holman	Boston		Portraits	Oil
E. R. Hood	Portsmouth, N. H.	1835	Landscape	
Washington Hood		1810-20	Genre	Oil
Lydia Hosmer	Concord, Mass.	1850	Still life, genre	Velvet painting, watercolor
E. K. Hough	Vermont	1850	Scene	Pastel
B. Howard	Rumford Point, Me.	1850	Landscape	Pastel
Rebecca F. Howard	Walpole, N. H.	1825?	Landscape	Pencil
Charity Howland	Bangor, Me.	1850	Landscape	Watercolor
Thomas Hoyt	New Hampshire	1835-45	Portraits	Oil
Thomas R. Hoyt, Jr.		1820-40	Townscapes	Watercolor
Hubbard	Boston, Mass.	1880	Portraits	Oil
William Hudson, Jr.	New Orleans, La.	1840-1935*	Portraits	Oil
Charles Hutson	Bridgeport, Conn.	1835-45	Genre	Oil
I. F. Huge	Boston, Mass.	1830	Ship pictures	Watercolor
Robert Ball Hughes	Ohio	1840	Portraits	Oil
Maria Hyde Humphrey			Landscape	Watercolor

Name	Locale	Date	Subject	Medium
Peter (Pa) Hunt	Provincetown, Mass.	1870-1924*	Genre	Oil
Ingalls	New Hampshire	1850	Portraits & miniatures	Oil
John Ingersoll	Haverhill, Mass.	1788-1815*	Still life	Watercolor
John Gage Ingersoll	Bradford, Mass.	b. 1815	Landscape	Watercolor
Mary L. Ingraham	Mass.	1810	Religious scene	Watercolor
H. Jenkins		1850	Portraits	Oil
N. D. Jenney	Portland, Me.	1850	Portraits	Oil
J. S. Jennings	New Hudson, N. Y.	1850	Landscape	Oil
Richard Jennys	Conn.	1790-1900	Portraits	Oil
William Jennys	Conn.	1795	Portraits	Oil
Frederick Stiles Jewett	Hartford, Conn.	1819-64*	Ship pictures	Watercolor
Ann Johnson	Conn.	1810-25	Religious scene	Oil
Charles Johnson	New York City	b. 1862	Portraits & landscapes	Oil
Hamlin Johnson	Litchfield, Conn.	1845	Portraits	Watercolor
S. D. Johnson		1820	Landscape	Watercolor
John Johnston	York, Me.	1790	Portraits	Oil
Joshua Johnston	Baltimore, Md.	1795-1825	Portraits	Oil
Thomas Johnston	Mass.	1825	Scene	Watercolor
Jones of Conn.	Conn.	1850	Portraits	Watercolor
S. Jordon	New York	1830	Portraits	Oil
Josephine Joy	Los Angeles, Calif.	b. 1860	Landscapes	Oil
John Kane	Pittsburgh, Pa.	1860-1934*	Landscapes & portraits	Oil
W. H. Kelly		1870	Scene	Oil on wood
A. Kemmelmeyer	Maryland	1790-1810	Hist. scenes of Washington	Oil
D. Kemp	Pennsylvania	1840	Decorative piece	Oil on wood
T. J. Kennedy	Auburn, N. Y.	b. 1820	Symbolical scene	Oil
William W. Kennedy		1845	Portraits	
Jane Keys	Troy, N. Y.	1825	Instructress in painting	
Caroline Keyes	Salisbury, Conn.	d. 1810	Genre	Watercolor
Mary Ann Kimball	Penn.	1825	Memorial	Velvet painting
Charles King	Maine	1850	Portraits	Oil
Josiah B. King	Conn.	1850	Miniature	Watercolor
Addison Kingsley		1860	Landscape	Oil
Hazel Knapp	Vermont	b. 1908	Landscapes	Oil
T. G. Knight	Penn.	1880	Genre	Oil
W. Knipers		1860	Portrait	Oil
Samuel Koch	New York City	b. 1887	Genre	Oil
Theo. Koeth		1860	Genre	Oil

175

Name	Locale	Date	Subject	Medium
Olaf Krans	Bishop Hill, Ill.	1838-1916*	Portraits & genre	Oil
Nathaniel Lakeman	Mass.	1780-90	Portraits	Oil
K. A. Lamb	New England	1850	Genre	Oil
Betsy B. Lathrop	New York	1810	Biblical scene	Watercolor on silk
Thomas B. Lawson	Mass.	1840	Portraits	Oil
Joseph Warren Leavitt	Chichester, N. H.	1824	Interior	Watercolor
Lawrence Lebduska	New York City	b. 1894	Genre	Oil
M. F. Lefferts		1841	Scene	Watercolor
Abraham Levin	New York City	b. 1880	Landscapes & flowers	Oil
C. L. Lewin	Penn.	1850	Portrait	Oil
Elijah P. Lewis	Maine	1830	Portraits	Oil
Flora Lewis	Atchison, Kansas	b. 1903	Genre	Oil
James Lincoln	Mass.	1840	Portraits	Oil
Ann Little	Mass.	1820	Landscape	
Israel Litwak	Brooklyn, N. Y.	b. 1868	Scenes	Oil
Mary Lord	Litchfield, Conn.	1800	Decorative piece	Watercolor on silk
George E. Lothrop	Boston, Mass.	?-1929*	Imaginative scenes	Oil
William Lovett	Mass.	1790	Portraits	Oil
C. Louis		1818	Landscape	Oil
H. Lyman	Conn.	1820	Instructress in painting	Pencil drawing
Jacob Maentle	New Harmony, Pa.	1840	Portraits	Watercolor
MacKay	Conn.	1790	Portraits	Oil
Jane Helena Manley	Kingston, N. Y.	1843	Pastoral scene	Crayon drawing
Edward D. Marchant	Mass.	1830	Portraits	Oil
Mirible Marford	Eatontown, N. J.	1814-27*	Landscape	Watercolor
G. W. Mark	Greenfield, Conn.	1825	Portraits & frescoes	Oil frescoes
Emily Marshall	White Plains, N. Y.	1810	Mythological subjects	Watercolor
J. B. Marston	Boston, Mass.	1810	Portraits	Oil
G. Martens		1840	Portrait	Oil
Benjamin Franklin Mason	Pomfret, Vt.	1804-71*	Portraits	Oil
Jonathan Mason	Mass.	1820-30	Portraits	Oil
William Sanford Mason	Mass.	1840	Portraits	Oil
Robert Mathes	Milton, N. H.	1830	Portraits	Oil
William Matlick	New Jersey	1800	Genre	Watercolor
Eliza McClellan Mayall	Maine	1840	Portraits	Oil
A. E. Maynard	Vermont	1880	Farm scene	Oil
J. McAuliffe		1830-70	Genre	Velvet painting
G. McConnell	Manchester, N. H.	1870	Landscape	Oil
R. McFarlane		1840	Portraits	Oil
A. C. McLean	Charlestown, Mass.	1830	Portrait of children	Oil

Name	Locale	Date	Subject	Medium
Robert McNaughton	Schoharie, N. Y.	1820	Portraits	Oil
William Mercer	Penn.	1800	Scenes	Oil
Susan Merrett	S. Weymouth, Mass.	1845	Genre	Watercolor
Ann Page Merridan		1820	Literary scene	Watercolor
Sarah Merrill		1815	Memorial	Watercolor
E. Merritt	Penn.	1850	Ship picture	Watercolor
Elizabeth Meyer		1830	Animals	Watercolor
Lewis Miller	York, Pa.	1795-1882*	Genre	Pen drawing & watercolor
Louisa F. Miller	New Lebanon, N. Y.	1830	Memorial	Watercolor on silk
Mrs. Miner		1850	Scene	Oil
Phoebe Mitchell	New York	1800-10	Landscape	Watercolor
Jacob B. Mooers	Deerfield, N. H.	1840	Portrait	Oil on academy board
A. E. Moore		1830	Portrait	Oil
Emily S. Moore	Mass.	1855	Landscape	Charcoal drawing
J. Moron		1830	Portrait	Oil
Jacob Bailey Moore	Candia & Manchester, N. H.	1845-90	Portraits	Oil, pastel, charcoal
D. Morrill	Conn.	1860	Genre	Oil
Jones Fawson Morris	Sterling, Mass.	1840	Portraits	Oil
Emeline Morton			Scene	Watercolor
Anna Mary Robertson Moses	Eagle Bridge, N. Y.	b. 1860	Scenes	Crayon on board
Thomas P. Moses	Portsmouth, N. H.	1850	Ship picture	Oil
Reuben Moulthrop	New Haven, Conn.	1763-1814*	Portraits	Oil
William S. Mulholland	Vermont	1870-1936*	Genre	Oil
George Munger	Mass.	1810	Portraits	Oil
Munn	New Haven, Conn.	1815-50	Portraits & scenes	Oil on wood & canvas
Elenor Murray	Red Bank, N. J.	1820	Romantic scene	Watercolor
Eliza Murray	New England	1810	Memorial	Watercolor
J. D. Neffensperger	Penn.	1840	Scene	Watercolor & ink
Nathan Negus	Mass. & Alabama	1850	Portraits	
G. N. Newell			Portrait	
Eleanor Nichols	Bridgeport, Conn.	1840	Landscape	Watercolor
Susan Fauntleroy Quarles Nicholson	Baltimore, Md.	1820	Portraits	Oil
Mary Altha Nims	Bennington, Vt.	1840	Romantic scenes	Watercolor
John Norman	Mass.	1775	Portraits	Oil
Benjamin F. Nutting	Boston, Mass.	b. 1813 d. after 1873	Portraits	Oil
Obe	New Hampshire	1850	Genre	Oil on wood
D. Oliver	Mass.	1870	Farm scene	Oil on wood

Name	Locale	Date	Subject	Medium
N. B. Onthank	N. Y. & Mass.	1850	Portraits	Oil
E. Opper	New York	1880	Genre	Pencil
K. V. Orcott	Gloucester, Mass.	1879	Portrait, sketch	Oil
Alfred Ordway	Mass.	1840	Portraits	Oil
B. F. Osborn	Hampton, N. H.	1870	Marine	Oil
James Osborn		1800	Portrait	Watercolor
Charles Osgood	Mass.	1840	Portraits	Oil
Samuel Stillman Osgood	Mass.	1840	Portraits	Oil
William Page	Mass.	1840	Portraits	Oil
W. Paine	New Bedford, Mass.	1845	Portraits	Oil on cardboard
C. H. Palmer	Penn.	1825	Portraits	Oil
Jane Palmer		1780	Genre	Watercolor
Julia Ann Palmer	Hallowell, Me.	1820	Genre	Watercolor
Linton Park	Indiana County, Pa.	1826-c. 1870*	Genre	Oil
Mary Parke	New England	1825	Biblical scene	Watercolor
Life Parker, Jr.		1840	Portraits	Watercolor
J. Parks	Mohawk Valley, N. Y.	1830	Portrait	Oil
Jeremiah Paul	Philadelphia, Pa.	1790	Portraits	Oil
J. W. S. Paul		1840	Decorative theorem	Watercolor
Eliza Paxton	Philadelphia	1814-16	Still life	Watercolor
Nathaniel Peck	Long Island	1830	Genre	Oil
Deacon Robert Peckham	Westminster, Mass.	1785-1877*	Portraits	Oil
C. Peters	Mass.	1835	Memorial	Watercolor
J. Peters	Vermont	1840	Genre	Oil
Captain "Phindoodle"		late 19th c.	Seascape	Oil
Joseph Pickett	New Hope, Pa.	1848-1918*	Landscape	Oil
C. A. Pilliner	Cambridge, Mass.	1860	Landscape	Oil on tin
P. Mignon Pimat	Mass.	1810	Portraits	Oil
Eunice Pinney	Windsor, Conn.	1770-1849*	Genre & memorials	Watercolor
Horace Pippin	West Chester, Pa.	1888-1948*	Miscellaneous	Oil
Plattenberger	Penn.	1860	Biblical scene	Oil
Edward Plummer	Conn.	1850	Miniature	Watercolor
Harrison Plummer	Haverhill, Mass.	1840	Portraits	Oil
R. Plummer	Maine	1860	Landscape	Oil
Luke Pollard	Harvard, Mass.	1845	Portraits	Oil
John Porter	Boston, Mass.	1830	Portraits	Oil
Rufus Porter	New England	1792-1884*	Landscapes	Fresco
Asahel Powers	Vermont	1820	Portraits	Oil on wood
Henry C. Pratt	Maine	1840	Portraits	Oil
Jessie Predmore	California	b. 1896	Genre	Oil

Name	Locale	Date	Subject	Medium
Luke Prince, Jr.	Haverhill, Mass.	1840	Portrait	Oil & tempera
William Mathew Prior	Maine & Mass.	1806-73*	Portraits & landscapes	Oil
H. Pudor	Lawville, N. Y.	1860	Group portrait	
Charlie Purdy	Salem, Mass.		Portraits	
J. Rand	Eastern Ohio	1820	Portraits	Oil
Mary Rappé	Berks County, Pa.	1790	Genre	Watercolor
J. Rasmussen	Vermont	1880	Scene	Oil on zinc
Eleanor Rawson	Mass.	1820	Genre	Watercolor
P. Reed		1840		
Max Reyher	Belmar, New Jersey	b. 1862	Mystical scenes	Oil
J. Richard		1865	Genre	Oil
Marvin S. Roberts	Mass.	1813-72*	Portraits	Oil & watercolor
John Robertson		1845	Ship picture	Watercolor & pencil
Frank Robinson		1860	Ship picture	Oil
Nathaniel Rogers	Mass.	1810	Portraits	Oil
D. F. Roman	Ashley, Ohio	1870	Landscape	Watercolor & pinpricking
Elmira Root	Ashley, Ohio	1840	Portrait	Oil
George Ropes	Salem, Mass.	1835-50	Seascapes	Oil
L. K. Rowe	Mass.	1860	Portrait	Oil
Samuel Rowell	Amesbury, Mass.	1815	Portraits	Oil
R. Rowley	New York	1825	Portraits	Oil
Thomas Ruckle	Baltimore, Md.	1850	Landscape	Oil
N. B. Russell				
Ladis Sabo	New York City	b. 1870	Landscapes	Oil
Ester Sackett	New York	1840	Still life	Watercolor
Ann Elizabeth Salter	Mass.	1810	Memorial	Velvet painting
W. S. M. Samuels	San Antonio, Texas	1850	Scenes	Oil
M. M. Sanford		1850	Battle scene	Oil
Patsy Santo	Bennington, Vt.	b. 1893	Landscapes	Oil
A. J. Savage		1845	Portraits	Oil
J. W. Sawin	Springfield, Mass.	1850	Landscape	Oil
Wealthy O. Sawin	Mass.	1820	Still life	Watercolor
Belinda A. Sawyer		1820	Still life	Watercolor
Caroline Schetky	Boston, Mass.	1815	Portraits	Oil
Paul Seifert	Gotham, Wis.	1840-1921*	Farm scenes	Watercolor & tempera
C. F. Senior	Reading, Pa.	1780	Genre	Oil
Benjamin J. Severence	Northfield, Mass.	1825	Miscellaneous	Oil
Samuel C. Shafer	Ohio	1810	Group portrait	Pen drawing
Harriet Sewell		1810	Genre	Watercolor
Samuel Seymour	Philadelphia	mid 19th c.	Genre	Oil

179

Name	Locale	Date	Subject	Medium
Frank M. Sheets	Allentown, Pa.	1870	Portrait	Oil
Isaac Sheffield	New London, Conn.	1798-1845*	Portraits of sea captains	Oil
Lucy McFarland Sherman	Peekskill, N. Y.	1850	Still life	Watercolor
Lucy Sheldon	Litchfield, Conn.	1810	Miscellaneous	Watercolor
J. Shirvington	Charlottesville, Va.	1840	Miniature portraits	Watercolor
J. W. Simpson		1880	Landscape	Oil on wood
T. W. Skeggs	Elmira, N. Y.	1870	Genre	Crayon
Joseph B. Smith	New York	early 19th c.	Street scene	Oil on wood
John H. Smith	Thomaston, Me.	1875	Historical scene	Watercolor
Roswell T. Smith	Nashua, N. H.	1860	Portraits	Oil
Tryphena Goldsbury Smith		1801-36*	Ornamental paintings, etc.	Oil, watercolor, fresco
Jenny Emily Snow	Hinsdale, Mass.	1845	Landscapes, biblical scenes	Oil
Philip Snyder	Schoharie, N. Y.	1830	Scene	Oil
F. T. Somerby	Newburyport, Mass.	1832	Trompe l'oeil	Oil on wood
Lorenzo Somerby	Mass.	1840 b. 1816	Portraits	Oil
George Southward	Mass.	1830	Portraits	Oil
Ella Southworth	Essex, Conn.	b. 1872	Landscapes & still life	Watercolor
E. Spalding		1825-50	Landscape	Oil
Thomas T. Spear	Mass.	1830	Portraits	Oil
Frederick B. Spencer		1840	Portraits	Oil
Harry L. Spencer			Scene	
John L. Sperry	Homer, Minn.	1870	Townscape	Watercolor
H. M. Stafford	Vermont	1875	Landscape	Oil
J. W. Stancliff	Hartford, Conn.	1860 b. 1814	Ship pictures	
A. Stanwood		1850	Scene	Oil
Mary Ann H. Stearns	Billerica, Mass.	1827	Still life	Watercolor
William Stearns	Mass. or Maine	1825	Still life	Velvet
Arnold Steere	Rhode Island	1792-1832*	Portraits	Oil
Mary E. Sterling	Painesville, Ohio	1860	Scene	Oil
John Stevens	West	1875	Genre	Oil
Mehetable Stickney		1825	Memorial	
Jeremiah Stiles	Keene, N. H.	1771-1826*	Portraits	Oil
Samuel Stiles	Mass.	1820	Portraits	Oil
Joseph W. Stock	Springfield, Mass.	1815-55*	Portraits	Oil
N. Stone	Prattsville, N. Y.	1830	Genre	Oil
Robert Street	Philadelphia, Pa.	1830-40	Portraits	Oil
Patrick J. Sullivan	West Virginia	b. 1894	Symbolical scenes	Oil
W. Sutton		1840	Portrait	Oil
W. Sutton		1850	Portraits	Oil
William Swain	Mass.	1825	Portraits	Oil
Harriet Swain	Nantucket, Mass.	1830	Portraits	Watercolor

Name	Locale	Date	Subject	Medium
Ann Waterman Swift	Poughkeepsie, N. Y.	1810	Romantic scene	Watercolor
Augustus Taite	Albany, N. Y.	1840	Portrait	Oil
William Talcott	Mass.	1820–36	Portraits	Oil
A. M. Taylor	New York	1825	Landscape	Watercolor
Charles Ryall Taylor		1860	Scenes	Oil
Eliza Ann Taylor	New Lebanon, N. Y.	1845	Shaker drawing	Ink
H. M. Taylor	Delaware	1850	Scene	Pencil drawing
M. B. Tenney		1840	Portraits	
C. H. Tern		1825	Landscape	Fresco
Sarah F. Terry	Stoddard, N. H.		Still life	Velvet painting
Cephas Thompson	Mass.	1835	Portraits	Oil
William Thompson	Bath, Me.	1840	Portraits	Oil
Jerome Thomson	Harvard, Mass.	1835	Portraits	Oil
Sarah Thomson	Mass.	1800	Portraits	Oil
Elizabeth Thurston	Mass.	1820	Memorial	Watercolor on silk
Elizabeth Tillou	Canaan, Conn.	1830	Still life	Watercolor
Philip Tilyard	Brooklyn, N. Y.	1810	Portraits	Oil
John Tolman	Mass.	1815	Portraits	Oil
Renault Tourneur	Boston & Salem, Mass.	b. 1851	Fantasies	Oil
J. Towers	New York City	1850	Portraits	Watercolors
Bertha Trabich	New York City	d. 1941	Landscapes & flowers	Gouache
Jona Treadwell	Readfield, Me.	1840	Portraits	Oil
Alice Tucker	New Bedford, Mass.	1807	Flowers	Watercolor
Mary B. Tucker	Concord & Sudbury, Mass.	1840	Portrait	Watercolor
Abraham G. D. Tuthill	Vt. & New York	1777–1843*	Portraits	Oil
M. Van Doort	Mass.	1825	Portraits	Oil
N. J. Vaughan		1825	Still life	Watercolor
T. Wale	White River Junction, Vt.	1820	Portraits	Oil on wood
Elizabeth L. Walker	Mass.	1840	Romantic scene	Watercolor
M. Walker		1835	Genre	Watercolor
H. Ward	Youngstown, Ohio	1840	Scene	Watercolor
Catherine Townsend Warner	Rhode Island	1810	Memorial	Watercolor on silk
J. H. Warner	Fitchburg, Mass.	1840	Mural scenes	Fresco
M. Warren, Jr.	White Plains, N. Y.	1830	Portraits	Watercolor
Almira Waters	Portland, Me.	1830	Still life	Watercolor
E. A. Waters		1840	Literary scene	Watercolor
D. E. Waters		1840		Watercolor
E. Webb			Historical picture	Oil on glass
H. T. Webb	Conn.	1840	Portraits	Oil

Name	Locale	Date	Subject	Medium
Betsy Wellman		1840	Equestrian portrait	Watercolor
T. H. Wentworth	Conn.	1820	Portraits	Watercolor
P. B. Wescott	Greenfield, Mass.	1835	Memorial	Watercolor
A. S. Western	Boston, Mass.	1820	Landscape	Oil
H. Weston	Virginia	1850	Landscape	Oil
Mary Pillsbury Weston	Bradford, N. H.	1850	Scene	Watercolor
Isaac A. Wetherby	Boston, Mass.	1840	Portraits	Oil
Susan Whitcomb	Brandon, Vt.	1840	Scene.	Watercolor
Ebenezer Baker White	Providence, R. I.	1840 b. 1806	Portraits	Oil
John White	Cheshire, Conn.	1850	Landscape	Oil
L. Whitney			Village scene	Oil
Alfred J. Wiggin	Cape Ann, Mass.	1850	Portraits	Oil
F. H. Wilder	Mass.	1850	Portraits	Oil
Matilda Wilder	Mass.	1820	Scene	Watercolor
John Wilkie		1840	Portraits	Oil
A. Williams		1850	Ship picture	Oil
Charles P. Williams		1875	Farm scene	Oil
Sarah Wilkins	Mass.	1830	Memorial	Watercolor
Micah Williams	Peekskill, N. Y.	1790	Portraits	Oil
Clara Williamson	Iredell, Texas	b. 1875	Genre	Oil
Mary Ann Willson	Greenville, N. Y.	1810-25	Miscellaneous	Watercolor
Eveline F. Willis	Castleton, Vt.	1880	Miscellaneous	Watercolor
E. Wilson	New Hampshire		Portraits	Oil
George W. Wilson		1850-60	Landscape	Charcoal
Mary R. Wilson	Mass.	1820	Still life	Watercolor
N. W. Wineland	Canterbury, O.	1880	Genre	Oil
William Winstanley	Philadelphia, Pa.	1800	Portraits	Oil
Hanna Wood	New Hampshire	1870	Portrait	Watercolor
J. A. Woodin	Palmyra, N. Y.	1830	Portraits	Watercolor
E. Woolson	Boston, Mass.	1843	Portraits	Oil on wood
Charlotte A. Woolworth	New Haven, Conn.	1865	Dog	Pastel
Almira Kidder Wright	Vermont	early 19th c.	Historical scene	Watercolor on silk
Edward Harland Wright	Norwich, Conn.	1850	Portrait	Oil
Wybrant	Gloucester, Mass.	1850	Portraits	Watercolor
Emma T. Wynkoop	Penn.	1870	Landscape	Oil
J. Harvey Young	Boston, Mass.	1860 b. 1830	Portraits	Oil
Rev. Young	Centre County, Pennsylvania	1825-40	Portraits	Watercolor & ink
H. Ziegler		1840	Portraits	Watercolor
A. E. Zeliff	Essex County, N. J.	1850	Genre, still life	Oil